Liam Gillick

Oktagon
EDITORS
HERAUSGEBER
Susanne Gaensheimer, Westfälischer Kunstverein Münster
Nicolaus Schafhausen, Frankfurter Kunstverein

This catalogue was sponsored by the Alfried Krupp von Bohlen und Halbach-Stiftung as publication no. 97 of **Kataloge für junge Künstler**.

Diese Publikation wurde als 97. Katalog der Alfried Krupp von Bohlen und Halbach-Stiftung im Programm **Kataloge für junge Künstler** gefördert.

7

Consultation Filter "If you want to fight, then you go underground, whether you're on the inside of things or on the outside…" The first lines from the first chapter of ROBERT McNAMARA, an unpublished novel which Liam Gillick wrote in 1993 based on his screenplay McNAMARA for an exhibition at the Kunstverein in Hamburg, appear like a metaphor for an artistic strategy which runs through the whole novel and through all following texts, installations, scenarios and objects: the construction of implicit, non-concrete elements around the actual meaning which in turn remains obscure – around a content which is not mentioned, which exists between the words and lines, only as a vague context, as assumption, as something ungraspable and yet all-embracing, underground, invisible and underlying everything.

All elements in McNAMARA – the characters, the scenes, the actions – show this character: they are not in the forefront but in the vague middle ground of a system through which they exist, by which they are conditioned and which they in turn affect. Every element is charged with a special metaphorical meaning which conveys this positioning and constructs the subtext of the novel. McNAMARA depicts several scenarios taking place in the Sixties in the political surroundings of John F. Kennedy. The scenes are orientated to the centre of power, i. e. the White House, yet they are placed underground or on the periphery, for instance in a tunnel system under the White House or in an inconspicuous highway motel on the outskirts of Washington DC. These are places outside the representative area of power, literary allusions to the structures and bureaucratic machinery acting in the background yet constituting the visible symbols of power. Robert McNamara, Secretary of Defense under John F. Kennedy, and Herman Kahn, director of the RAND institute, are the main characters in the story. They are not unknown, yet they move in a field which lies alongside central events yet influences them substantially – "not at the centre of power, but central to power" (Liam Gillick). The other figures in the story, i. e. the economist, J. K. Galbraith, as well as Fiddle and Faddle, two of the President's presumed lovers, are defined by the vagueness of the roles they play: "I have no evidence that Galbraith wrote to JFK on a regular basis, yet his letters in the film are essential," Gillick writes, and about the two women: "We never find out their real names, but we know they know a great deal." It is significant to Liam Gillick's meandering method of moving around the actual core that the story of McNAMARA is constructed around the absence of the central figure – the former President of the United States – and is never concrete. It only consists of implications and allusions to "something" which is never named.

Very early, in the late Eighties and before his collaboration with Henry Bond, Gillick produced a number of sculptural

8 constructions of prefabricated parts to which he ascribed certain functions, yet functions which did not have a comprehensible sense based in the objects, but were themselves mere constructions. FLOOR MOUNTED DOUBLE WHITE RAIL, for instance, is a device which consists of a couple of two meter long rails held together by plastic grips which is mounted on the floor a few centimetres away from a wall. In this position the rails can fulfil none of the functions for which they are normally used. Nevertheless Gillick ascribes a specific function to this object: "The work functions best as a way to limit access to a particular area." Yet the question of which area could be meant and why these rails should be useful remains unanswered. Similarly vague and non-concrete is the function of SINGLE LEANING CORNER RAIL, a chest-high rail leaning at a sharp angle in a corner of the room, "viewed as operating somewhere between an architectural improvement and a sculptural intervention." A parallel between these works and Gillick's method of arranging highly complex elements into non-significant contexts in projects such as McNAMARA and following scenarios becomes especially visible in QUAD RAIL, a construction of four prefabricated, sixty centimetre long dark blue rails, forming a cuboid and fixed fairly low down onto a wall by means of large brackets of aluminium and oak veneer. According to Gillick the function of QUAD RAIL is "to emphasise otherwise overlooked areas of a chosen space." Hence the elaborate construction and its conspicuous visual presence do not have a function in and of themselves – except for the one to refer to something else, something otherwise unseen.

Arranging materials, objects, facts, fragments of knowledge and assumptions around something which itself is not graspable seems to have been a method in Liam Gillick's work right from the beginning. It implies a view of the world as mere construction in which knowledge, communication and action do not have a reality of their own but are themselves mere constructions. On the basis of this immanent and at the same time detached attitude towards the world Gillick makes use of its elements. When everything is a construction, why then not take the single elements, arrange them in new and different ways, play with them, create scenarios, develop visions, produce a future? It comes as no surprise that the set of works around the book ERASMUS IS LATE, which followed after McNAMARA, not only uses a number of fragments from the history of knowledge and politics to form a new situation, but also annuls our notion of time as a stringent linear course of events by developing parallel histories. Like Robert McNamara the central character in ERASMUS IS LATE, Erasmus Darwin is not a leading figure in a certain system, but rather someone who supports and influences the development of other people's ideas. In Gillick's story he is the host of a dinner in London, to which a number of persons from different periods in history

McNAMARA gerade um die Abwesenheit der zentralen Figur – des ehemaligen Präsidenten der Vereinigten Staaten – herum konstruiert und dabei nie konkret wird. Sie besteht ausschließlich aus Implikationen und Anspielungen auf „etwas", das selbst nicht genannt wird.

Sehr früh, in den späten 80er Jahren, noch vor Gillicks Zusammenarbeit mit Henry Bond, entstanden eine Reihe von skulpturalen Konstruktionen aus Fertigbauteilen, denen der Künstler bestimmte Funktionen zugeschrieben hat – Funktionen, die keinen nachvollziehbaren, im Objekt selbst begründeten Sinn hatten, sondern selbst reine Konstruktionen waren. FLOOR MOUNTED DOUBLE WHITE RAIL, zum Beispiel, ist eine am Boden montierte Vorrichtung aus zwei ca. zwei Meter langen Schienen, die mit Kunststoffgriffen zusammengehalten und wenige Zentimeter vor einer Wand befestigt sind. Die Schienen können in dieser Position keine der Funktionen erfüllen, für die sie normalerweise eingesetzt werden. Dennoch wird diesem Objekt von Gillick eine spezifische Funktion zugeschrieben: „The work functions best as a way to limit access to a particular area." Doch welcher Bereich damit gemeint sein könnte und warum dazu solche Schienen sinnvoll sein sollten, bleibt offen. Vage und unkonkret ist auch die Funktion von SINGLE LEANING CORNER RAIL, einer im spitzen Winkel in eine Raumecke gelehnten, etwa brusthohen Schiene, „viewed as operating somewhere between an architectural improvement and a sculptural intervention." Eine Parallele zwischen diesen Arbeiten und Gillicks Strategie des Arrangierens von impliziten Bedeutungen zu nicht-signifikanten Zusammenhängen in Projekten wie McNAMARA und späteren Szenarien, ist besonders eklatant in QUAD RAIL, einer auf niedriger Höhe angebrachten Wandkonstruktion aus vier zu einem Quader angeordneten, sechzig Zentimeter langen, dunkelblauen Fertigbauschienen, die mit massiven Winkeln aus Aluminium und Eichenfurnier an die Wand montiert werden. Die Funktion von QUAD RAIL besteht laut Gillick darin, „to emphasise otherwise over-looked areas of a chosen space." Die aufwendige Konstruktion und ihre auffällige optische Präsenz haben also selbst keine Funktion – außer der, auf etwas Anderes, eben ansonsten Nicht-Gesehenes, zu verweisen.

Das Zusammenfügen von Materialien, Objekten, Fakten, Wissensfragmenten und Vermutungen um etwas herum, das selbst nicht geifbar ist, scheint von Anfang an eine Methode im Werk von Liam Gillick zu sein. Es impliziert eine Sicht der Welt als reine Konstruktion, in der Wissen, Kommunikation und Handlung keine eigene Wirklichkeit besitzen, sondern selbst reine Konstruktionen sind. Aufbauend auf dieser immanenten und zugleich distanzierten Haltung zur Welt, macht sich Gillick deren einzelne Elemente verfügbar. Wenn alles eine Konstruktion ist, warum kann man dann nicht die einzelnen Elemente nehmen,

between 1810 and 1997 have been invited. These are Masaru Ibuka, Harriet Martineau, Elsie McLuhan and Murry Wilson, who as "secondary figures" are not central, but certainly have their places in the web of history. The moment of the event is a historical one, namely the night "before the mob are redefined as the workers in the collective social consciousness", a moment after which the positions in Western society had to be redefined: "Everyday is not the same, the near future is roughly predictable through capitalist projection and therefore potentially changeable." From today's perspective this particular moment is historically determined and has decisively influenced the social situation of our present. Gillick's design of a synchronisation of different times, development s and ideas at a place in the past and seen from today is certainly a mental act of liberation from our seemingly absolute concept of time as a continuous flow, a concept which was developed centuries ago. It was established and increasingly precisely structured so that flexibility and scope are completely excluded. Only fiction seems to make it possible to see the relationship of past, present and future not only as a horizontal, but also as a vertical one. In his utopian novel LOOKING BACKWARD 2000–1887, Edward Bellamy has ventured the shift from the late 19th century into our present in order to look back onto his own time from a fictitious Marxist-humanist utopia. Today we can look at this utopia from the position of reality. Liam Gillick has produced a special edition of the German translation of Bellamy's novel for the Galerie für Zeitgenössische Kunst in Leipzig. Republishing the book in connection with an exhibition in Leipzig and at a time when the realisation of Marxist ideas has become history, Gillick has overcome the continuous flow of time and brought together future and past in the present.

In association with the novels ROBERT McNAMARA and ERASMUS IS LATE and over a period of several years a range of different works in various forms have been produced: an animation, texts, pinboards, scenarios, installations and objects. The ideas behind these elements are connected to the novels, yet at the same time absolutely autonomous. The works neither function as illustrations or translations of the ideas introduced in the novels, nor are the novels explanations of the information included in the works. The relation of text and object in Liam Gillick's work cannot clearly be defined. In a similar way to the single metaphors and allusions in the novels, the meanings included in the texts and objects are interconnected in a complex network whose immanent systematic remains as opaque as the narrative structure of the novels. In 1997 another book by the artist entitled DISCUSSION ISLAND: BIG CONFERENCE CENTRE was published. The story is structured in parallel plots following the obscure missions of three characters – Ramsgate, Lincoln and Denmark –

neu und anders arrangieren, mit ihnen spielen, Szenarien schaffen, Visionen entwickeln, Zukunft produzieren? Es erstaunt nicht, daß in dem auf McNAMARA folgenden Werkkomplex um das Buch ERASMUS IS LATE nicht nur eine Vielzahl von Fragmenten aus der Geschichte des Wissens und der Politik zu einem neuen Szenarium zusammengefügt werden, sondern dabei auch unsere Auffassung von Zeit als stringent linearem Ablauf aufgehoben und eine Vision paralleler Geschichten entworfen wird. Wie Robert McNamara ist auch Erasmus Darwin, die zentrale Figur in ERASMUS IS LATE, keine Frontfigur eines bestimmten Systems, sondern eher ein Zuspieler, jemand der für die Entwicklung von Ideen anderer Einfluß hat. In Gillicks Geschichte ist er der Gastgeber eines Abendessens in London, zu dem eine Reihe von Personen aus verschiedenen Abschnitten der Geschichte zwischen 1810 und 1997 eingeladen sind. Es sind Masaru Ibuka, Harriet Martineau, Elsie McLuhan und Murry Wilson, die als „secondary figures" zwar nicht im Zentrum, wohl aber in den Vernetzungen der Geschichtsschreibung ihren Platz einnehmen. Der Zeitpunkt des Geschehens ist ein historischer, nämlich jene Nacht „before the mob are redefined as the workers in the collective social consciousness" (Liam Gillick) – ein Augenblick, nach dem die Positionen in der westlichen Gesellschaft neu definiert werden mußten: „Everyday is not the same; the near future is roughly predictable through Capitalist projection and therefore potentially changeable" (Liam Gillick). Aus der heutigen Perspektive ist dies ein historisch determinierter Moment, der die gesellschaftliche Situation unserer Gegenwart maßgeblich mitbestimmt hat.

Gillicks Entwurf einer Synchronschaltung verschiedener Zeiten, Entwicklungen und Ideen an einem Ort in der Vergangenheit aus der Perspektive von heute ist zweifellos ein geistiger Befreiungsakt von dem scheinbar absoluten Konzept der Zeit als ausschließlich vorwärtsgerichteter Bewegung. Dieses Konzept wurde vor Jahrhunderten entwickelt, etabliert und immer präziser strukturiert, so präzise, daß Beweglichkeit und Spielraum vollkommen ausgeschlossen sind. Nur in der Fiktion scheint es möglich, das Verhältnis von Vergangenheit, Gegenwart und Zukunft nicht nur horizontal, sondern auch vertikal zu denken. Edward Bellamy hat in seinem utopischen Roman LOOKING BACKWARD 2000–1887 im ausgehenden 19. Jahrhundert einen Zeitsprung in unsere Gegenwart gewagt, um aus der fiktiven Perspektive der Utopie auf sein eigenes Zeitgeschehen zurückzublicken. Seinem aus damaliger Sicht idealtypischen Entwurf einer marxistisch-humanistischen Gesellschaft können wir heute aus der Position der Wirklichkeit ins Auge blicken. Liam Gillick hat für die Galerie für Zeitgenössische Kunst in Leipzig eine Sonderausgabe der deutschen Übersetzung des Romans von Bellamy herausgegeben. Mit der Wiederveröffentlichung des Buches im Rahmen der Ausstellung in Leipzig und in einem Augenblick,

10 which take place simultaneously in different parts of a contemporary landscape and finally meet in one situation: the mysterious suicide of a person who jumps from the twenty-second story of a conference centre. Without ever being concrete, the book outlines processes of observation, communication and movement which are connected to the characters' mysterious actions. Reflections about "Think Tanks", the search for a "Discussion Island" and the construction of a conference centre play a central role and are described from constantly changing perspectives. While developing the novel, Gillick created a number of sculptural objects with titles reminiscent of elements from the book: DISCUSSION ISLAND CONCILIATION PLATFORM, DISCUSSION ISLAND REVISION PLATFORM, DISCUSSION ISLAND RECONCILIATION PLATFORM etc. These objects were presented in several exhibitions, further developed and are produced up to this day. Though the titles refer directly to the novel, the relation between text and object is not a dialectical one. Both the book and the objects are independent units of an intellectual structure whose interrelationships are not fixed but can be interconnected in many different ways.

In their introduction to MILLE PLATEAUX Gilles Deleuze and Felix Guattari use the image of a tree as a metaphor for the classical structure of thinking in Western culture, a structure of thinking which the authors consider to be exhausted. The bifurcations of the tree are used as an image of the principle of reflection, i. e. the dialectical relationship to the outside in which a dichotomy between subject and object is firmly established. As an alternative to the outdated model of the tree Deleuze and Guattari propose the model of the rhizome, a term also borrowed from biology. Rhizomes are the root-like structures of, for instance, mushrooms, tubers or onions. Yet also rats scurrying over one another do so in rhizomatic formations. In contrast to the tree which always expands through bifurcations so that every point within the whole structure is definitely fixed, within a rhizome every point can be connected to any other point. This creates a diversity, a scope and flexibility which – with regard to structures of thinking – allows heterogeneity and new patterns. "A diversity has neither subject nor object, but only definitions, sizes, dimensions which do not grow without changing the diversity" (Gilles Deleuze, Felix Guattari). The image of the rhizome has often been used in contemporary art and also in new electronic music in order to describe alternative models. Yet in no case does it seem to be as consistently applicable as in Liam Gillick's work. The variable interconnections of the single elements of a system and their heterogeneity cannot only be compared to the network of different outlets of Liam Gillick's thinking and production, but also seem to have been translated into a working method in an almost ideal way. This is not meant to claim that this is the artist's goal or intention. Yet comparing his

in dem die Umsetzung marxistischer Vorstellungen bereits wiederum zur Vergangenheit geworden ist, hat er sich über den kontinuierlichen Fluß der Zeit hinweggesetzt und die Zukunft mit der Vergangenheit im Moment der Gegenwart zusammengeführt.

Im Umfeld der Romane ROBERT MCNAMARA und ERASMUS IS LATE sind im Zeitraum von einigen Jahren eine Fülle von unterschiedlichen Arbeiten in den verschiedensten Formen entstanden: ein Animationsfilm, Texte, Pinboards, Szenarien, Installationen und Objekte. Diese Elemente stehen in gedanklicher Verbindung mit den Romanen, sind jedoch zugleich vollkommen autonom. Sie funktionieren weder als Illustrationen oder Umsetzungen der in den Romanen eingeführten Ideen, noch sind die Romane Ausführungen der in den Objekten enthaltenen Informationen. Das Verhältnis zwischen Text und Objekt läßt sich bei Liam Gillick nicht eindeutig definieren. Ähnlich wie die einzelnen Metaphern und Anspielungen innerhalb der Romane, fügen sich die in Text und Objekt enthaltenen Bedeutungen zu einem vielschichtigen Netzwerk, dessen immanente Systematik ebenso opak bleibt wie die narrative Struktur der Romane. 1997 erscheint ein weiteres Buch des Künstlers mit dem Titel DISCUSSION ISLAND: BIG CONFERENCE CENTRE. Die Geschichte ist in parallelen Handlungssträngen strukturiert und folgt den undurchsichtigen Missionen von drei Charakteren – Ramsgate, Lincoln und Denmark –, die gleichzeitig in verschiedenen Teilen einer zeitgenössischen Landschaft stattfinden und schließlich in einem Punkt zusammenlaufen: dem mysteriösen Selbstmord einer Person, die sich von der zweiundzwanzigsten Etage eines Konferenzzentrums in den Tod stürzt. Ohne jemals konkret zu werden, umschreibt das Buch Prozesse der Beobachtung, der Kommunikation und der Bewegung, die mit den rätselhaften Tätigkeiten der Figuren verbunden sind. Reflexionen über „Think Tanks", die Suche nach einer „Discussion Island" und die Konstruktion eines Konferenzzentrums spielen eine zentrale Rolle und werden aus permanent wechselnden Perspektiven beschrieben. Während der Entwicklung des Romans entstanden eine Reihe von skulpturalen Objekten mit Titeln, die an Elemente des Buches erinnern: DISCUSSION ISLAND CONCILIATION PLATFORM, DISCUSSION ISLAND REVISION PLATFORM, DISCUSSION ISLAND RECONCILIATION PLATFORM, u.s.w. Diese Objekte wurden in verschiedenen Ausstellungen gezeigt, weiterentwickelt und bis heute produziert. Obwohl ihre Titel direkt auf den Roman verweisen, ist das Verhältnis zwischen Text und Objekt keineswegs ein dialektisches. Vielmehr sind sowohl das Buch als auch die Objekte autonome Einheiten eines gedanklichen Gefüges, deren Beziehungen zueinander nicht festgelegt sind, sondern in vielfältiger Weise miteinander verknüpft werden können.

11

approach to Deleuze's and Guattari's model helps to show how far Liam Gillick's artistic thinking has left behind a conventional concept of representation.

When Gillick translates an idea or an intellectual context into a visual form, be it texts, book covers, letters, wall paintings or objects, he uses forms and colours which in the context of our late-capitalist society are encoded in a certain way. Normally he uses typefaces, colours and paints, materials and designs which are known from the corporate world and are encoded with certain social and cultural values. They introduce these codes into the artwork and charge it with additional meaning. Yet this does not happen in a direct and one-dimensional way, but in an abstracted, modified and ambiguous form so that the visual discourse takes place on a meta-level. Coca-Cola-coloured walls, for instance, is not just the description of a coloured wall in BIG CONFERENCE CENTRE, but also a concept inducing further formal decisions. Materials such as acrylic paint, chipboard, Plexiglas or aluminium strips are mass products and were bought at the local supplier. Gillick does not regard the given conditions as a limitation but, on the contrary, makes use of them in order to include the implications of their causes into the work. Hence the wealth of colours in his scenarios is just a range of what is available to everybody. Yet it also reflects the decisions made by industry for the masses. In contrast to other developments in the art of recent years in which design as mere surface has been made a subject and fetishised within a mainly formal discourse, colour, material and form in Gillick's works are charged with information like encoded messages. When Gillick chooses a Brionvega Algol TVC 11R – a TV-set designed in the United States in the Sixties – for the presentation of his animation McNAMARA and determines that the film may only be presented on this model, this does not mean that he is only interested in the pure design. It is rather a decision to include in his work the whole range of meanings, implications and projections related to this object in order to create a perfect parallel between form and content.

Liam Gillick was invited by the Westfälischer Kunstverein to take the architecture of the exhibition space as a starting point for a new work. Since at the time of the publication of this catalogue this work only existed as a concept, it could not be illustrated. Yet the title of the work, CONSULTATION FILTER, gives a significant image not only of this work but of the artist's general artistic approach. Consultation suggests a questioning attitude, a potential of communication and discourse, a capability of analysis and reflection, a movement to the outside and to the forefront. Liam Gillick not only analyses these processes and tendencies and makes them the subject of his work, but he also stimulates them. And filter is a perfect image for his method of

In der Einleitung zu den MILLE PLATEAUX verwenden Gilles Deleuze und Felix Guattari das Bild des Baums, um die klassische Denkstruktur der abendländischen Kultur zu veranschaulichen, eine Denkstruktur, die nach Meinung der Autoren ausgelaugt ist. Die zwiegespaltenen Verzweigungen des Baums stehen metaphorisch für das Prinzip der Reflexion, jener dialektischen Beziehung zum Außen, in der eine Dichotomie zwischen Subjekt und Objekt fest etabliert wird. Als Alternative zum überkommenen Modell des Baums schlagen Deleuze und Guttari das aus der Biologie entlehnte Modell des Rhizoms vor. Rhizom ist ein naturwissenschaftlicher Begriff für Wurzelstrukturen, wie sie etwa bei Pilzen, Knollengewächsen oder Zwiebeln auftreten. Doch auch Ratten, die übereinander hinweghuschen, bilden rhizomatische Formationen. Im Unterschied zur Struktur des Baums, der sich stets durch zweigeteilte Spaltungen erweitert und bei dem daher jeder Punkt innerhalb der gesamten Ordnung eindeutig festgelegt ist, kann bei einem Rhizom jeder Punkt mit einem beliebig anderen Punkt innerhalb des Rhizoms verbunden werden. Auf diese Weise entsteht eine „Mannigfaltigkeit", ein Spielraum und eine Beweglichkeit, die – bezogen auf Denkstrukturen – Heterogenität zuläßt und neue Muster ermöglicht: „Eine Mannigfaltigkeit hat weder Subjekt noch Objekt, sondern nur Bestimmungen, Größen, Dimensionen, die nicht wachsen, ohne daß sie sich dabei verändert" (Gilles Deleuze, Felix Guattari). Das Bild des Rhizoms wurde im Bereich der zeitgenössischen Kunst und auch der neuen elektronischen Musik häufig verwendet, um alternative Modelle zu bezeichnen. Doch in keinem Fall scheint es in aller Konsequenz so zuzutreffen wie bei der Werkstruktur von Liam Gillick. Die variable Verknüpfbarkeit einzelner Elemente eines Systems und deren Heterogenität scheint mit der Vernetzung unterschiedlicher Denk- und Produktionsstränge bei Liam Gillick nicht nur vergleichbar zu sein, sondern geradezu idealtypisch umgesetzt zu werden. Nicht, daß dies als ein Ziel oder eine Absicht des Künstlers behauptet werden soll; doch die Anlehnung an das Modell von Deleuze und Guattari hilft aufzuzeigen, wie weit sich das künstlerische Denken von Liam Gillick über eine herkömmliche Konzeption von Repräsentation hinweggesetzt hat.

Wenn Gillick für die Umsetzung einer Idee oder eines gedanklichen Zusammenhangs eine visuelle Form wählt, seien es Texte, Buchcover, Schriftzüge, Wandbemalungen oder Objekte, verwendet er Formen und Farben, die im Kontext unserer spätkapitalistischen Gesellschaft in bestimmter Weise kodiert sind. Meist sind es Schrifttypen, Farben und Farbsubstanzen, Materialien und Designs, die aus dem korporativen Bereich bekannt und Ausdrucksträger bestimmter gesellschaftlicher und kultureller Wertvorstellungen sind. Sie bringen diese Kodierungen in das Werk mit ein und reichern es mit Bedeutung an. Dies geschieht jedoch nicht direkt und eindimensional, sondern

12 singling out significant elements from certain situations and contexts in order to assemble them into new multilayered structures thus providing a different, surprising and manifold perspective of something already known or seen.

This publication is the first comprehensive documentation of Liam Gillick's work from its beginning in the late Eighties up to this day. The development of concepts, trains of thought and groups of work is illustrated by the reproductions and elucidated by Michael Archer's fundamental essay. Liam Gillick is one of the most influential artists of his generation. His work has had a fundamental impact on the central developments in the art of the Nineties, and has continually inspired and changed my own way of thinking about and looking at the world and contemporary art. I am happy to be able to present this book which could only be realised in co-operation with the artist and thanks to his personal commitment. I would like to thank all those who substantially contributed to the production of this publication: Liam Gillick, Nicolaus Schafhausen, Catsou Roberts, Michael Archer, Andreas Vitt and Markus Weisbeck, Brigitte Kalthoff, Andreas Balze, Caroline Schneider as well as the Alfried Krupp von Bohlen und Halbach-Stiftung.

Susanne Gaensheimer
Westfälischer Kunstverein

in abstrahierter, modifizierter und mehrdeutiger Form, so daß der visuelle Diskurs auf einer Metaebene geführt wird. „Coca-Cola-coloured walls", zum Beispiel, ist nicht nur die Beschreibung einer farbigen Wand in BIG CONFERENCE CENTRE, sondern auch ein Konzept, dem weitere formale Entscheidungen folgten. Materialien wie Acryllack, Spanplatten, Plexiglas oder Aluminiumleisten sind massenproduzierte Waren und kommen direkt vom örtlichen Baumarkt. Dabei betrachtet Gillick örtlich bedingte Vorgaben nicht als Limitierung, sondern, im Gegenteil, er verwendet sie, um die Implikationen ihrer Ursachen in das Werk miteinzubringen. Die Farbenvielfalt von Gillicks Szenarien ist daher nichts anderes als eine Skala dessen, was für jedermann verfügbar ist. Sie ist aber auch Spiegel jener Entscheidungen, die von der Industrie für die Massen getroffen werden. Im Unterschied zu anderen Entwicklungen in der Kunst der letzten Jahre, in denen Design im Rahmen eines formalästhetischen Diskurses als reine Oberfläche thematisiert und fetischisiert wird, sind Farbe, Material und Form in den Arbeiten von Liam Gillick wie verschlüsselte Mitteilungen aufgeladen mit Information. Wenn Liam Gillick für die Präsentation des Animationsfilm McNAMARA einen Brionvega Algol TVC 11R Fernseher auswählt und festlegt, daß der Film ausschließlich auf diesem Gerät gezeigt werden darf, dann ist dies keine an der reinen Form interessierte Haltung. Es ist vielmehr die bewußte Entscheidung, das gesamte Feld der Bedeutungen, Implikationen und Projektionen, die mit diesem in den USA der 60er Jahre entworfenen Gegenstand verbunden sind, in die Arbeit miteinzubringen und auf diese Weise eine perfekte Parallele zwischen Form und Inhalt herzustellen.

Liam Gillick wurde vom Westfälischen Kunstverein dazu eingeladen, die Architektur des Ausstellungsraums als Ausgangspunkt für eine neue Arbeit zu nehmen. Da diese zum jetzigen Zeitpunkt nur als Konzept existiert, kann sie hier leider photographisch nicht dokumentiert werden. Doch der Titel der Arbeit – CONSULTATION FILTER – bietet ein signifikantes Bild nicht nur für diese Arbeit, sondern auch für das gesamte künstlerische Vorgehen des Künstlers. Konsultation suggeriert eine fragende Haltung, Bereitschaft zur Kommunikation und Auseinandersetzung, die Fähigkeit zur Analyse und Überlegung, eine Bewegung nach außen und vorne – Prozesse und Tendenzen, die Liam Gillick nicht nur analysiert und thematisiert, sondern auch mit seinen Werken beim Betrachter in Bewegung setzt. Und Filter ist das ideale Bild für seine Strategie, von bestimmten Situationen und Zusammenhängen signifikante Elemente herauszugreifen, um sie zu neuen, vielschichtigen Gebilden zusammenzufügen und dabei eine andere, überraschende und mannigfaltigere Perspektive auf etwas bereits Gewußtes oder Gesehenes anzubieten.

Diese Publikation ist die erste umfassende Dokumentation des Werks von Liam Gillick von den Anfängen in den späten

13

80er Jahren bis heute. Die Entwicklung von Konzepten, Denksträngen und Werkgruppen in seiner Arbeit wird durch die Abbildungen veranschaulicht und durch den grundlegenden Text von Michael Archer erhellt. Für mich zählt Liam Gillick zu den bedeutendsten und einflußreichsten Künstlern seiner Generation, dessen Arbeit die zentralen Entwicklungen der 90er Jahre maßgeblich geprägt hat und meine persönlichen Seh- und Denkgewohnheiten in Bezug auf Phänomene der Kunst und der Welt immer wieder inspiriert und verändert. Ich möchte daher an dieser Stelle meine Freude über dieses Buch zum Ausdruck bringen, dessen Entstehung nur durch die Zusammenarbeit mit dem Künstler und durch dessen hohen persönlichen Einsatz möglich war. Allen, die zur Realisierung der Publikation maßgeblich beigetragen haben, möchte ich meinen besonderen Dank aussprechen: Liam Gillick, Nicolaus Schafhausen, Catsou Roberts, Michael Archer, Andreas Vitt und Markus Weisbeck, Brigitte Kalthoff, Andreas Balze, Caroline Schneider sowie der Alfried Krupp von Bohlen und Halbach-Stiftung.

Susanne Gaensheimer
Westfälischer Kunstverein Münster

15

However At first I was puzzled and then impressed by Liam Gillick's remark "Prevision. Should the future help the past?"

Whenever I am about to search, contemplate, understand, and eventually judge a work of art, these words come to me more and more often. For this I am grateful. Liam Gillick not only influences my work as a curator. Standing on top of the Sony building in Miami and actually ten years after I had first seen them, I really understood why the electric currents of some gallery wall in Nice had been traced. I was not quite sure whether I felt cold or hot. Suddenly a strong breeze came up and all those hats, suits and dresses made by Gucci no longer looked the way they were supposed to according to the presumed stage directions, or was this the intention, after all? After that, my notion of the present changed dramatically.

Nicolaus Schafhausen
Frankfurter Kunstverein

Aber Verwirrt und wirklich beeindruckt hat mich Liams Bemerkung „Prevision. Should the future help the past?"

Bei dem Suchen, der Betrachtung, dem Verstehen und schließlich der Beurteilung von Kunst denke ich immer häufiger an diese Aussage. Dafür bin ich ihm dankbar: Denn er beeinflußt nicht nur mein kuratorisches Handeln. Erst 10 Jahre danach, auf dem Dach des Sony-Buildings in Miami, habe ich verstanden, warum die Elektroströme einer Galeriewand in Nizza nachgezeichnet wurden. Ich konnte mich nicht richtig entscheiden, ob mir kalt oder warm wurde. Auf einmal wurde es ziemlich windig auf dem Sonydach und die Gucci-Hüte, Anzüge und Kostüme sahen nicht mehr so aus, wie die Inszenierung es vermeintlich vorsah. Oder doch? Danach wurde alles ganz anders in meinen Vorstellungen vom Jetzt.

Nicolaus Schafhausen
Frankfurter Kunstverein

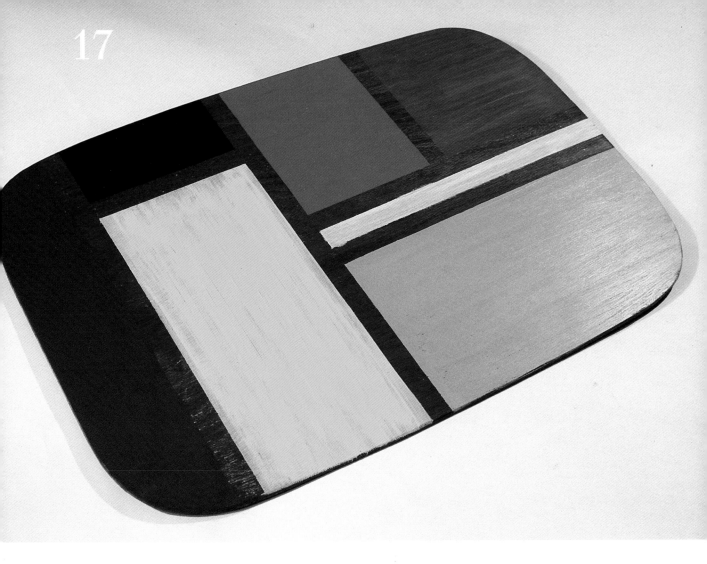

ADI DASSLER #2
1987
acrylic paint, wood
height 35 cm width 70 cm
A painted panel that refers to the founder of Adidas and is the
second in a series of works that provided an abstract portrait of
corporate aesthetics.

Acrylfarbe, Holz
Höhe 35 cm, Breite 70 cm
Bemalte Tafel, die sich auf den Gründer der Firma Adidas bezieht.

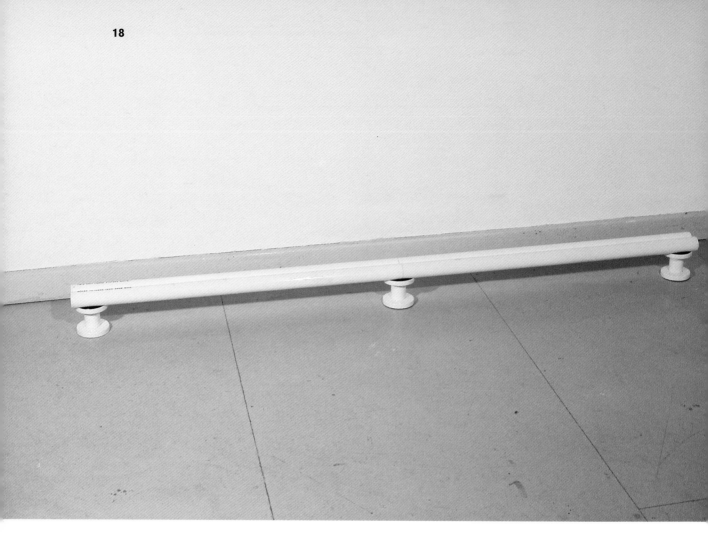

FLOOR MOUNTED DOUBLE WHITE RAIL
1988
plastic, steel
height 15 cm, length 200 cm, diameter 34 mm
A double length of round rail fabricated into a floor mounted work
that resembles an interior fitting or low heating system. The work
functions best as a way to limit access to a particular area. The
user of the work has placed it in front of papers that are stacked
by bookshelves.

Kunststoff, Stahl
Höhe 15 cm, Länge 200 cm, Durchmesser 34 mm
Zwei gleich lange runde Schienen, zu einer am Boden befestigten
Arbeit montiert, die einer Inneninstallation oder einem niedrigen
Heizkörper ähnelt. Am besten funktioniert die Arbeit als Zugangs-
beschränkung für einen bestimmten Bereich. Beim Benutzer der
Arbeit ist sie vor einem Regal mit Papierstapeln plaziert.

19

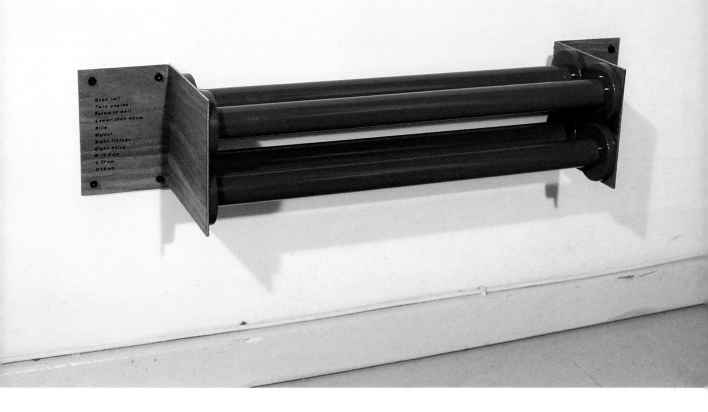

QUAD RAIL (BLUE)
1989
plastic, steel, aluminium, oak veneer
height 15 cm, width 60 cm, depth 15 cm
Four round rails fabricated into a low wall-mounted structure that
is constructed in order to emphasise otherwise over-looked areas
of a chosen space.

Kunststoff, Stahl, Aluminium, Eichenfurnier
Höhe 15 cm, Breite 60 cm, Tiefe 15 cm
Vier runde Schienen, zu einer niedrigen, an der Wand befestigten
Konstruktion montiert, die ansonsten übersehene Bereiche eines
ausgewählten Raums hervorhebt.

84 DIAGRAMS
1989
greyboard boxes, laser-printed Colourplan paper
each box height 31 cm, width 22 cm, depth 3 cm. Each sheet
height 30 cm, width 21 cm
Four greyboard boxes each containing 21 computer generated
diagrams printed onto Colourplan paper, each sheet a different
colour. A series of diagrams of potential buildings from a series
of work where the parallel activity of near-architecture is particular
due to the large numbers of drawings produced in any one day.
This work indicates something of the work carried out at that time
using early Apple computers for the production of the images.
Originally edition of 50 but maximum 10 sets produced.
LIAM GILLICK, Karsten Schubert Ltd, 1989

graue Kartons, Laserdruck auf Colourplan-Papier
Karton jeweils Höhe 31 cm, Breite 22 cm, Tiefe 3 cm, Blatt
jeweils Höhe 30 cm, Breite 21 cm
Vier graue Kartons mit jeweils 21 computergenerierten
Diagrammen, ausgedruckt auf Colourplan-Papier, jedes Blatt in
einer anderen Farbe. Eine Serie von Diagrammen möglicher
Gebäude aus einer Werkgruppe, in der die parallele Aktivität
von Beinahe-Architektur vor allem auf die große Anzahl an jedem
Tag produzierter Zeichnungen zurückzuführen ist.
Diese Arbeit zeigt die damals mit Hilfe früher Apple-Computer
produzierten Bilder. Von der ursprünglich geplanten Auflage von
50 Exemplaren wurden maximal 10 produziert.
LIAM GILLICK, Karsten Schubert Ltd, 1989

SINGLE LEANING CORNER RAIL (WHITE)
1989
plastic, steel
length 150 cm, diameter 3.4 cm
Single white round rail leaning against the wall.
The work should be placed in the corner of a room and viewed
as operating somewhere between an architectural improvement
and a sculptural intervention.

Kunststoff, Stahl
Länge 150 cm, Durchmesser 3,4 cm
An die Wand gelehnte einzelne weiße runde Schiene.
Die Arbeit sollte in einer Raumecke plaziert werden. Ihre Funktion
liegt irgendwo zwischen einer architektonischen Verbesserung
und einem skulpturalen Eingriff.

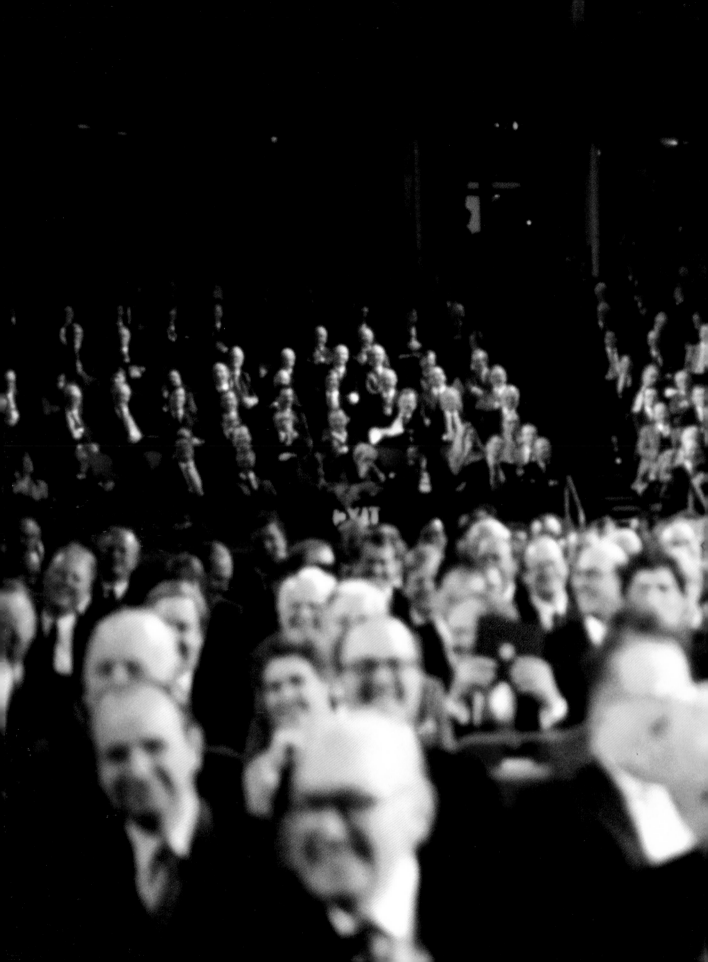

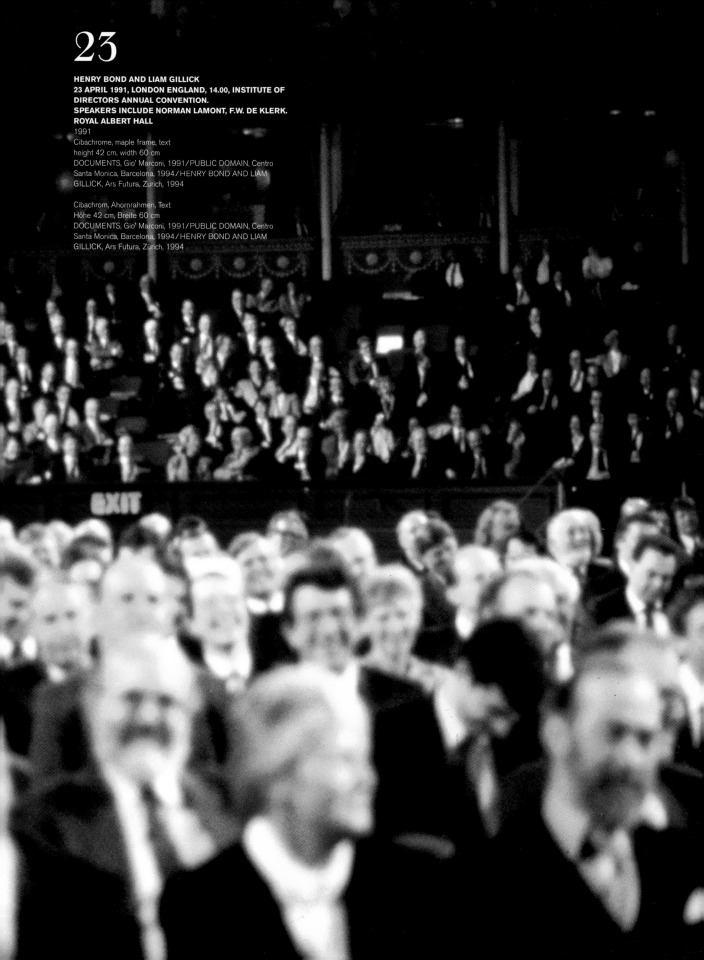

23

HENRY BOND AND LIAM GILLICK
23 APRIL 1991, LONDON ENGLAND, 14.00, INSTITUTE OF
DIRECTORS ANNUAL CONVENTION.
SPEAKERS INCLUDE NORMAN LAMONT, F.W. DE KLERK.
ROYAL ALBERT HALL
1991
Cibachrome, maple frame, text
height 42 cm, width 60 cm
DOCUMENTS, Gio' Marconi, 1991/PUBLIC DOMAIN, Centro
Santa Monica, Barcelona, 1994/HENRY BOND AND LIAM
GILLICK, Ars Futura, Zurich, 1994

Cibachrom, Ahornrahmen, Text
Höhe 42 cm, Breite 60 cm
DOCUMENTS, Gio' Marconi, 1991/PUBLIC DOMAIN, Centro
Santa Monica, Barcelona, 1994/HENRY BOND AND LIAM
GILLICK, Ars Futura, Zürich, 1994

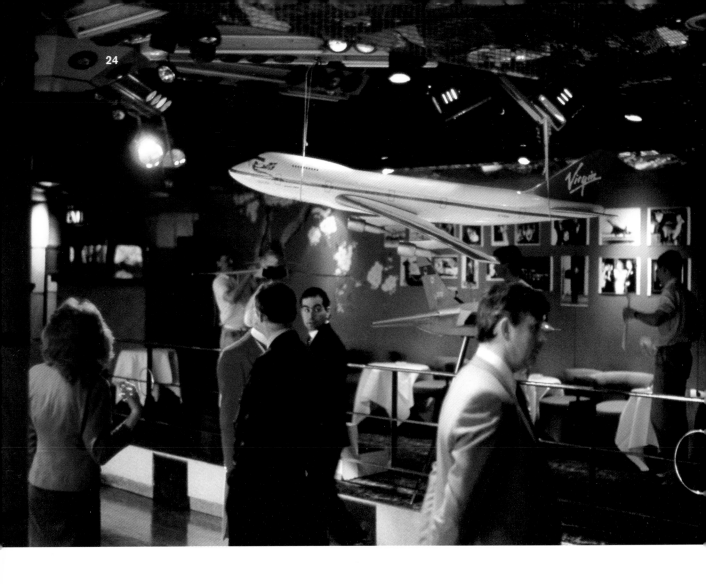

25

HENRY BOND AND LIAM GILLICK
25 APRIL 1991, LONDON ENGLAND, 17.00, RECEPTION TO
LAUNCH SUPER-COMMUTER, FRED FINN'S TEN MILLION
MILE TRIP. ROOF GARDENS, KENSINGTON
1991
Cibachrome, maple frame, text
height 42 cm, width 60 cm
DOCUMENTS, Gio' Marconi, 1991 / PUBLIC DOMAIN, Centro
Santa Monica, Barcelona, 1994 / HENRY BOND AND LIAM.
GILLICK, Ars Futura, Zurich, 1994

Cibachrom, Ahornrahmen, Text
Höhe 42 cm, Breite 60 cm
DOCUMENTS, Gio' Marconi, 1991 / PUBLIC DOMAIN, Centro
Santa Monica, Barcelona, 1994 / HENRY BOND AND LIAM
GILLICK, Ars Futura, Zürich, 1994

PINBOARD PROTOTYPE #2
1992
chipboard, hessian (colour Lincoln green), wood, screws,
printed Ingres paper, various papers
height 100 cm, width 100 cm, depth 4 cm
A prototype for the Pinboard series. The potential use of this
board is not as flexible as with the later series. A 100 cm,
square pin board and instructions for use printed on a sheet
of paper. Information about the exhibition WONDERFUL LIFE
is currently displayed on the board, other specific information
may be added later.
WONDERFUL LIFE, Lisson Gallery, 1993

Spanplatte, Sackleinen (Farbe Lincoln Grün), Holz,
Schrauben, bedrucktes Ingres-Papier, verschiedene Papiere
Höhe 100 cm, Breite 100 cm, Tiefe 4 cm
Prototyp für die Pinboard-Serie. Diese Tafel ist nicht so
flexibel einsetzbar wie die späteren Serien. Eine 100 x 100 cm
große Pinnwand und eine auf einem Blatt Papier ausgedruckte
Gebrauchsanleitung. Informationen zur Ausstellung WONDERFUL
LIFE sind zur Zeit auf der Tafel ausgehängt, andere spezielle
Informationen können später hinzugefügt werden.
WONDERFUL LIFE, Lisson Gallery, 1993

PINBOARD PROJECT (GREY)
1992
chipboard, hessian (colour Grey), wood, screws, printed
Ingres paper, various papers
height 100 cm, width 100 cm, depth 4 cm
A one metre square pinboard constructed from hessian covered
chipboard. Instructions for use printed on a sheet of paper. Various
potential items for use on the board are also supplied. Each
board is accompanied by the recommendation to subscribe to a
limited number of specialist journals. A low technology device for
the transfer and modification of information.
LYING ON TOP OF A BUILDING THE CLOUDS LOOKED
NO NEARER THAN THEY HAD WHEN I WAS LYING IN THE
STREET, Monika Sprüth, Cologne / Le Case d'Arte, Milan, 1992

Spanplatte, Sackleinen (Farbe Grau), Holz,
Schrauben, bedrucktes Ingres-Papier, verschiedene Papiere
Höhe 100 cm, Breite 100 cm, Tiefe 4 cm
Eine ein Quadratmeter große Pinnwand aus mit Sackleinen bezo-
gener Spanplatte. Gebrauchsanleitung ausgedruckt auf einem Blatt
Papier. Verschiedene mögliche Gebrauchsgegenstände auf der
Tafel werden ebenfalls gestellt. Jede Tafel wird begleitet von der
Empfehlung, eine begrenzte Anzahl von Fachzeitschriften zu
abonnieren. Eine technologisch nicht sehr hoch entwickelte Vor-
richtung für den Transfer und die Modifikation vonInformationen.
LYING ON TOP OF A BUILDING THE CLOUDS LOOKED
NO NEARER THAN THEY HAD WHEN I WAS LYING IN THE
STREET, Monika Sprüth, Köln / Le Case d'Arte, Mailand, 1992

**MUSEUM BOARD (LUZERN) #4 (TATTOO,
WOMEN'S BASKETBALL)**
1994
hessian (colour Gold) chipboard with cuttings from Tattoo
magazine and Women's Basketball
height 200 cm, width 300 cm, depth 4 cm
The work is a consolidated form of the material used for the
original BACKSTAGE exhibition in Hamburg transformed for
exhibition in Luzern. In Hamburg an information room was created
with walls covered in hessian. For Luzern the material was edited
and presented on large museum boards. Board 4 uses specific
material from the Tattoo magazine and Basketball Magazine.
All text in German.
BACKSTAGE, Kunstmuseum, Luzern, 1994

Sackleinen (Farbe Gold) Spanplatte mit Ausschnitten aus
einem Tattoo-Magazin und der Zeitschrift Women's Basketball
Höhe 200 cm, Breite 300 cm, Tiefe 4 cm
Die Arbeit ist eine für die Ausstellung in Luzern umgewandelte
konsolidierte Form des für die ursprüngliche BACKSTAGE-Aus-
stellung in Hamburg benutzten Materials. In Hamburg war aus mit
Sackleinen bespannten Wänden ein Informationsraum konstruiert
worden. Für Luzern wurde das Material bearbeitet und auf großen
Museumstafeln präsentiert. Tafel 4 verwendet spezielles Material
aus dem Tattoo-Magazin und der Basketball-Zeitschrift.
Alle Texte in Deutsch.
BACKSTAGE, Kunstmuseum, Luzern, 1994

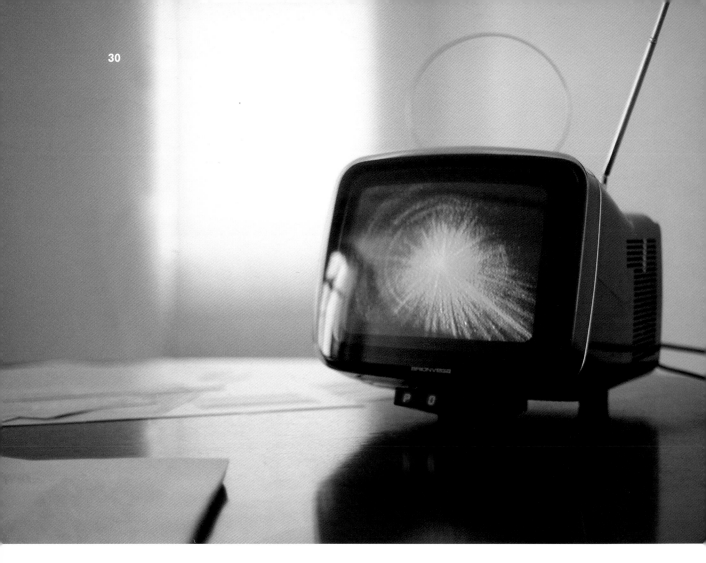

McNAMARA
1994
Brionvega Algol TVC 11R, 35 mm film transferred onto
appropriate format, Florence Knoll table (optional), copies of
various drafts of the film McNAMARA, additional copy of film
script written for owner of work. Edition of 3.
variable
The opening scene of the fifth draft of the script McNAMARA
realised as an animated cartoon film. It should only be viewed on
the Brionvega television. The film is approximately two minutes
long and concerns the potential of a dialogue between former
US Secretary of Defense, Robert McNamara and Director of the
RAND Institute, Herman Kahn.
McNAMARA, Schipper & Krome, 1994/NACH WEIMAR,
Landesmuseum, Weimar, 1996/LIFE/LIVE, ARC, Paris, 1996

Brionvega Algol TVC 11R, 35 mm-Film auf entsprechendes
Format umkopiert, Florence Knoll-Tisch (optional), Exemplare ver-
schiedener Entwürfe für den Film McNAMARA, zusätzliches
Exemplar des Drehbuchs, geschrieben für den Besitzer der Arbeit.
Auflage 3.
variabel
Die Eröffnungsszene des fünften Drehbuchentwurfs für
McNAMARA als animierter Zeichentrickfilm. Er sollte nur auf
einem Brionvega-Fernsehgerät angesehen werden. Der Film ist
etwa zwei Minuten lang und handelt von der Möglichkeit eines
Dialogs zwischen dem ehemaligen amerikanischen Verteidigungs-
minister Robert McNamara und dem Direktor des RAND-Instituts
Herman Kahn.
McNAMARA, Schipper & Krome, 1994/NACH WEIMAR,
Landesmuseum, Weimar, 1996/LIFE/LIVE, ARC, Paris, 1996

ANGELA BULLOCH AND LIAM GILLICK
WE ARE MEDI(EVIL)
1994
hole in the ground, video, meadow
variable
A series of specific interventions for the Portikus in Frankfurt.
Including a hole left permanently outside the space, a meadow
planted in the grounds around the Portikus and a video by the
artists that both documents and expands upon the work.
The project takes a pre-football, prior Karaoke position during
an exhibition themed around the '94 World Cup and Karaoke.
WM/KARAOKE, Portikus, Frankfurt, 1994

Loch im Boden, Video, Rasen
variabel
Eine Reihe spezieller Interventionen für den Portikus in Frankfurt.
Dazu gehören ein außerhalb des Raumes permanent offengehalte-
nes Loch, ein auf dem Grundstück um den Portikus herum ange-
legter Rasen und ein Video des Künstlers, das die Arbeit sowohl
dokumentiert als auch erweitert. Das Projekt nimmt während einer
Ausstellung um die Themen Weltcup 94 und Karaoke eine
Vor-Fußball-, Vor-Karaoke-Position ein.
WM/KARAOKE, Portikus, Frankfurt, 1994

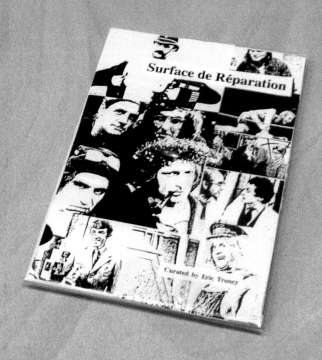

SURROGATE CATALOGUE
1994
catalogue with photocopied collage cover sealed in plastic sheeting
height 15 cm, width 11.5 cm
A surrogate catalogue design for the exhibition SURFACE DE
RÉPARATIONS. Placed in the centre of an extremely large table
and therefore just out of reach of the visitors to the exhibition.
Despite the existence of the prototype, an official catalogue was
later
produced by the curator of the show which looked nothing like it.
SURFACE DE RÉPARATIONS 2, FRAC, Bourgogne, 1994

in Folie eingeschweißter Katalog mit fotokopiertem
Collage-Einband
Höhe 15 cm, Breite 11,5 cm
Ein Katalogersatzentwurf für die Ausstellung SURFACE DE
RÉPARATIONS. In der Mitte eines extrem großen Tischs plaziert
und somit für die Ausstellungsbesucher knapp außer Reichweite.
Trotz Vorhandenseins dieses Prototyps produzierte der Kurator der
Ausstellung später einen offiziellen Katalog, der völlig anders aussah.
SURFACE DE RÉPARATIONS 2, FRAC, Bourgogne, 1994

Lost Paradise
A Parallel Information Service

Jeremy Deller/Liam Gillick/Jorge
Pardo/Laura Stein/Rirkrit
Tiravanija/Jeanette Schulz/Irene &
Christina Hohenbüchler/Philippe

ar
athy Skene
all/Kurt
n de
n/Andreas
d and
October
Kunstraum
one end of
rest to
hone
d the fax
u can call
how.
el
tion
se.)

Lost Paradise Information Service

Tel (43) 1 522 76 13

Fax (43) 1 522 66 42

[Liam Gillick/LPIS] Jeremy Deller/Liam Gillick/Jorge Pardo/Laura
Stein/Rirkrit Tiravanija/Jeanette Schulz/Irene & Christine
Hohenbüchler/Philippe Parreno/Christine Hill/Hans
Scharnagl/Carola Dertnig/Elmar Hess/Gertraud
Presenhuber/Cathy Skene und Christoph Schäfer/Eva Krall/Kurt
Baluch/Aage Hansen-Löve/Jean de Loisy/Stephan Schmidt-
Wulffen/Andreas Spiegl/Sabine B. Vogel/Barbara Steiner
October through December 1994 - Kunstraum Vienna

Lost Paradise Information Service
Tel (43) 1 522 76 13
Fax (43) 1 522 66 42

[Liam Gillick/LPIS] Jeremy Deller/Liam Gillick
Stein/Rirkrit Tiravanija/Jeanette Schulz/Iren
Hohenbüchler/Philippe Parreno/Christine Hi
Scharnagl/Carola Dertnig/Elmar Hess/Gertra
Presenhuber/Cathy Skene und Christoph Sch
Baluch/Aage Hansen-Löve/Jean de Loisy/Step
Wulffen/Andreas Spiegl/Sabine B. Vogel/Barba
October through December 1994 - Kunstraum

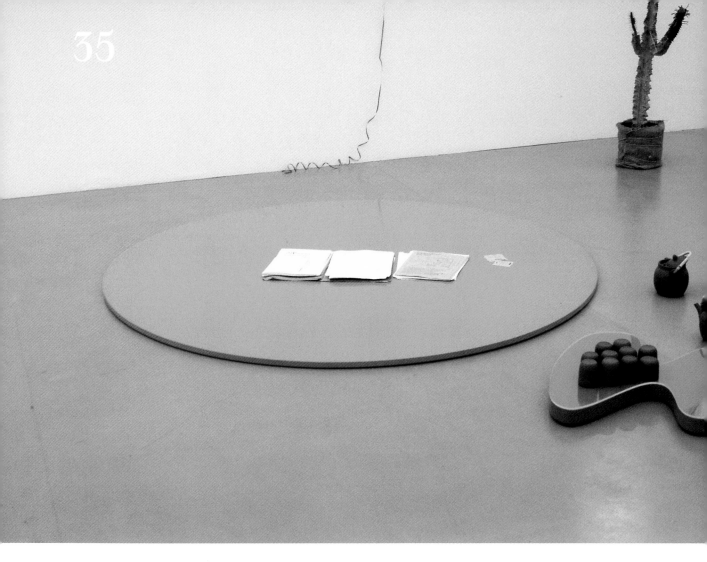

LOST PARADISE INFORMATION SERVICE (ARCHIVE)
1994
various papers, archive box
variable
The establishment of a parallel information service to run
alongside the exhibition LOST PARADISE. All the material was
later boxed and exists as an archive. The work was displayed
on a circular base designed for the artist by Jorge Pardo.
LOST PARADISE, Kunstraum, Vienna, 1994/LIAM GILLICK,
Interim Art, 1994

verschiedene Papiere, Archivkasten
variabel
Die Einrichtung eines parallelen Informationsdienstes während
der Ausstellung LOST PARADISE. Alles Material wurde später in
Kästen abgelegt und bildet jetzt ein Archiv. Die Arbeit wurde auf
einem von Jorge Pardo für den Künstler entworfenen runden
Sockel ausgestellt.
LOST PARADISE, Kunstraum, Wien, 1994/LIAM GILLICK,
Interim Art, 1994

PROTOTYPE ERASMUS TABLE #2 (GENT)
1994
chipboard, square cut legs, hardware, papers, various art works
variable
A large table, designed to nearly fill a room. Initially conceived of
as a working place where it might be possible to finish working on
the book ERASMUS IS LATE, the table was also made available
to other people for the storage and exhibition of work on, under and
around it.
ON-LINE, Gent, Belgium, 1995

Spanplatte, Beine mit quadratischem Querschnitt,
verschiedene Kunstwerke
variabel
Ein großer Tisch, der den Raum nahezu ausfüllt. Dieser Tisch,
der ursprünglich als Arbeitsplatz konzipiert war, an dem es möglich
wäre, die Arbeit an dem Buch ERASMUS IS LATE zu beenden,
wurde dann jedoch auch anderen zur Verfügung gestellt, um darauf,
darunter und darum herum Arbeiten zu lagern und auszustellen.
ON-LINE, Gent, Belgien, 1995

IBUKA! (PART 1)
1995
table, name plates, halogen lights, drawings, scripts,
Carl Stalling CD
variable
An installation which includes all the basic elements required to
begin thinking about the staging of the musical IBUKA! which is
based on the book ERASMUS IS LATE.
IBUKA! Part 1, Air de Paris, Paris, 1995

Tisch, Namensschilder, Halogenlampen, Zeichnungen,
Schriften, Carl Stalling-CD
variabel
Eine Installation, die alle Grundelemente beinhaltet, die erforderlich
sind, um über die Inszenierung des Musicals IBUKA! nachzudenken,
das auf dem Buch ERASMUS IS LATE basiert.
IBUKA! Part 1, Air de Paris, Paris, 1995

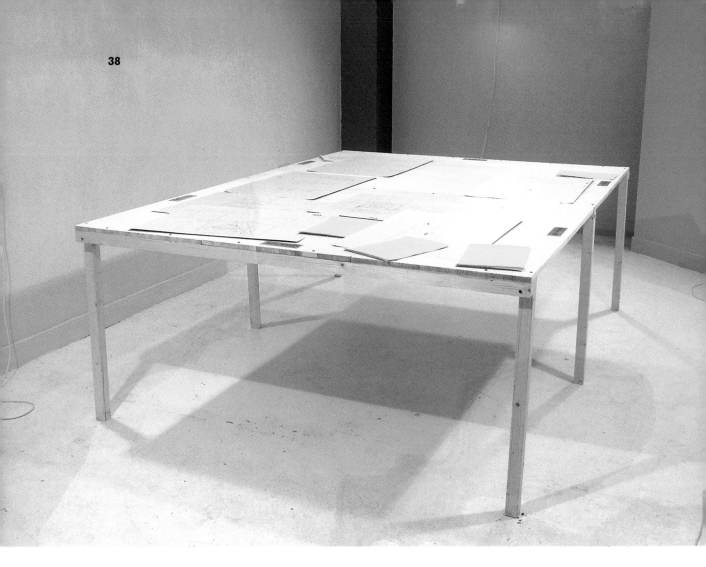

IBUKA! (PART 1)
1995
table, name plates, halogen lights, drawings, scripts,
Carl Stalling CD
variable
An installation which includes all the basic elements required to
begin thinking about the staging of the musical IBUKA! which is
based on the book ERASMUS IS LATE.
IBUKA! Part 1, Air de Paris, Paris, 1995

Tisch, Namensschilder, Halogenlampen, Zeichnungen,
Schriften, Carl Stalling-CD
variabel
Eine Installation, die alle Grundelemente beinhaltet, die erforderlich
sind, um über die Inszenierung des Musicals IBUKA! nachzudenken,
das auf dem Buch ERASMUS IS LATE basiert.
IBUKA! Part 1, Air de Paris, Paris, 1995

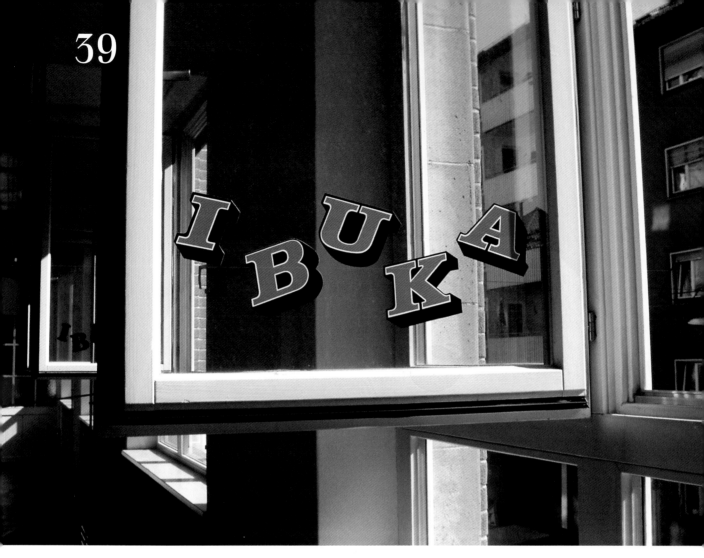

IBUKA! ANNOUNCEMENT #1
1995
adhesive letters on window
variable
The word IBUKA should be displayed on a window
so that the text is clearly readable from the exterior of a building.
IBUKA! (PART 2), Künstlerhaus, Stuttgart, 1995

selbstklebende Buchstaben auf einem Fenster
variabel
Das Wort IBUKA sollte auf einem Fenster erscheinen, so daß
es von außen klar erkennbar ist.
IBUKA! (PART 2), Künstlerhaus, Stuttgart, 1995

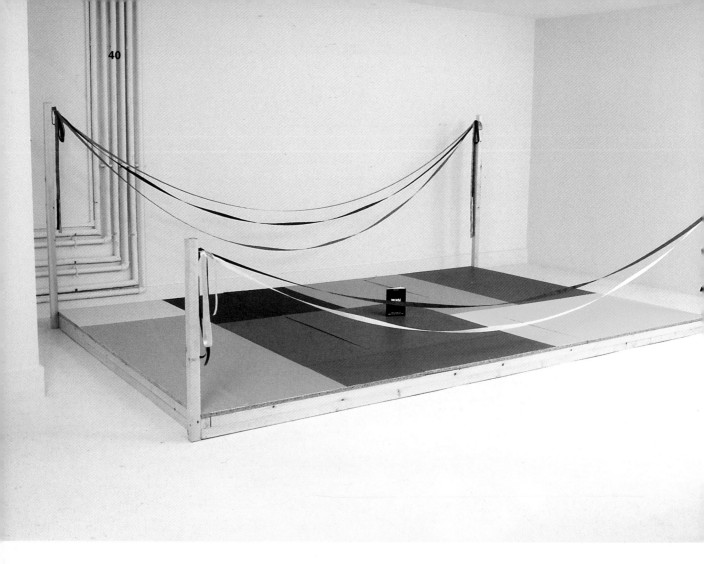

IBUKA! (PART 2) (STUTTGART)
1995
painted stage, ribbons, copy of IBUKA!
variable
A provisional stage fabricated from chipboard and planed soft-
wood. The floor of the stage is painted in various colours. Ribbons
are strung across the back and front of the work. A copy of the
book IBUKA! stands in the middle. A construction derived from the
original context specific installation in Stuttgart and adapted to
present the same basic elements in a mobile form.
IBUKA! (PART 2), Künstlerhaus, Stuttgart, 1995/
HOW WILL WE BEHAVE, Robert Prime, London, 1996

farbig gestrichene Bühne, Bänder, Exemplar von IBUKA!
variabel
Eine aus Spanplatten und gehobeltem Weichholz konstruierte
provisorische Bühne. Der Boden der Bühne ist in verschiedenen
Farben gestrichen. Über die Rück- und Vorderseite der Arbeit
sind Bänder gespannt. In der Mitte steht ein Exemplar des Buchs
IBUKA! Eine von der ursprünglichen, kontextbezogenen Installation
in Stuttgart abgeleitete, für eine Präsentation derselben Grundele-
mente in mobiler Form abgewandelte Konstruktion.
IBUKA! (PART 2), Künstlerhaus, Stuttgart, 1995/
HOW WILL WE BEHAVE, Robert Prime, London, 1996

IBUKA! ENVIRONMENT
1995
sawdust, halogen lights, plastic gel, bulldog clips, hooks
variable
An environment within which to consider the ideas proposed
through the book IBUKA!.
IBUKA!, Galleria Emi Fontana, Milan, 1995

Sägemehl, Halogenlampen, Kunststoffgel, Papierklammern, Haken
variabel
Eine Umgebung zum Nachdenken über die durch das Buch
IBUKA! entstandenen Ideen.
IBUKA!, Galleria Emi Fontana, Mailand, 1995

PROTOTYPE IBUKA! COFFEE TABLE/STAGE (ACT 1)
1995
sheet of chipboard with rounded corners, standing on hardwood
legs, printed paper, Plexiglas
table top length 250 cm, width 150 cm, table legs height 20 cm,
width 11 cm
A low table with pages from the book IBUKA! This version
concentrates on Act 1 of the book. The pages are protected
under sheets of glass sitting on the table/stage top.
IBUKA!, Galleria Emi Fontana, Milan, 1995

Spanplatte mit abgerundeten Ecken auf Hartholzbeinen,
bedrucktes Papier, Plexiglas
Tischplatte Länge 250 cm, Breite 150 cm, Tischbeine Höhe
20 cm, Breite 11 cm
Ein niedriger Tisch mit Seiten aus dem Buch IBUKA! Diese
Fassung konzentriert sich auf den ersten Akt des Buches. Die Seiten
werden von Glasscheiben geschützt, die auf der Tischplatte/dem
Bühnenboden stehen.
IBUKA!, Galleria Emi Fontana, Mailand, 1995

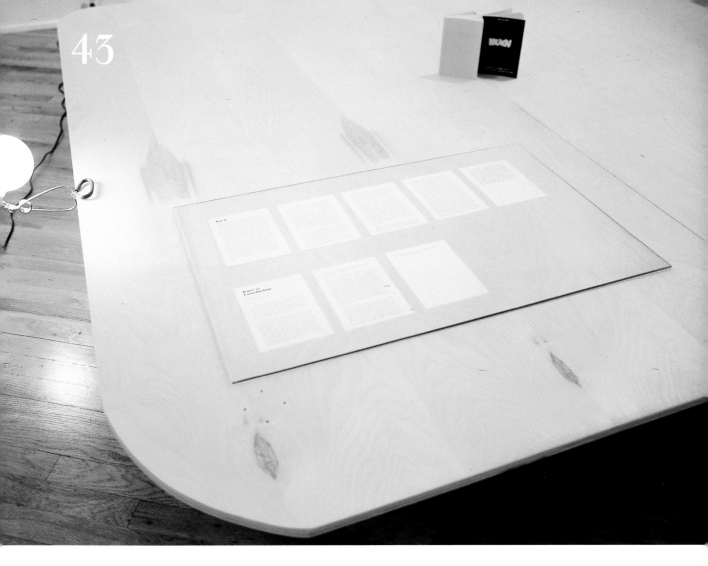

BACKSTAGE (NEW YORK)
1995
plywood, wood, halogen flood-lights
variable
A three sided, brightly lit construction that is completed by the
use of a wall as a fourth side with an opening facing away from
the entrance to the gallery, room or installation space. Two halogen
lights are fixed to the interior of the backstage area and illuminate
it extremely brightly. The work is a reference to the exhibition
BACKSTAGE that had taken place in Hamburg two years earlier
and functions as a temporary resting place out of view from the
gallery reception desk.
PART 3, Basilico Fine Arts, New York, 1995

Sperrholz, Holz, Halogenscheinwerfer
variabel
Eine sehr hell erleuchtete, dreiseitige Konstruktion, die von einer
Wand als vierter Seite komplettiert wird, mit einer Öffnung auf der
dem Eingang der Galerie, des Zimmers oder des Installationsraums
abgewandten Seite. Auf der Innenseite des rückwärtigen Bereichs
sind zwei Halogenlampen angebracht, die ihn extrem hell erleuch-
ten. Die Arbeit verweist auf die Ausstellung BACKSTAGE, die zwei
Jahre zuvor in Hamburg stattgefunden hatte, und dient als vom
Empfangsbereich der Galerie aus nicht einzusehender Ort, um
sich vorübergehend auszuruhen.
PART 3, Basilico Fine Arts, New York, 1995

PROTOTYPE IBUKA! COFFEE TABLE/STAGE (ACT 3)
1995
2 sheets of birch plywood, wood legs, books (ERASMUS
IS LATE and IBUKA!), printed paper, 5 mm plate glass sheet
table top length 240 cm, width 240 cm, table legs
height 20 cm, width 10 cm, depth 10 cm
A table with four differently rounded edges that carries information
about Act 3 of the book IBUKA! and copies of the books IBUKA!
and ERASMUS IS LATE. Due to the lack of corners the table
legs are fixed to the top in an irregular way, this is visible through
the screw heads that show on the table surface. The work is a
double function object, coffee table and potential stage.
PART 3, Basilico Fine Arts, New York, 1995

2 Platten Birkensperrholz, Holzbeine, Bücher (ERASMUS IS
LATE und IBUKA!), bedrucktes Papier, 5 mm starke Glasscheibe
Tischplatte Länge 240 cm, Breite 240 cm, Tischbeine Höhe
20 cm, Breite 10 cm, Tiefe 10 cm
Ein Tisch mit vier unterschiedlich abgerundeten Ecken, auf
dem Informationen zu Akt 3 des Buches IBUKA! und Exemplare
der Bücher IBUKA! und ERASMUS IS LATE liegen. Aufgrund der
fehlenden Ecken des Tischs sind die Beine ungleichmäßig an der
Platte befestigt, was an den auf der Oberseite sichtbaren Schrau-
benköpfen zu sehen ist. Die Arbeit ist ein Objekt mit doppelter
Funktion: Couchtisch und mögliche Bühne.
PART 3, Basilico Fine Arts, New York, 1995

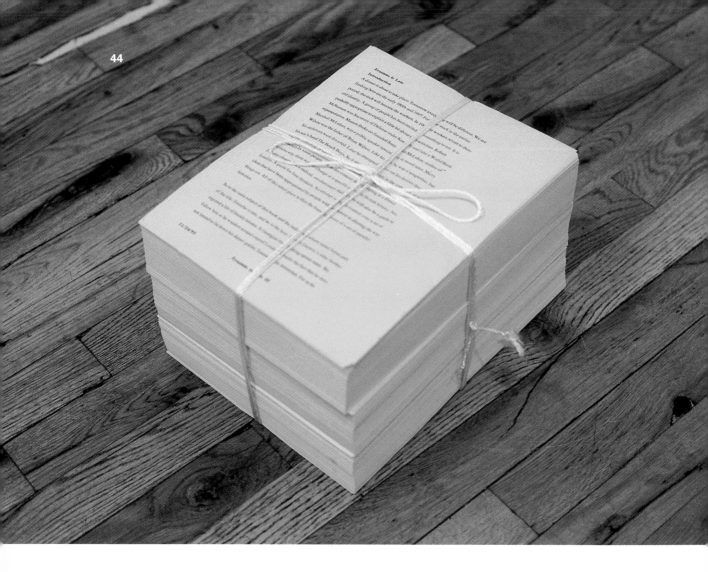

44

**ERASMUS IS LATE COMPLETE PROTOTYPE
MANUSCRIPT FILE**
1995
paper, printed paper, twine
height 30 cm, width 21 cm, depth 25 cm
A fake manuscript of the book ERASMUS IS LATE comprising a
large ream of plain paper with a printed top sheet bundled together
with string. The real manuscript exists in the Sammlung FER.
PART 3, Basilico Fine Arts, New York, 1995

Papier, bedrucktes Papier, Schnur
Höhe 30 cm, Breite 21 cm, Tiefe 25 cm
Attrappe des Buches ERASMUS IS LATE, die aus einem mit
einer Schnur zusammengebundenen dicken Stoß leerer Blätter
mit einem gedruckten Deckblatt besteht. Das echte Manuskript
befindet sich in der Sammlung FER.
PART 3, Basilico Fine Arts, New York, 1995

ERASMUS IS LATE IN BERLIN INFORMATION ROOM
1996
clay brown, lime green and light blue walls, halogen spotlights,
12 card information boards with collaged information, four sheets
of text in German
variable
A setting for the consideration of ideas that are contained in the
book ERASMUS IS LATE. The work provides information in short
form about the content of the book, in order to provide rapid access
to the ideas within it. The colours are bright and the lights are
powerful. The work is a postscript version of the earlier IBUKA!
presentation in Paris.
ERASMUS IS LATE IN BERLIN VERSUS THE WHAT IF?
SCENARIO, Schipper & Krome, Berlin, 1996 / LIAM GILLICK,
Raum Aktuelle Kunst, Vienna, 1996

lehmbraune, hellgrüne und hellblaue Wände,
Hallogenspots,12 Papptafeln mit zusammengestellten
Informationen, vier Blätter mit deutschem Text
variabel
Ein Rahmen für Überlegungen zu den im Buch ERASMUS IS
LATE enthaltenen Ideen. Die Arbeit liefert Informationen zum
Buchinhalt in Kurzform, um einen raschen Zugang zu den darin
enthaltenen Ideen zu ermöglichen. Die Farben sind hell und die
Lampen stark. Die Arbeit ist eine nachträgliche Version der
früheren IBUKA!-Präsentation in Paris.
ERASMUS IS LATE IN BERLIN VERSUS THE WHAT IF?
SCENARIO, Schipper & Krome, Berlin, 1996 / LIAM GILLICK,
Raum Aktuelle Kunst, Wien, 1996

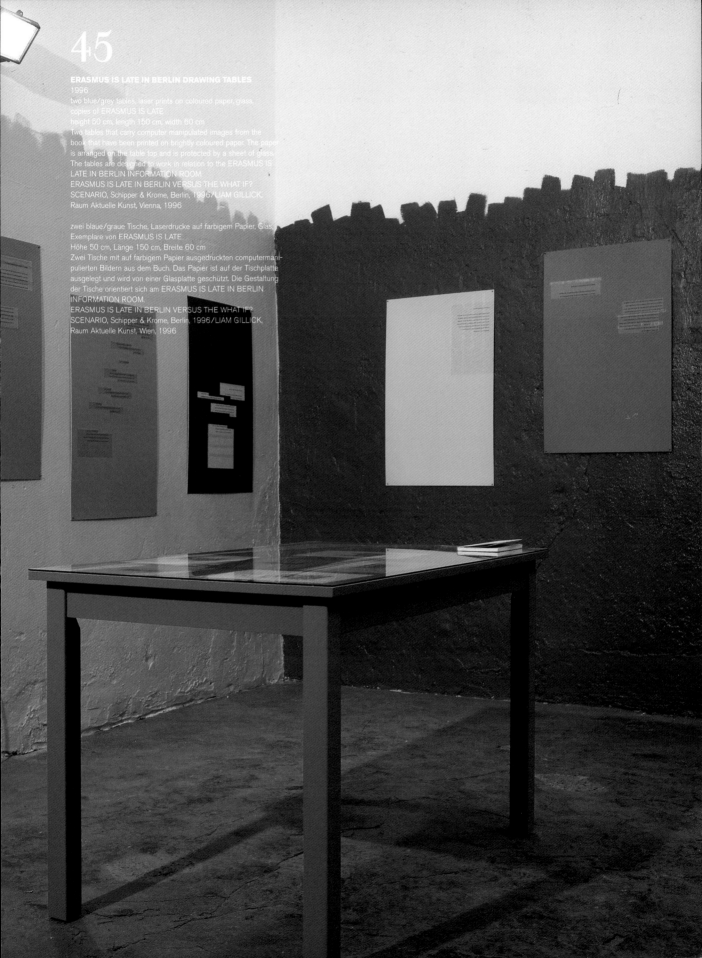

45

ERASMUS IS LATE IN BERLIN DRAWING TABLES
1996
two blue/grey tables, laser prints on coloured paper, glass,
copies of ERASMUS IS LATE
height 50 cm, length 150 cm, width 60 cm
Two tables that carry computer manipulated images from the
book that have been printed on brightly coloured paper. The paper
is arranged on the table top and is protected by a sheet of glass.
The tables are designed to work in relation to the ERASMUS IS
LATE IN BERLIN INFORMATION ROOM.
ERASMUS IS LATE IN BERLIN VERSUS THE WHAT IF?
SCENARIO, Schipper & Krome, Berlin, 1996/LIAM GILLICK,
Raum Aktuelle Kunst, Vienna, 1996

zwei blaue/graue Tische, Laserdrucke auf farbigem Papier, Glas,
Exemplare von ERASMUS IS LATE
Höhe 50 cm, Länge 150 cm, Breite 60 cm
Zwei Tische mit auf farbigem Papier ausgedruckten computermani-
pulierten Bildern aus dem Buch. Das Papier ist auf der Tischplatte
ausgelegt und wird von einer Glasplatte geschützt. Die Gestaltung
der Tische orientiert sich am ERASMUS IS LATE IN BERLIN
INFORMATION ROOM.
ERASMUS IS LATE IN BERLIN VERSUS THE WHAT IF?
SCENARIO, Schipper & Krome, Berlin, 1996/LIAM GILLICK,
Raum Aktuelle Kunst, Wien, 1996

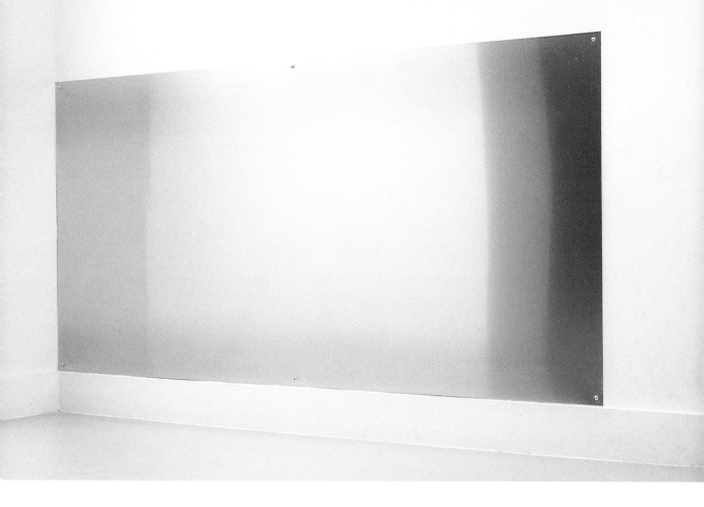

(THE WHAT IF? SCENARIO) SECOND STAGE DISCUSSION PLATFORM AND SURFACE DESIGNS
1996
anodised aluminium, Plexiglas, wrapping paper, fixings
height 200 cm, length 60 cm, width 60 cm
The first unit constructed from aluminium angle and coloured
Plexiglas. Twenty sheets of wrapping paper collaged onto graph
paper that hang from a hook in reasonably close proximity to
the corner unit. Both elements articulate the first stage in thinking
towards the production of the book DISCUSSION ISLAND: BIG
CONFERENCE CENTRE.
ERASMUS IS LATE IN BERLIN VERSUS THE WHAT IF?
SCENARIO, Schipper & Krome, Berlin, 1996 / LIAM GILLICK,
Raum Aktuelle Kunst, Vienna, 1996

eloxiertes Aluminium, Plexiglas, Geschenkpapier, Halterungen
Höhe 200 cm, Länge 60 cm, Breite 60 cm
Die erste Konstruktion aus Aluminiumwinkeln und farbigem
Plexiglas. Zwanzig auf Millimeterpapier aufgeklebte Bögen
Geschenkpapier, die an einem Haken in angemessenem Abstand
neben der Eckeinheit hängen. Beide Elemente artikulieren
das erste Stadium des Nachdenkens über die Produktion des
Buches DISCUSSION ISLAND: BIG CONFERENCE CENTRE.
ERASMUS IS LATE IN BERLIN VERSUS THE WHAT IF?
SCENARIO, Schipper & Krome, Berlin, 1996 / LIAM GILLICK,
Raum Aktuelle Kunst, Wien, 1996

(THE WHAT IF? SCENARIO) MIRRORED INSULATION PLATES
1996
sheet of aluminium, screws, domed covers for screws
height 100 cm, width 200 cm
A sheet of industrial grade aluminium is screwed directly to the
wall with one longer edge as close to the floor as possible.
The fixings are capped with rounded covers. The sheet functions
as protection and insulation while also offering a blurred, mirrored
finish. Edition of 5 with one artist's proof.
THE WHAT IF? SCENARIO, Robert Prime, London, 1996/
ENTROPY, Ludwig Forum, Aachen, 1998

Aluminiumblech, Schrauben, gewölbte Schraubenkopfverblendungen
Höhe 100 cm, Breite 200 cm
Ein Blech aus Industriealuminium ist direkt auf eine Wand
geschraubt, mit einer der Längsseiten so nahe wie möglich am
Boden. Die Halterungen werden mit abgerundeten Kappen
verdeckt. Das Blech dient als Schutz und Isolierung und bietet
außerdem eine verzerrende Spiegelfläche. Auflage 5 und ein
Künstlerexemplar.
THE WHAT IF? SCENARIO, Robert Prime, London,1996/
ENTROPY, Ludwig Forum, Aachen, 1998

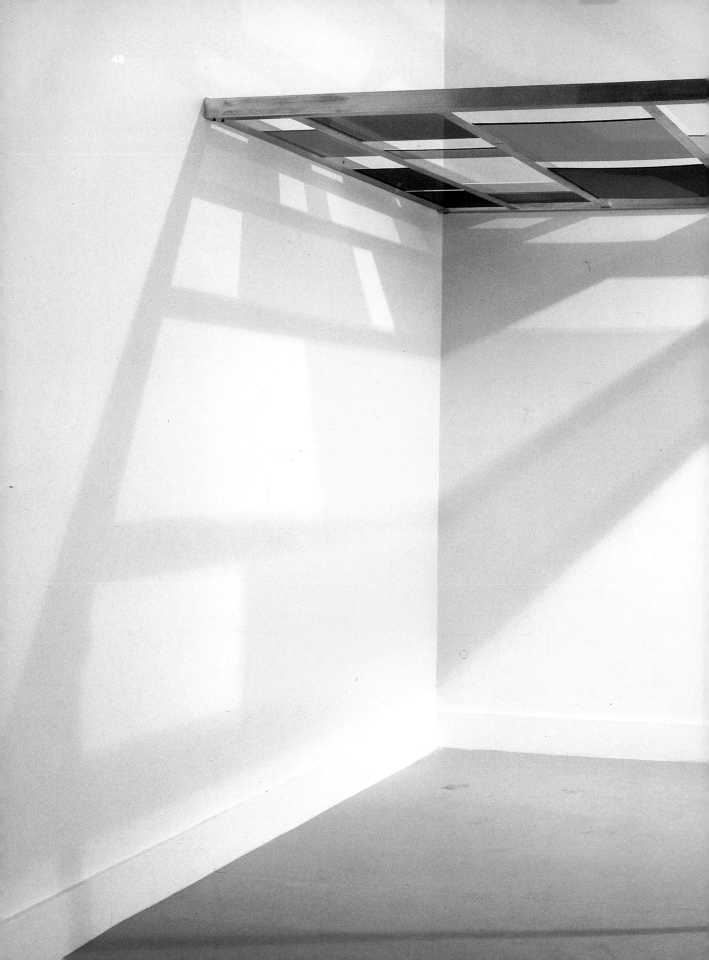

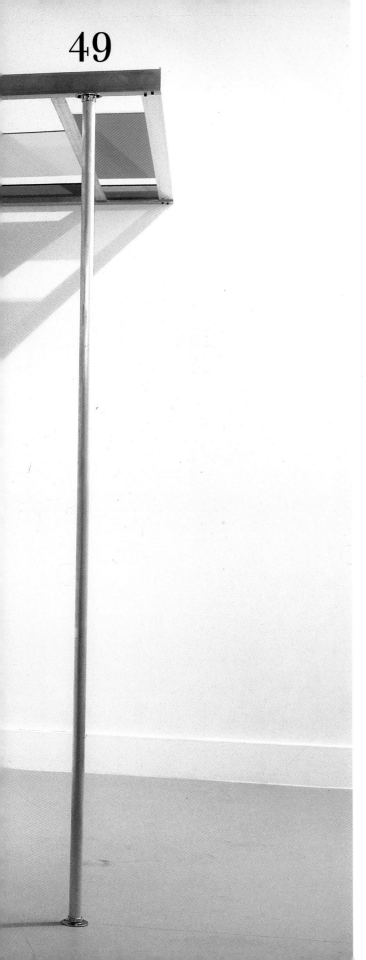

(THE WHAT IF? SCENARIO) DISCUSSION PLATFORM (LONDON)
1996
aluminium, Plexiglas, chromed brass fittings
height 200 cm, length 200 cm, width 200 cm
A large platform positioned in the corner of a room and high enough to stand under. The work projects a site for discussion. It offers that chance to address THE WHAT IF? SCENARIO as a framework for potential developments that led towards the book DISCUSSION ISLAND: BIG CONFERENCE CENTRE. Coloured Plexiglas partially fills the framework at the top of the platform. It allows different coloured shadows to be cast over the people standing below it and onto the gallery walls. The size and colour of the Plexiglas cladding was determined by the off-cuts available at the time of construction of the work.
THE WHAT IF? SCENARIO, Robert Prime, London, 1996

Aluminium, Plexiglas, verchromte Messinghalterungen
Höhe 200 cm, Länge 200 cm, Breite 200 cm
Ein große, in der Ecke eines Raumes und in ausreichender Höhe angebrachte Plattform, um darunter stehen zu können. Die Arbeit bietet einen Ort für Diskussionen. Sie eröffnet die Möglichkeit, THE WHAT IF? SCENARIO als Rahmen für potentielle Entwicklungen zu sehen, die zum Buch DISCUSSION ISLAND: BIG CONFERENCE CENTRE führen. Farbiges Plexiglas füllt zumTeil den Rahmen im oberen Bereich der Plattform. Dadurch fallen farbige Schatten auf die darunter stehenden Menschen und auf die Wände des Ausstellungsraums. Größe und Farbe der Plexiglasverkleidungen wurden von den zur Zeit des Aufbaus der Arbeit erhältlichen Abschnitten bestimmt.
THE WHAT IF? SCENARIO, Robert Prime, London, 1996

GILLIAN GILLICK AND LIAM GILLICK
(THE WHAT IF? SCENARIO) SCENARIO
1996
ink on plastic drafting film, coloured paper, aluminium frames
height 32 cm, width 23 cm
A first potential scenario, with illustrations of elements that
could form a WHAT IF? SCENARIO. A beach, a house,
and a basement are rendered in a clear, pen and ink style by
a designer/visualiser who is also the artist's mother.
THE WHAT IF? SCENARIO, Robert Prime, London, 1996

Tinte auf Kunststoffolie, farbiges Papier, Aluminiumrahmen
Höhe 32 cm, Breite 23 cm
Ein erstes mögliches Szenario mit Illustrationen von Elementen,
die ein WHAT IF? SCENARIO bilden könnten. Ein Strand,
ein Haus und ein Keller sind in einem klaren Stil mit Bleistift und
Tusche dargestellt, gezeichnet von einer Designerin, die außerdem
die Mutter des Künstlers ist.
THE WHAT IF? SCENARIO, Robert Prime, London, 1996

DISCUSSION ISLAND TUBULAR BELLS
1996
chromed steel tubes
each 25 mm diameter, two length 180 cm, three length 120 cm
A hanging work designed to function best in locations where it
might be necessary to indicate potential change. Edition of 5.

verchromte Stahlrohre
Durchmesser jeweils 25 mm, zwei Rohre von 180 cm,
drei von 120 cm Länge
Eine hängende Arbeit, entworfen für den bestmöglichen
Einsatz an Orten, an denen es nötig sein könnte, auf mögliche
Veränderungen hinzuweisen. Auflage 5.

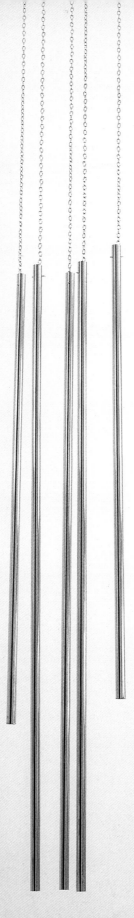

WI?S CANTILEVERED DELAY PLATFORM
1996
aluminium, Plexiglas, cables, fittings
height variable length 120 cm, width 120 cm
A discussion platform designed for exterior application. A solution
to aspects of time control in relation to the WHAT IF? SCENARIO
REPORT that eventually appeared as the book DISCUSSION
ISLAND: BIG CONFERENCE CENTRE. Designed specifically for
the Stillpass house in Cincinnati, Ohio, to be installed above the
front door of the building. An aluminium frame is fitted with
coloured Plexiglas sheets. The sheets may be moved around or
removed completely in winter.

Aluminium, Plexiglas, Kabel, Halterungen
Höhe variabel, Länge 120 cm, Breite 120 cm
Eine Diskussionsplattform für einen Außenbereich. Eine Lösung
für Aspekte der Zeitkontrolle in bezug auf den WHAT IF?
SCENARIO REPORT, der schließlich als DISCUSSION ISLAND:
BIG CONFERENCE CENTRE in Buchform erschien. Speziell für
das Stillpass-Gebäude in Cincinnati, Ohio, entworfen, anzubringen
über dem Vordereingang des Gebäudes. In einen Aluminium-
rahmen sind farbige Plexiglasplatten eingesetzt. Die Platten können
im Winter bewegt oder völlig herausgenommen werden.

DISCUSSION ISLAND: ITEM A001
1996
glitter
variable
Glitter should be purchased and sprinkled in private areas of a
home. Under furniture, beneath rugs and in cupboards. A very
light sprinkling may also be made over general floor surfaces. The
work designates a fragmented zone where it might be possible to
consider the potential of discussion and compromise.
I FEEL EXPLOSION, Manchester, 1996

Glitzerpartikel
variabel
Glitzerpartikel sollten gekauft und in privaten Räumen verstreut
werden. Unter Möbeln, Teppichen und in Schränken. Außerdem
können die Fußböden insgesamt sehr dünn bestreut werden. Diese
Arbeit kennzeichnet eine fragmentierte Zone, in der es möglich
sein könnte, über das Potential von Dialog und Kompromiß
nachzudenken.
I FEEL EXPLOSION, Manchester, 1996

LIAM GILLICK AND GABRIEL KURI
EVERYDAY HOLIDAY/LA FÊTE AU QUOTIDIEN
1996
stickers (text: LA FÊTE AU QUOTIDIEN in white on light blue),
confetti, (multicoloured), sign (black and blue text on white ground)
variable
A proclamation rather than a series of performances where
people are invited to come together, for example: Airline Pilot's And
Secretary's Day; Fools And Idiots Day or Railway Workers And
Passengers Day. A large sign is positioned on a wall and indicates
the potential of a series of Everyday Holidays that could take place
in the large public space of Le Magasin. Stickers and confetti are
offered to visitors to the place in order for them to begin partici-
pation or observation of the potential events. All the elements of
the work have been produced by the in-house design team of Le
Magasin in Grenoble in order to formulate a look that is
consistent with the existing image of the place.
LA FÊTE AU QUOTIDIEN, Le Magasin, Grenoble, 1996

Aufkleber (Text: LA FÊTE AU QUOTIDIEN in Weiß auf
Hellblau), Konfetti, (bunt), Schild (schwarze und blaue Schrift
auf weißem Grund)
variabel
Eher eine Ankündigung als eine Serie von Veranstaltungen, zu
denen Leute eingeladen werden, wie zum Beispiel: Airline Pilot's
And Secretary's Day; Fools And Idiots Day oder Railway Workers
And Passengers Day. Ein großes Schild an einer Wand weist auf
die Möglichkeiten einer Reihe von Everyday Holidays hin, die im
Außenraum des Magasin stattfinden könnten. Aufkleber und Kon-
fetti werden den Besuchern angeboten, um an den möglichen
Veranstaltungen teilzunehmen oder sie sich anzusehen.
Alle Elemente der Arbeit wurden vom hauseigenen Designer-
Team des Magasin hergestellt, um eine mit dem Image des Hauses
in Einklang stehende Gestaltung zu erreichen.
LA FÊTE AU QUOTIDIEN, Le Magasin, Grenoble, 1996

DISCUSSION ISLAND: PROJECTED THINK TANK
1997
anodised aluminium, Plexiglas
height 120 cm, length 120 cm, width 120 cm
A cube with an open base and top which is designed to stand
on the floor. The work may be used as an object that might signify
an enclosed zone for the consideration of exchange, information
transfer and strategy.
DISCUSSION ISLAND, Basilico Fine Arts, New York, 1997

eloxiertes Aluminium, Plexiglas
Höhe 120 cm, Länge 120 cm, Breite 120 cm
Ein oben und unten offener Kubus, der auf dem Boden steht.
Die Arbeit kann als Objekt benutzt werden, das eine abgeschlossene
Zone zum Nachdenken über Austausch, Informationstransfer und
Strategie markieren könnte.
DISCUSSION ISLAND, Basilico Fine Arts, New York, 1997

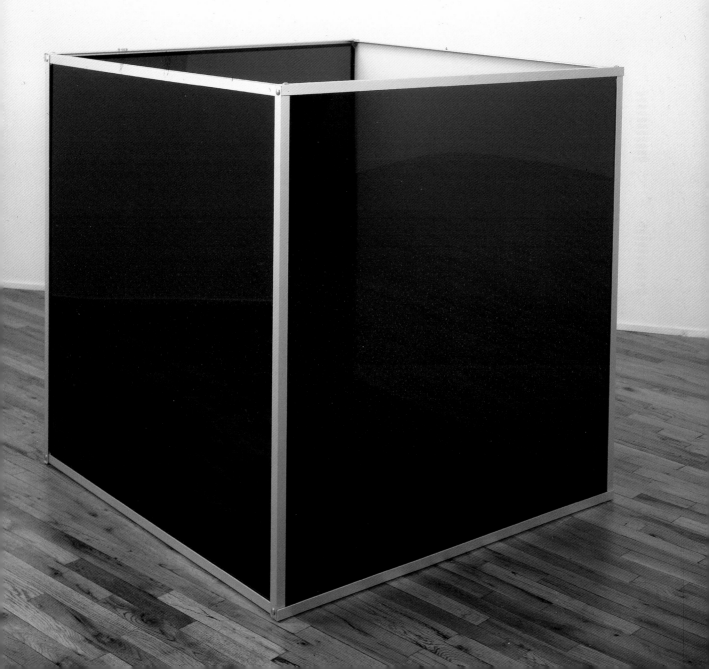

DISCUSSION ISLAND: ASSESSMENT THINK TANK
1997
anodised aluminium, Plexiglas, cardboard
height 120 cm, length 240 cm, width120 cm
A cube with an open base and top which is designed to stand
on the floor. The work may be used as an object that might signify
an enclosed zone for the consideration of exchange, information
transfer and strategy.
DISCUSSION ISLAND, Basilico Fine Arts, New York, 1997

eloxiertes Aluminium, Plexiglas, Karton
Höhe 120 cm, Länge 240 cm, Breite 120 cm
Ein oben und unten offener Kubus, der auf dem Boden steht. Die
Arbeit kann als Objekt benutzt werden, das eine abgeschlossene
Zone zum Nachdenken über Austausch, Informationstransfer und
Strategie markieren könnte.
DISCUSSION ISLAND, Basilico Fine Arts, New York, 1997

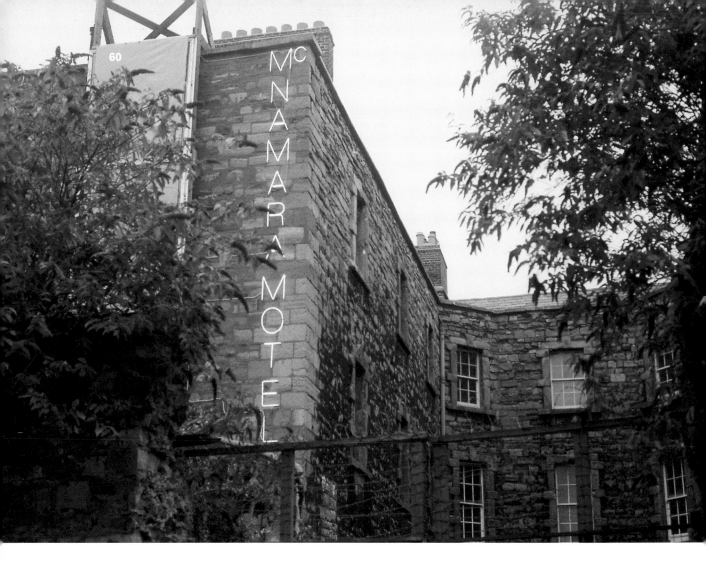

McNAMARA MOTEL
1997
white neon
variable
A temporary public work for the City of Dublin. A neon sign
positioned on the old Debtor Prison. The work relates to the
film McNAMARA.
IRELAND AND EUROPE, The Sculpture Society of Ireland, 1997

weiße Neonschrift
variabel
Eine zeitlich begrenzte Arbeit für die Stadt Dublin. Eine auf dem
alten Schuldnerturm angebrachte Neonschrift. Die Arbeit bezieht
sich auf den Film McNAMARA.
IRELAND AND EUROPE, The Sculpture Society of Ireland, 1997

DR. ROBERT BUTTIMORE
1997
colour photograph, frame
height 40 cm, width 50 cm

Farbfotografie, Rahmen
Höhe 40 cm, Breite 50 cm

DISCUSSION ISLAND RESIGNATION PLATFORM
1997
anodised aluminium, Plexiglas, cables, fittings
height variable, length 360 cm, width 240 cm
A large discussion platform designed for a space where people
may be passing through towards another location. The work is
fixed along one long edge to a wall, the other long edge carries
cables that fix it to the ceiling. The work addresses certain issues
of compromise, the moment when it might be necessary to
discontinue involvement in a strategy or concept and remove
yourself from a situation.
DOCUMENTA X, Kassel, 1997

eloxiertes Aluminium, Plexiglas, Kabel, Halterungen
Höhe variabel, Länge 360 cm, Breite 240 cm
Eine große Diskussionsplattform für einen Raum, durch den
man auf dem Weg zu einem anderen Ort kommen kann.
Die Arbeit ist mit einer Längsseite an der Wand befestigt, die
andere Längsseite ist mit Kabeln an der Decke aufgehängt. Die
Arbeit spricht bestimmte Fragen des Kompromisses an, den
Moment, wenn es notwendig werden kann, die Beschäftigung
mit einer Strategie oder einem Konzept abzubrechen und sich
aus der Situation heraus zu begeben.
DOCUMENTA X, Kassel, 1997

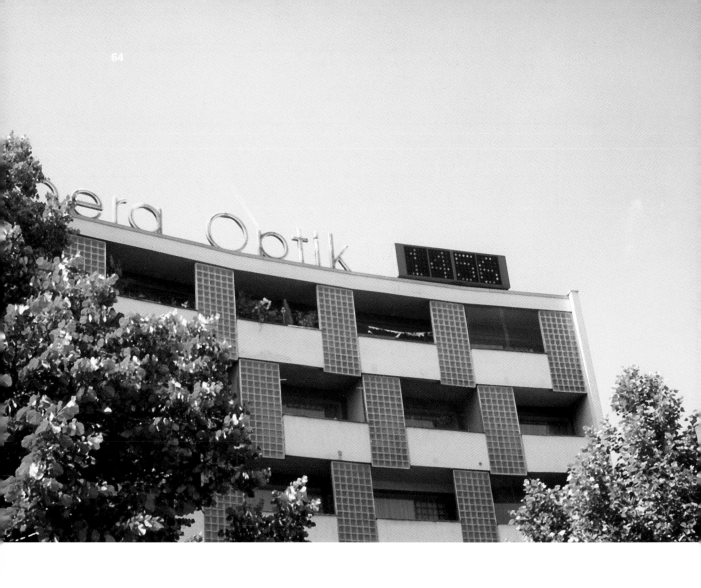

65

ERASMUS ASS ZEHN JAHRE OPIUM #2
1997
lamp technique clock, programmed silicon chip
variable
Clock installed on top of Osterberg Optik in central Kassel. The
clock is fitted with a chip that allows it to flicker between the current
time and local time for Kassel in the year 1810, a difference of
around 18 minutes. The work relates to the book ERASMUS IS
LATE which was written in 1995 but set between 1810 and 1997.
The coincidence of the dating and the exhibition seemed useful.
DOCUMENTA X, Kassel, 1997

Lichttechnik-Uhr, programmierter Silikon-Chip
variabel
Uhr installiert auf dem Haus Osterberg Optik im Zentrum Kassels.
Die Uhr ist mit einem Chip ausgestattet, mit dessen Hilfe sie
zwischen der aktuellen Zeit und der Kasseler Ortszeit im Jahr 1810
wechseln kann, ein Unterschied von etwa 18 Minuten.
Die Arbeit bezieht sich auf das Buch ERASMUS IS LATE, das 1995
geschrieben wurde, aber zwischen 1810 und 1997 spielt.
Das Zusammentreffen der Datierung und der Ausstellung erschien
nützlich.
DOCUMENTA X, Kassel, 1997

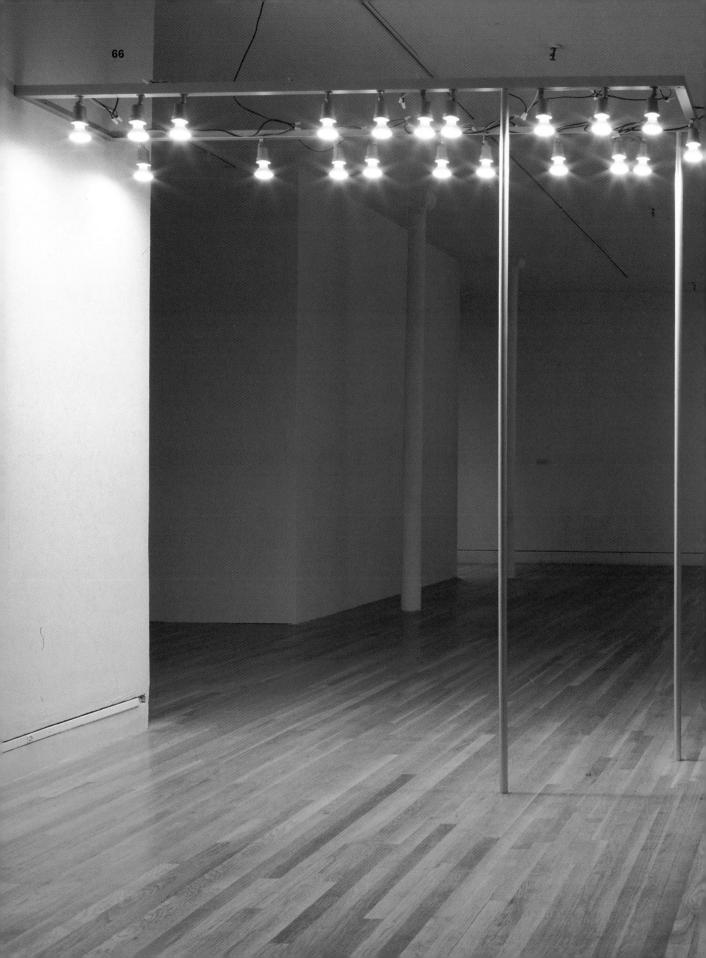

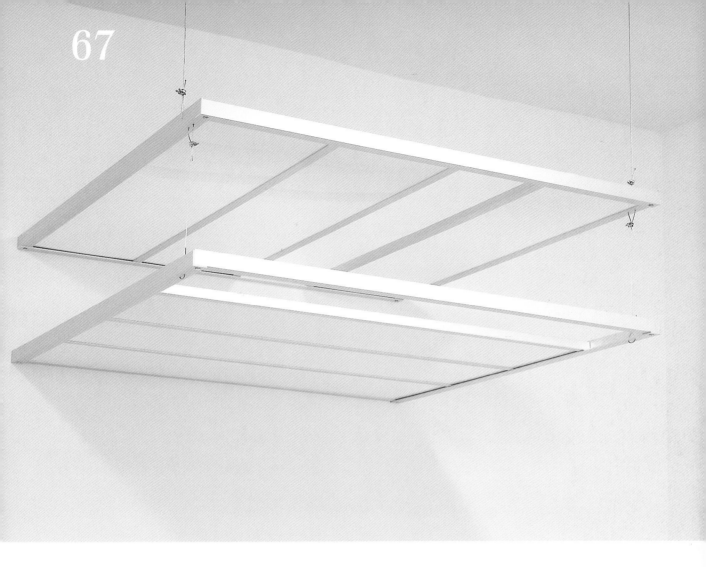

DISCUSSION ISLAND RETRIBUTION RIG
1997
anodised aluminium, lamp holders, lamps, wiring
height 240 cm, length 200 cm, width 50 cm
A lighting rig designed for the exhibition ENTERPRISE at the
ICA in Boston. The work was located close to the entrance of a
room just at the point where it began to be possible to hear to
sounds coming from Rirkrit Tiravanija's rehearsal room at the other
end of the space. The work designates a space where it might be
possible to consider the potential of error.
ENTERPRISE, ICA Boston, 1997

eloxiertes Aluminium, Lampenfassungen, Lampen, Verkabelung
Höhe 240 cm, Länge 200 cm, Breite 50 cm
Eine für die Ausstellung ENTERPRISE im ICA in Boston entwor-
fene Beleuchtungsanlage. Die Arbeit war in der Nähe des Eingangs
zu einem Raum angebracht, genau an dem Punkt, von dem aus
es möglich wurde, die aus Rirkrit Tiravanijas Probenraum am
anderen Ende des Raums kommenden Geräusche zu hören. Die
Arbeit bezeichnet einen Raum, in dem es möglich sein könnte,
über das Potential von Irrtum nachzudenken.
ENTERPRISE, ICA Boston, 1997

DISCUSSION ISLAND DIALOGUE PLATFORM
1997
anodised aluminium, Plexiglas, cables, fittings
each element total height variable length 120 cm, width 120 cm
A double layered platform designed for the exhibition ENTER-
PRISE at the ICA in Boston. The work designates a space where
it might be possible to reconsider the potential of dialogue.
ENTERPRISE, ICA, Boston, 1997/MAXWELL'S DEMON,
Margo Leavin, Los Angeles, 1997

eloxiertes Aluminium, Plexiglas, Kabel, Halterungen
jedes Element Gesamthöhe variabel, Länge 120 cm,
Breite 120 cm
Eine Doppelplattform für die Ausstellung ENTERPRISE im ICA
in Boston. Die Arbeit bezeichnet einen Raum, in dem es möglich
sein könnte, erneut über das Potential des Dialogs nachzudenken.
ENTERPRISE, ICA, Boston, 1997/MAXWELL'S DEMON,
Margo Leavin, Los Angeles, 1997

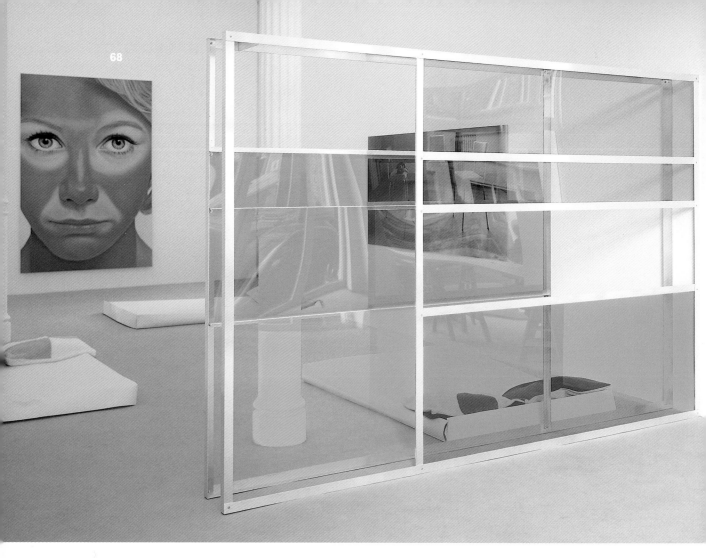

DISCUSSION ISLAND BIG CONFERENCE SCREEN
1997
aluminium, Plexiglas
height 240 cm, length 360 cm, depth 30 cm
The work divides a space where it might be possible to reconsider
the issues raised in the book DISCUSSION ISLAND: BIG
CONFERENCE CENTRE.
HOSPITAL, Galerie Max Hetzler, 1997

Aluminium, Plexiglas
Höhe 240 cm, Länge 360 cm, Tiefe 30 cm
Die Arbeit teilt einen Raum, in dem es möglich sein könnte,
erneut über die in dem Buch DISCUSSION ISLAND: BIG
CONFERENCE CENTRE aufgeworfenen Fragestellungen
nachzudenken.
HOSPITAL, Galerie Max Hetzler, 1997

69

SO WERE PEOPLE THIS DUMB BEFORE TELEVISION?
1998
sign writing on wall
variable
A line from the book DISCUSSION ISLAND: BIG
CONFERENCE CENTRE. A post-textual device in relation to
the project in general.
LIAM GILLICK, JOHN MILLER, JOE SCANLAN, RAK Vienna,
February 1998 / PLACES TO STAY 4 P(RINTED) M(ATTER),
Büro Friedrich, Berlin, 1998

Schriftzug auf einer Wand
variabel
Eine Zeile aus dem Buch DISCUSSION ISLAND: BIG
CONFERENCE CENTRE. Ein nach dem Text entstandener
Kunstgriff mit Bezug
zum Projekt im allgemeinen.
LIAM GILLICK, JOHN MILLER, JOE SCANLAN, RAK Wien,
February 1998 / PLACES TO STAY 4 P(RINTED) M(ATTER),
Büro Friedrich, Berlin, 1998

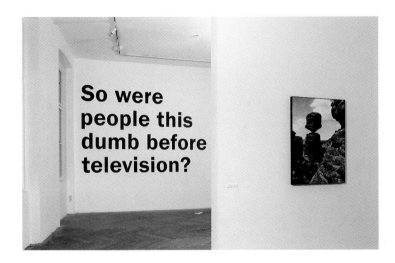

DISCUSSION ISLAND DEFICIT DISCUSSION PLATFORM
1997
anodised aluminium, Plexiglas, cables, fittings
height variable length 240 cm, width 240 cm
A large discussion platform that projects a zone where notions of
exchange may be considered.

eloxiertes Aluminium, Plexiglas, Kabel, Halterungen
Höhe variabel, Länge 240 cm, Breite 240 cm
Eine große Diskussionsplattform, die eine Zone vorspringen läßt, in
der über Vorstellungen von Austausch nachgedacht werden kann.

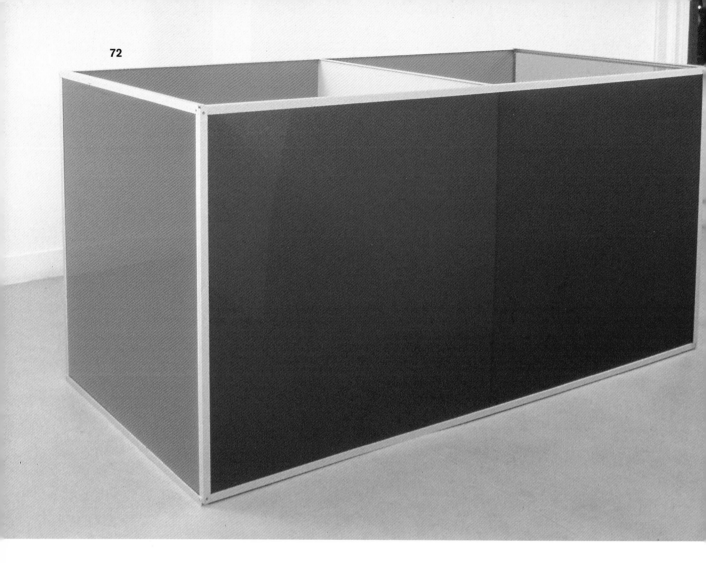

DISCUSSION ISLAND BORDER THINK TANK
1997
anodised aluminium, Plexiglas
height 120 cm, width 240 cm, depth 120 cm
A large free-standing structure to be located in the centre of a
room. The work comprises an aluminium frame containing Plexiglas
panels. The work defines two distinct areas for storage or may
be left empty.

eloxiertes Aluminium, Plexiglas
Höhe 120 cm, Breite 240 cm, Tiefe 120 cm
Eine große, freistehende Konstruktion für die Mitte eines Raums.
Die Arbeit besteht aus einem Aluminiumrahmen mit Plexiglasplatten.
Die Arbeit definiert zwei unterschiedliche Aufbewahrungsbereiche
oder kann leer bleiben.

DISCUSSION ISLAND MODERATION PLATFORM
1997
anodised aluminium, Plexiglas, cables, fittings
height variable length 240 cm, width 240 cm
A discussion platform that encourages a sense of limitation
and restricted growth.

eloxiertes Aluminium, Plexiglas, Kabel, Halterungen
Höhe variabel, Länge 240 cm, Breite 240 cm
Eine Diskussionsplattform, die ein Gefühl der Begrenzung und
des beschränkten Wachstums hervorruft.

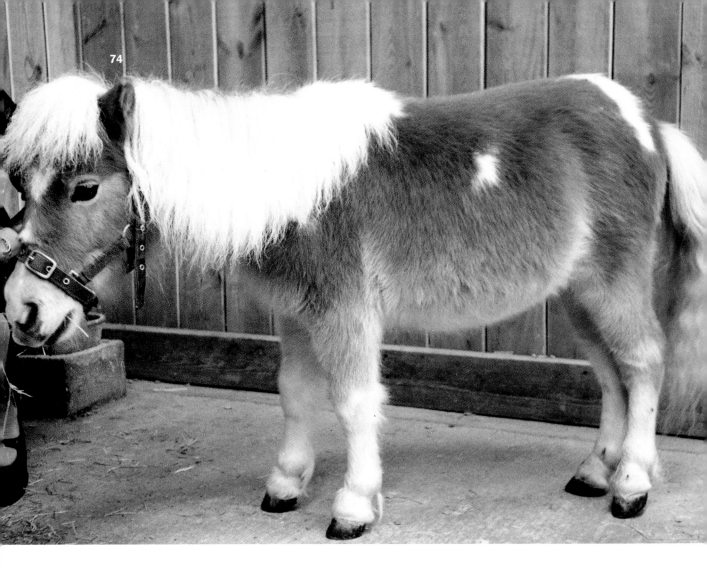

75

LIAM GILLICK AND SARAH MORRIS
THE HORSE SUCKED MY HAND
1997
photograph, maple frame
height 100 cm, width 200 cm
One element of a larger project for the Albion Hotel, Miami Beach,
which also included the design of a night-light.

Fotografie, Ahornrahmen
Höhe 100 cm, Breite 200 cm
Element eines größeren Projekts für das Albion Hotel, Miami
Beach, zu dem auch die Gestaltung einer Nachtbeleuchtung
gehörte.

DOCUMENTARY REALISATION ZONE #1 TO #3
1997
aluminium, Plexiglas, 3 television sets, 3 video recorders,
catalogues, climbing rope
variable
Three aluminium and Plexiglas cubes located within a space.
Each cube to match the size of a television. In Dijon, three different
rooms were used. Each cube is a different colour and plays one
of two videos produced at Forde in Geneva and Transmission in
Glasgow. A third video contains digitally generated colour. Books
containing information about the projects McNAMARA, ERASMUS
IS LATE, IBUKA! and THE WHAT IF? SCENARIOS are tied to
either end of lengths of climbing rope. The main door to Le
Consortium was also renovated.
McNAMARA PAPERS, ERASMUS AND IBUKA! REALISATION
AND THE WHAT IF? SCENARIOS, Le Consortium, Dijon, 1997

Aluminium, Plexiglas, 3 Fernsehgeräte, 3 Videorecorder,
Kataloge, Bergseil
variabel
Drei Würfel aus Aluminium und Plexiglas in einem Raum. Jeder
Würfel hat die Größe eines Fernsehers. In Dijon wurden die Würfel
in drei verschiedenen Räumen plaziert. Jeder Würfel hat eine andere
Farbe und spielt einen von zwei bei Forde in Genf und Transmission
in Glasgow produzierten Videofilm ab. Ein drittes Video zeigt digital
generierte Farben. Bücher mit Informationen über die Projekte
McNAMARA, ERASMUS IS LATE, IBUKA! und THE WHAT IF?
SCENARIOS sind an die Enden von Bergseilen gebunden.
Außerdem wurde der Haupteingang zum Consortium renoviert.
McNAMARA PAPERS, ERASMUS AND IBUKA! REALISATION
AND THE WHAT IF? SCENARIOS, Le Consortium, Dijon, 1997

79

COLD ROLLED TANK TRAPS (1969)
1998
Plexiglas, MDF, glitter
each height 100 cm, width 100 cm, depth 100 cm
Three cubes of MDF covered with Plexiglas lined up in a row.
The resulting arrangement is sprinkled with glitter.
LIAM GILLICK, Kunstverein Hamburg, 1998

Plexiglas, MDF-Platte, Glitzerpartikel
jeweils Höhe 100 cm, Breite 100 cm, Tiefe 100 cm
Drei mit Plexiglas verkleidete und in einer Reihe aufgestellte
Würfel aus MDF-Platten. Die so entstandene Anordnung wird
mit Glitzerpartikeln bestreut.
LIAM GILLICK, Kunstverein Hamburg, 1998

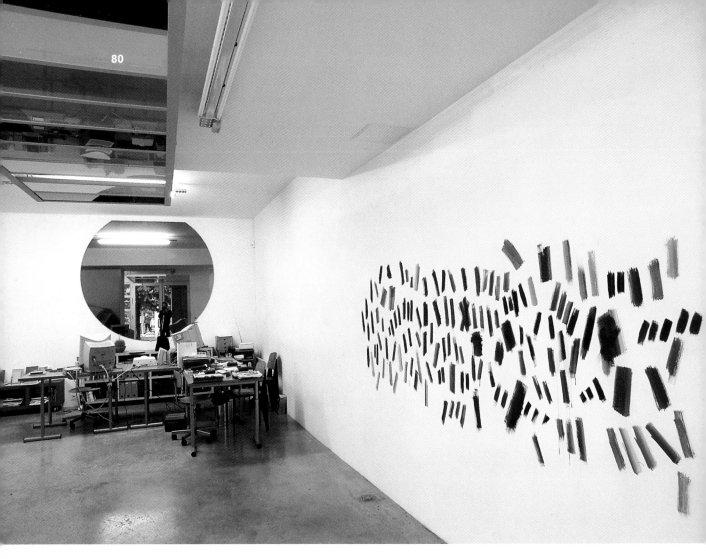

**INSIDE NOW, WE WALKED INTO A ROOM WITH
COCA-COLA COLOURED WALLS**
1998
acrylic paint on wall
variable
An attempt to match the colour of Coca-Cola, leaving test marks
on the wall. The act reflects a reference to a passage in the book
DISCUSSION ISLAND: BIG CONFERENCE CENTRE where one
location has walls the colour of Coca-Cola.
UP ON THE TWENTY SECOND FLOOR, Air de Paris, April 1998/
LE CAPITALE, Centre régional d'art contemporain, Sête

Acrylfarbe auf Wand
variabel
Ein Versuch, die Farbe von Coca-Cola zu treffen, bei dem Probe-
anstriche auf der Wand sichtbar bleiben. Die Aktion spiegelt einen
Verweis auf eine Passage in dem Buch DISCUSSION ISLAND:
BIG CONFERENCE CENTRE, in dem es einen Raum mit Wänden
in der Farbe von Coca-Cola gibt.
UP ON THE TWENTY SECOND FLOOR, Air de Paris, April 1998/
LE CAPITALE, Centre régional d'art contemporain, Sête

**BIG CONFERENCE CENTRE MIDDLE MANAGEMENT
PLATFORM**
1998
anodised aluminium, Plexiglas, cables, fittings
height variable length 300 cm, width 100 cm
A discussion platform that operates within the limited concerns
expressed by the middle tier of social and economic development.
UP ON THE TWENTY SECOND FLOOR, Air de Paris, 1998

eloxiertes Aluminium, Plexiglas, Kabel, Halterungen
Höhe variabel, Länge 300 cm, Breite 100 cm
Eine Diskussionsplattform, die innerhalb der von der mittleren
Stufe der sozialen und wirtschaftlichen Entwicklung zum Ausdruck
gebrachten begrenzten Anliegen funktioniert.
UP ON THE TWENTY SECOND FLOOR, Air de Paris, 1998

**A SEARCH FOR THE CENTRE GROUND KEPT IN CHECK
BY VIOLENCE, DISORDER AND CONSPIRACY**
1998
mirror with bronze tint
diameter 220 cm, with the top sliced off
A large mirror that is deployed in search of the three main characters
from the book DISCUSSION ISLAND: BIG CONFERENCE
CENTRE.
UP ON THE TWENTY SECOND FLOOR, Air de Paris, 1998

Spiegel mit Bronzetönung
Durchmesser 220 cm, mit abgeschnittenem oberen Teil
Ein großer Spiegel, der bei der Suche nach den drei Hauptfiguren
aus dem Buch DISCUSSION ISLAND: BIG CONFERENCE
CENTRE eingesetzt wird.
UP ON THE TWENTY SECOND FLOOR, Air de Paris, 1998

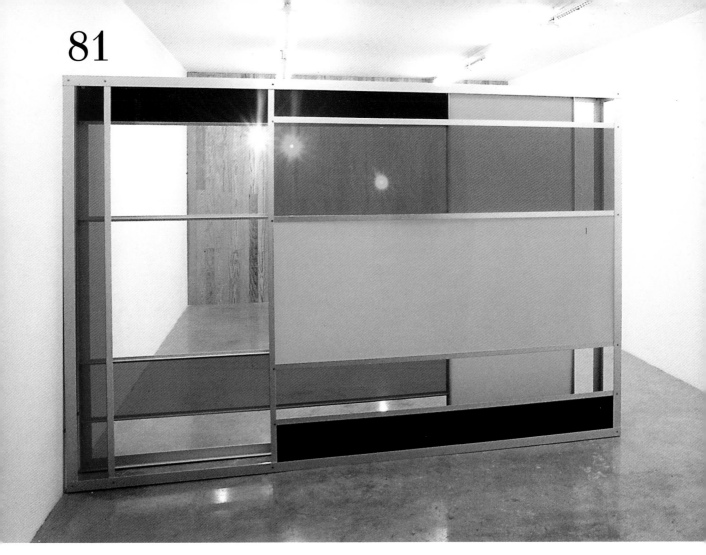

BIG CONFERENCE CENTRE LEGISLATION SCREEN
1998
anodised aluminium, Plexiglas, cables, fittings
width 300 cm, height 200 cm, depth 30 cm
A double skinned screen that helps to define a location where
individual actions are limited by rules imposed by the community
as a whole.
UP ON THE TWENTY SECOND FLOOR, Air de Paris, 1998

eloxiertes Aluminium, Plexiglas, Kabel, Halterungen
Breite 300 cm, Höhe 200 cm, Tiefe 30 cm
Doppelwandige Trennwand, die hilft, einen Ort zu definieren,
an dem individuelles Handeln durch von der Gemeinschaft als
Ganzes bestimmte Regeln beschränkt wird.
UP ON THE TWENTY SECOND FLOOR, Air de Paris, 1998

BIG CONFERENCE CENTRE RELATIONAL TOOL
1998
pine planking, halogen lamps
variable
A wall of pine planking inset with halogen lamps. The wall high-
lights a location where it might be possible to become involved
in constantly flickering relationships.
UP ON THE TWENTY SECOND FLOOR, Air de Paris, 1998

Kieferplanken, Halogenlampen
variabel
Eine Wand aus Kieferplanken mit eingelassenen Halogenlampen.
Die Wand beleuchtet einen Ort, an dem es möglich sein könnte,
sich auf ständig schwankende Beziehungen einzulassen.
UP ON THE TWENTY SECOND FLOOR, Air de Paris, 1998

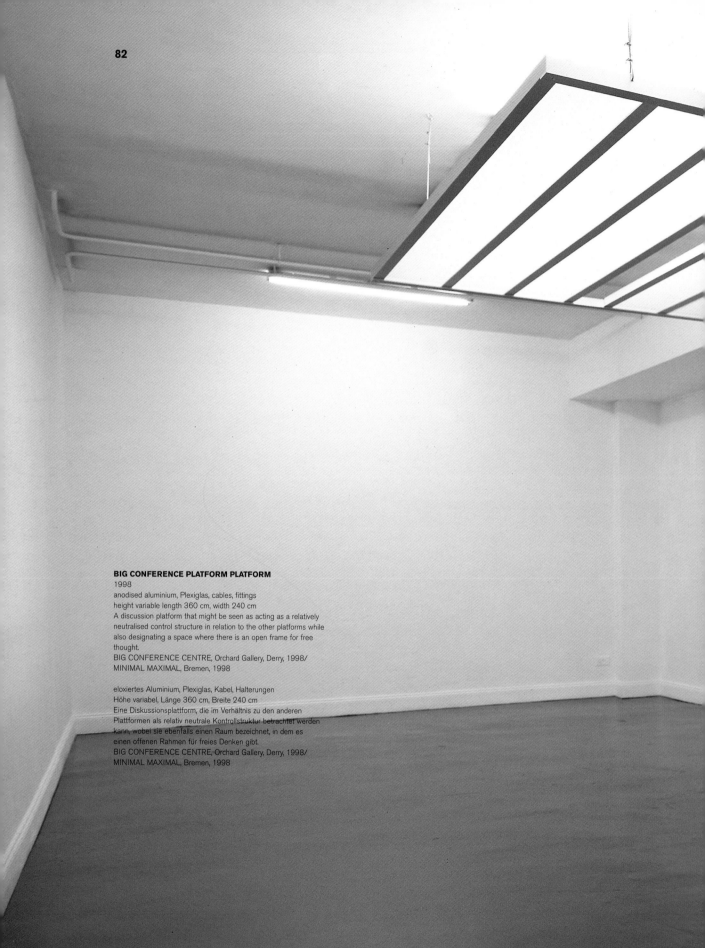

BIG CONFERENCE PLATFORM PLATFORM
1998
anodised aluminium, Plexiglas, cables, fittings
height variable length 360 cm, width 240 cm
A discussion platform that might be seen as acting as a relatively
neutralised control structure in relation to the other platforms while
also designating a space where there is an open frame for free
thought.
BIG CONFERENCE CENTRE, Orchard Gallery, Derry, 1998/
MINIMAL MAXIMAL, Bremen, 1998

eloxiertes Aluminium, Plexiglas, Kabel, Halterungen
Höhe variabel, Länge 360 cm, Breite 240 cm
Eine Diskussionsplattform, die im Verhältnis zu den anderen
Plattformen als relativ neutrale Kontrollstruktur betrachtet werden
kann, wobei sie ebenfalls einen Raum bezeichnet, in dem es
einen offenen Rahmen für freies Denken gibt.
BIG CONFERENCE CENTRE, Orchard Gallery, Derry, 1998/
MINIMAL MAXIMAL, Bremen, 1998

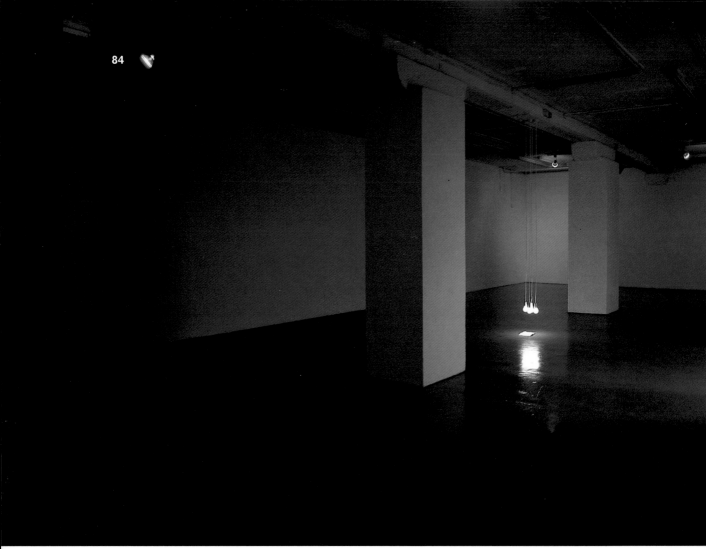

BIG CONFERENCE CENTRE FOCAL POINT
1998
four 12 Watt light-bulbs, cables and fittings,
copy of DISCUSSION ISLAND: BIG CONFERENCE CENTRE
variable
Four 12 watt light-bulbs, normally used as night-lights are
suspended from the ceiling to a point about 30 cm from the floor.
The bulbs are close together yet hang free. Low lit and balanced,
an image of a prototype lighting system for a forgotten room of
the Big Conference Centre.
BIG CONFERENCE CENTRE, Orchard Gallery, Derry, 1998

vier 12 Watt-Glühbirnen, Kabel und Halterungen, Exemplar von
DISCUSSION ISLAND: BIG CONFERENCE CENTRE
variabel
Vier normalerweise als Nachtbeleuchtung verwendete 12 Watt-
Glühbirnen hängen von der Decke etwa 30 cm vom Fußboden
entfernt. Die Glühbirnen hängen nah beieinander, berühren sich
aber nicht. Schwaches und ausgewogenes Licht, das Bild eines
Prototyps für eine Beleuchtungsanlage für ein vergessenes
Zimmer des Großen Konferenzzentrums.
BIG CONFERENCE CENTRE, Orchard Gallery, Derry, 1998

DISCUSSION ISLAND PROTOTYPE ITEM B002
1998
MDF, stereo system, copies of DISCUSSION ISLAND:
BIG CONFERENCE CENTRE, CD: TUBULAR BELLS,
two halogen lamps
variable
A provisional and temporary structure to display copies of the book
DISCUSSION ISLAND: BIG CONFERENCE CENTRE. The space
is well lit and can be used as a browsing place. A domestic hi-fi
system is also positioned on the shelves and should be set to play
the first section of TUBULAR BELLS.
BIG CONFERENCE CENTRE, Orchard Gallery, Derry, 1998

MDF-Platte, Stereoanlage, Exemplare von DISCUSSION ISLAND:
BIG CONFERENCE CENTRE, CD: TUBULAR BELLS,
zwei Halogenlampen
variabel
Eine provisorische und zeitlich begrenzte Konstruktion für die
Auslage von Exemplaren des Buchs DISCUSSION ISLAND:
BIG CONFERENCE CENTRE. Der Raum ist gut beleuchtet und
kann als Schmökerecke genutzt werden. Auf den Regalen steht
außerdem eine normale Stereoanlage, die das erste Stück von
TUBULAR BELLS abspielen sollte.
BIG CONFERENCE CENTRE, Orchard Gallery, Derry, 1998

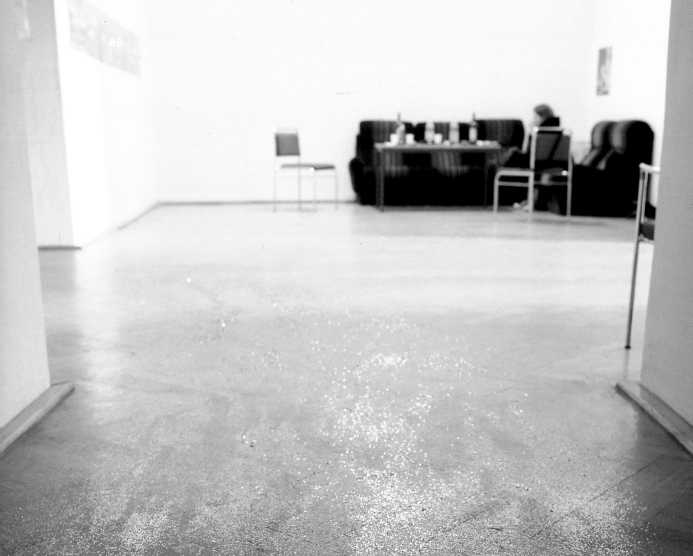

DISCUSSION ISLAND PREPARATION ZONE
1998
vodka, silver and gold glitter
86
The work involves the preparation of space. A mixture of vodka, water and glitter should be used to wash down the floors of the gallery or of the space under consideration.
KAMIKAZE, Berlin, 1998/ODRADEK, Bard College, NY, 1998.

Wodka, Silber- und goldfarbene Glitzerpartikel.
86/87
Zu Arbeit gehört die Vorbereitung des Raums. Die Fußböden der Galerie oder des in Frage kommenden Raumes sollten mit einer Mischung aus Wodka, Wasser und Glitzerpartikeln gewischt werden.
KAMIKAZE, Berlin, 1998/ODRADEK, Bard College, NY, 1998.

JUST OUT OF TIME
1998
newspapers, string
at least 60 cm high
Find a bundle of newspapers, it doesn't matter which ones they are, they can be local, national, international or varied. The pile of newspapers should be tied up with string. The final stack should be at least 60 cm high, but the final work can be a number of separate bundles stacked on top of each other. At least one important door inside a building should be propped open with the bundle/s. The work presents an improvised way to play with the flow of people through a space. Edition of 3.
UK-MAXIMUM DIVERSITY, Galerie Konzinger, Vienna, 1998.

Zeitungen, Schnur
mindestens 60 cm hoch
Suche einen Stapel Zeitungen, es spielt keine Rolle welche, regionale, nationale, internationale oder vermischte. Der Stapel sollte mit einer Schnur zusammengebunden werden. Der fertige Stoß sollte mindestens 60 cm hoch sein, aber die endgültige Arbeit kann auch aus mehreren aufeinander gestapelten Bündeln bestehen. Mindestens eine wichtige Tür im Innern eines Hauses sollte von dem Bündel/den Bündeln offengehalten werden. Die Arbeit zeigt eine improvisierte Form, mit dem Strom von Menschen in einem Raum zu spielen. Edition 3.
UK-MAXIMUM DIVERSITY, Galerie Konzinger, Wien, 1998.

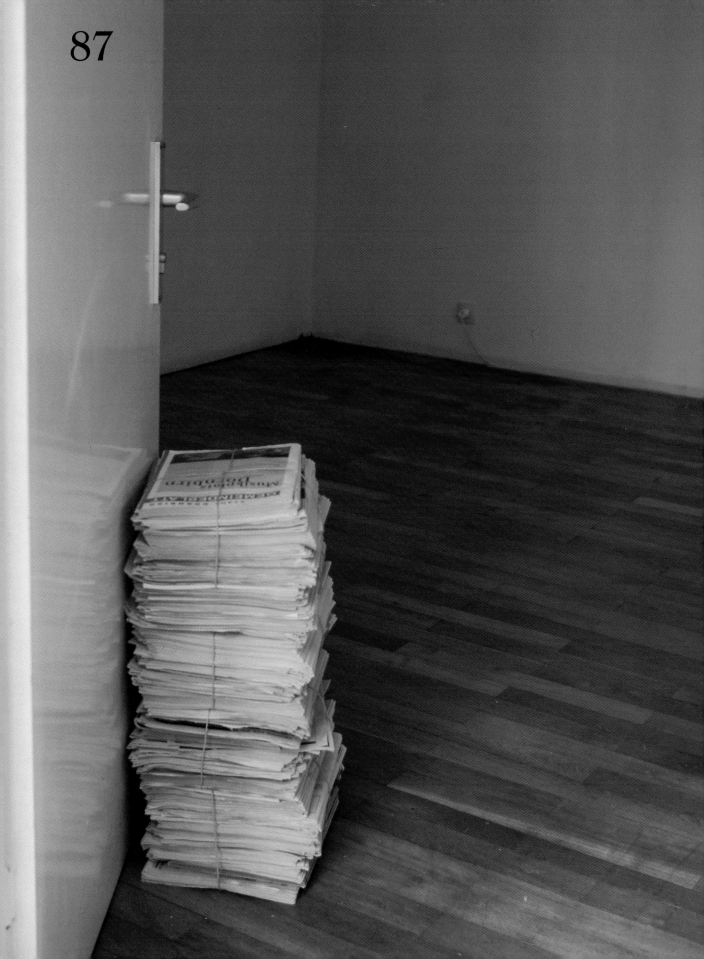

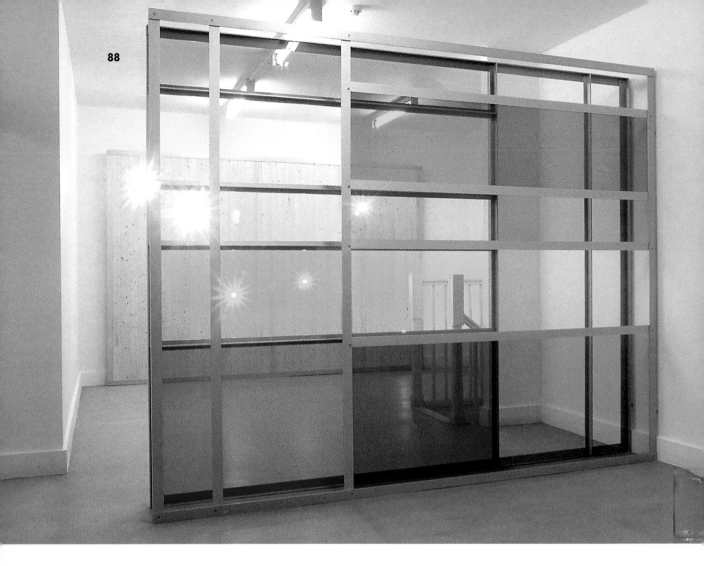

BIG CONFERENCE CENTRE LIMITATION SCREEN
1998
anodised aluminium, Plexiglas
height 240 cm, width 300 cm, depth 30 cm
A screen that provides a space where it might be possible to
establish limits to development and discussion.
LIAM GILLICK, Robert Prime, London, 1998

eloxiertes Aluminium, Plexiglas
Höhe 240 cm, Breite 300 cm, Tiefe 30 cm
Eine Trennwand, die einen Raum zur Verfügung stellt, in dem es
möglich sein könnte, Grenzen für Entwicklung und Diskussion
zu ziehen.
LIAM GILLICK, Robert Prime, London, 1998

**THE CONTINUING SEQUENCE OF EVENTS MUST
HAVE STARTED AND THEN SPUN OFF FROM THIS
PLACE. SEVEN-UP COLOURED CURTAINS?**
1998
a big glass, eight cans of Seven-Up
variable
A big glass containing the contents of eight cans of Seven-Up.
The work is a specific post-textual reference to the book
DISCUSSION ISLAND: BIG CONFERENCE CENTRE
LIAM GILLICK, Robert Prime, London, 1998

großes Glas, acht Dosen Seven-Up
variabel
Ein großes Glas enthält den Inhalt von acht Dosen Seven-Up.
Die Arbeit ist ein nach dem Text entstandener spezieller Verweis
auf das Buch DISCUSSION ISLAND: BIG CONFERENCE
CENTRE.
LIAM GILLICK, Robert Prime, London, 1998

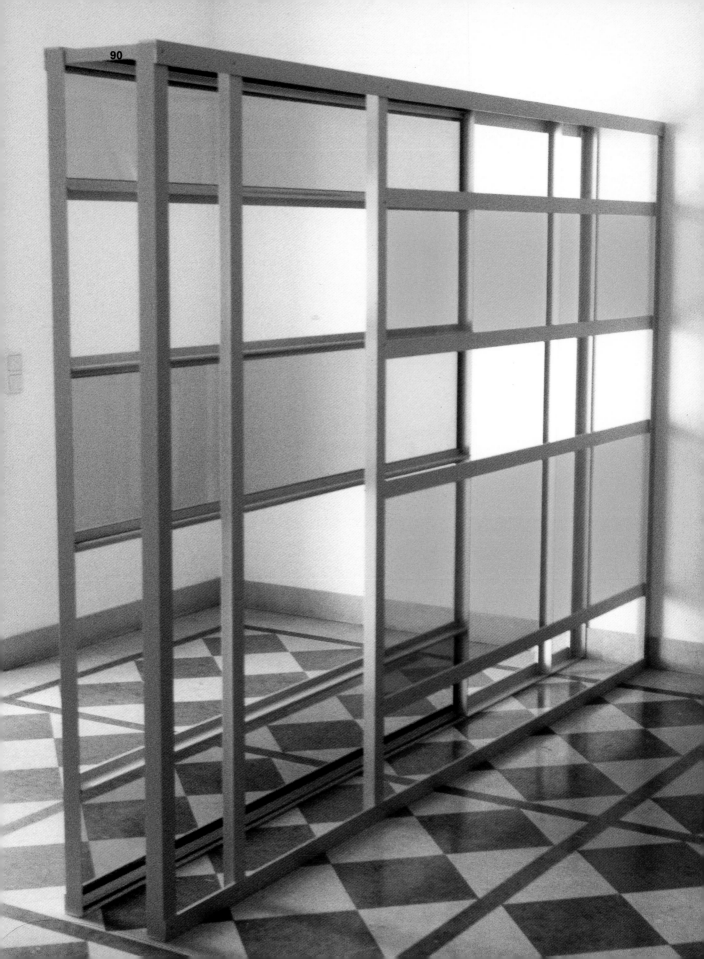

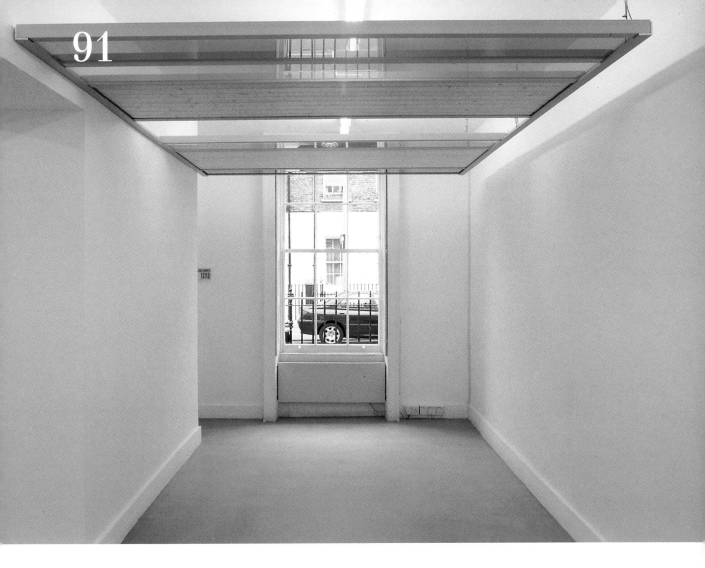

DISCUSSION ISLAND RESIGNATION SCREEN
1998
anodised aluminium, Plexiglas
height 200 cm, width 300 cm, depth 30 cm,
The work suggest a space where it might be possible to consider
situations where it is better to change direction rather than
continue on a given path.
THE EROTIC SUBLIME, Thaddaeus Ropac, Salzburg, 1998

eloxiertes Aluminium, Plexiglas
Höhe 200 cm, Breite 300 cm, Tiefe 30 cm
Die Arbeit deutet einen Raum an, in dem es möglich sein könnte,
über Situationen nachzudenken, in denen es besser ist, die
Richtung zu wechseln, als den vorgezeichneten Weg weiterzugehen.
THE EROTIC SUBLIME, Thaddaeus Ropac, Salzburg, 1998

POST CONFERENCE PLATFORM
1998
anodised aluminium, pine planking, Plexiglas, cables, fittings
height variable length 360 cm, width 240 cm
LIAM GILLICK, Robert Prime, London, 1998

eloxiertes Aluminium, Kieferplanken, Plexiglas, Kabel, Halterungen
Höhe variabel, Länge 360 cm, Breite 240 cm
LIAM GILLICK, Robert Prime, London, 1998

92

REVISION/22ND FLOOR WALL DESIGN
1998
brown and orange acrylic based paint, anodised aluminium,
Plexiglas, cables, fittings
platforms length 240 cm, width 240 cm, wall diagram variable
above a minimum of at least 2 elements each 240 cm x 240 cm
Two walls are painted with graphic devices. Four platforms are
installed, one in each corner of the room. The graphic devices are
squared off spirals in brown and orange. The platforms are installed
at a height corresponding to the penultimate band of colour
towards the top of the spiral. The resulting artwork is a combination
of two distinct parts. One is the set of platforms which is a pre-
textual element in relation to the book DISCUSSION ISLAND: BIG
CONFERENCE CENTRE. The spiral is a post-textual element.
REVISION, Villa Arson, Nice, 1998

Farbe auf Acrylbasis in Braun und Orange, eloxiertes Aluminium,
Plexiglas, Kabel, Halterungen
Plattformen Länge 240 cm, Breite 240 cm, Wand-Diagramm
variabel über mindestens zwei Elementen von jeweils 240 x 240 cm
Zwei Wände sind mit grafischen Entwürfen bemalt. Vier Plattformen
sind in den vier Ecken des Raums installiert. Die grafischen Entwürfe
sind eckige Spiralen in Braun und Orange. Die Plattformen sind in
einer Höhe installiert, die dem vorletzten Farbstreifen zum oberen
Ende der Spirale hin entspricht. Das daraus resultierende Kunstwerk
besteht aus zwei unterschiedlichen Teilen. Der eine ist die Gruppe
der Plattformen, die im Verhältnis zum Buch DISCUSSION ISLAND:
BIG CONFERENCE CENTRE ein vor dem Text liegendes Element
darstellen. Die Spirale ist ein nach dem Text entstandenes Element.
REVISION, Villa Arson, Nizza, 1998

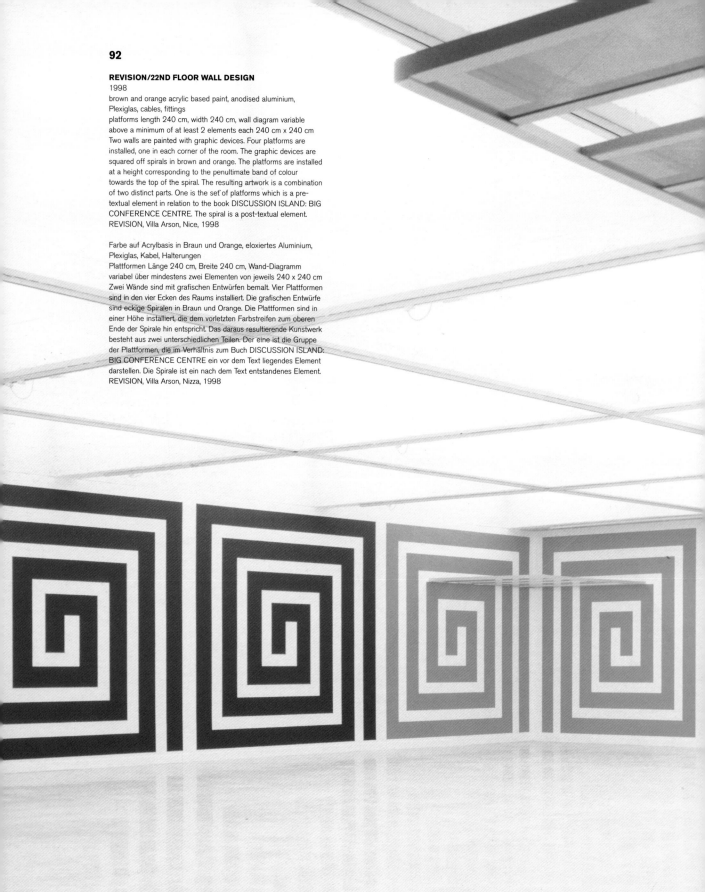

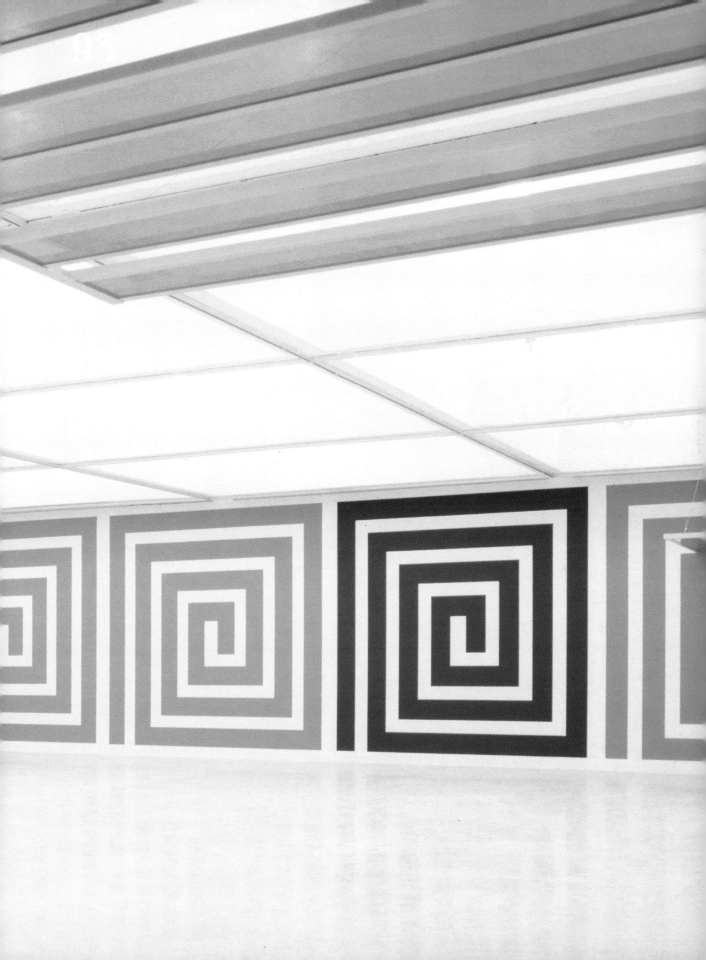

WILLIAM H. DANFORTH (WHEN PURITY WAS PARAMOUNT)
1998
paint on windows
variable/each element minimum 100 cm square
Nine images each approximately 100 cm x 100 cm to be painted
onto windows. The images are a combination of logos from formerly
nationalised British Industries and contextualising graphic devices
by the artist. Each is executed in a specific colour that is not rela-
ted to the original colour schemes of the logos. The companies
include British Leyland, British Telecom, British Gas, British Steel.
The title refers to the founder of the Purina Corporation in the US
in the nineteenth century, credited with the first use of an abstracted
corporate logo.
WHEN PURITY WAS PARAMOUNT: WILLIAM H. DANFORTH,
British Council Gallery, Prague, 1998

Farbe auf Fenstern
variabel/jedes Element mindestens 100 cm im Quadrat
Neun auf Fenster zu malende Bilder von je etwa 100 x 100 cm.
Die Bilder sind eine Kombination von Logos ehemals staatlicher
britischer Industriefirmen und setzen grafische Entwürfe des
Künstlers in einen Kontext. Jedes Bild ist in einer bestimmten
Farbe ausgeführt, die nichts mit den ursprünglichen Farben der
Logos zu tun hat. Zu den Firmen gehören British Leyland, British
Telecom, British Gas, British Steal. Der Titel bezieht sich auf den
Gründer der Purina Corporation in den Vereinigten Staaten im
19. Jahrhundert, dem die erste Verwendung eines abstrakten
Firmenlogos zugeschrieben wird.
WHEN PURITY WAS PARAMOUNT: WILLIAM H. DANFORTH,
British Council Gallery, Prag, 1998

ODRADEK WALL
1998
pine cladding, halogen lamps, fittings, wiring
variable
A wall constructed to fit a specific wall in the exhibition spaces
of Bard College, functioning as a backdrop for the exhibition
ODRADEK.
ODRADEK, Bard College, 1998

Kieferverkleidung, Halogenlampen, Halterungen, Verkabelung
variabel
Eine zu einer bestimmten Wand in den Ausstellungsräumen des
Bard College passende Wand, konstruiert als Hintergrund für
die Ausstellung ODRADEK.
ODRADEK, Bard College, 1998

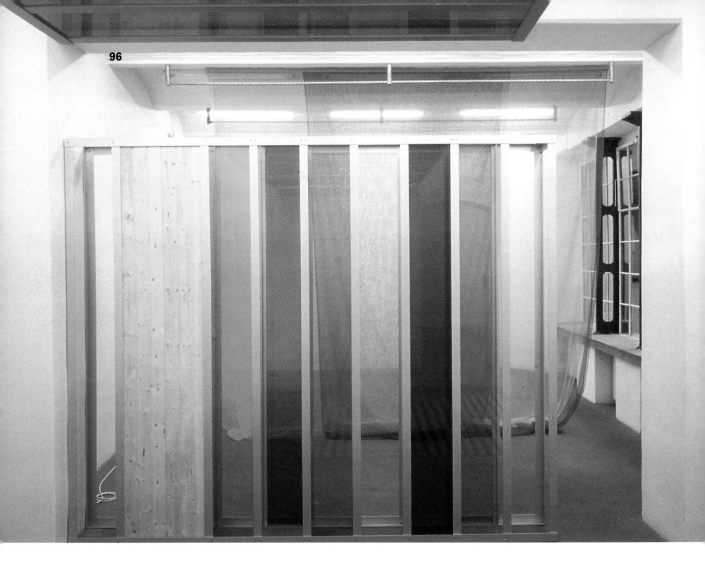

TWINNED RENEGOTIATION PLATFORMS
1998
anodised aluminium, pine planking, Plexiglas, cables, fittings
height variable two platforms each length 300 cm, width 180 cm
Two discussion platforms mounted at different heights with a
minimum of 30 cm differential in height between the two. The plat-
forms must always be exhibited together. One is predominantly
wood with one section of red Plexiglas, one is predominantly red
with one section of wood. The work provides a place where it
might be possible to reassess the idea of planning when it moves
into the hands of speculators.
WHEN DO WE NEED MORE TRACTORS?, Schipper & Krome,
Berlin, 1998

eloxiertes Aluminium, Kieferplanken, Plexiglas, Kabel, Halterungen
Höhe variabel, zwei Plattformen jeweils Länge 300 cm,
Breite 180 cm
Zwei Diskussionsplattformen in unterschiedlicher Höhe mit einem
Unterschied von mindestens 30 cm. Beide Plattformen müssen
immer zusammen ausgestellt werden. Die eine besteht in erster Linie
aus Holz mit einem Teil in rotem Plexiglas, die andere ist überwiegend
rot mit einem Teil in Holz. Die Arbeit stellt einen Raum zur Verfügung,
in dem es möglich sein könnte, die Idee von Planung neu zu
überdenken, wenn sie in die Hände von Spekulanten gelegt wird.
WHEN DO WE NEED MORE TRACTORS?, Schipper & Krome,
Berlin, 1998

LAYERED IMPASSE SCREEN
1998
anodised aluminium, pine planking, Plexiglas
height 240 cm, width 300 cm, depth 30 cm
A double skinned screen with vertical elements that bolts to
one wall. The spaces are filled with a mixture of Plexiglas and one
panel of pine planking on each face. The work provides a place
where it might be possible to reassess the idea of planning when
it moves into the hands of speculators.
WHEN DO WE NEED MORE TRACTORS?, Schipper & Krome,
Berlin, 1998

eloxiertes Aluminium, Kieferplanken, Plexiglas
Höhe 240 cm, Breite 300 cm, Tiefe 30 cm
Eine doppelwandige Trennwand mit vertikalen Elementen, die an
einer Wand festgeschraubt ist. Die Zwischenräume sind auf jeder
Sichtseite mit einer Mischung aus Plexiglas und einer Tafel aus
Kieferplanken gefüllt. Die Arbeit stellt einen Raum zur Verfügung,
in dem es möglich sein könnte, die Idee von Planung neu zu
überdenken, wenn sie in die Hände von Spekulanten gelegt wird
WHEN DO WE NEED MORE TRACTORS?, Schipper & Krome,
Berlin, 1998

POLL! HEAR THEM!
1998
anodised aluminium, polyester cloth red, orange, yellow, blue
each drape height 400 cm, width 400 cm
A double drape that comprises two T-shape sections screwed to
the ceiling. Clamped to the T-shape with a retaining strip are two
sheets of material for each length of aluminium. The length of each
draped element is 400 cm. The width of each cloth sheet is 300
cm. The two drapes must be hung parallel to each other with a
width difference of at least 30 cm between them. The relation be-
tween the two drapes may be staggered up to a distance no more
than half way along each other so that the completed work may
be up to 600 cm long. Height is variable up to 400 cm which is
the maximum length of the cloth. The title of the work is an
anagram of Lothar Hempel.
WHEN DO WE NEED MORE TRACTORS?, Schipper & Krome,
Berlin, 1998

eloxiertes Aluminium, Polyestergewebe in Rot, Orange, Gelb, Blau
jede Bahn Höhe 400 cm, Breite 400 cm
Ein doppelter Vorhang aus zwei T-förmigen, an die Decke
geschraubten Teilen. Zwei Stoffbahnen für jeden
Aluminiumabschnitt sind mit einem Halteband an die T-Form
geheftet. Jedes drapierte Element ist 400 cm lang, jede Stoffbahn
300 cm breit. Die beiden Vorhänge müssen in einem Abstand von
mindestens 30 cm zueinander parallel aufgehängt werden. Das
Verhältnis zwischen den beiden Vorhängen kann schwanken, bis zu
einem Abstand von nicht mehr als der Hälfte der jeweils anderen,
so daß die fertige Arbeit bis zu 600 cm lang sein kann. Die Höhe
kann bis zu 400 cm, der maximalen Länge des Stoffs variieren.
Der Titel der Arbeit ist ein Anagramm des Namens Lothar Hempel.
WHEN DO WE NEED MORE TRACTORS?, Schipper & Krome,
Berlin, 1998

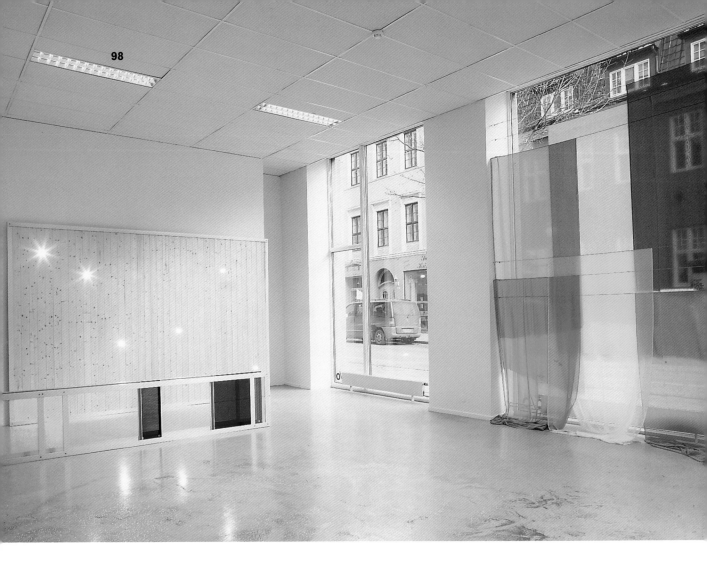

DISCUSSION ISLAND ADVISORY SCREEN
1998
anodised aluminium, Plexiglas
height 60 cm, length 360 cm, depth 30 cm
A double faced low screen with yellow and dark red transparent
Plexiglas. A discussion screen that acts as a low barrier, creating
designated space while also functioning as a device around which
it might be possible to reconsider the role of the consultant and
advisor within a post-planning situation.
LIAM GILLICK, c/o Atle Gerhardsen, Oslo, 1998

eloxiertes Aluminium, Plexiglas
Höhe 60 cm, Länge 360 cm, Tiefe 30 cm
Eine zweiseitige, niedrige Trennwand mit gelbem und dunkelrotem
Plexiglas. Eine Diskussionstrennwand, die eine niedrige Barriere
darstellt und einen festgelegten Raum schafft, wobei sie gleichzeitig
als Vorrichtung fungiert, um die herum es möglich sein könnte,
die Rolle des Beraters in einer Situation nach Abschluß des
Planungsstadiums zu überdenken.
LIAM GILLICK, c/o Atle Gerhardsen, Oslo, 1998

THINK TANK WALL
1998
anodised aluminium, pine planking (Dutch groove),
6 halogen lamps
height 240 cm, width 360 cm
A wood structure with halogen lamps that illuminates a space and
acts as a false wall. The work is constructed as a backdrop for the
reconsideration of the function of think tanks and the constantly
mutating role of the strategist and planner.
LIAM GILLICK, c/o Atle Gerhardsen, Oslo, 1998

eloxiertes Aluminium, Kieferplanken (Dutchgroove),
6 Halogenlampen
Höhe 240 cm, Breite 360 cm
Eine Holzkonstruktion mit Halogenlampen, die einen Raum
beleuchtet und als falsche Wand fungiert. Die Arbeit dient als
Hintergrund für ein Überdenken der Funktion von THINK TANKS
und der sich ständig verändernden Rolle des Strategen
und Planers.
LIAM GILLICK, c/o Atle Gerhardsen, Oslo, 1998

HALF ASLEEP, HALF AWAKE
1998
golden glitter, silver glitter, 0.5 litres clear alcohol
variable, minimum quantity 100 gm of each glitter type
The title is a direct reference to the condition of one of the
characters in the book DISCUSSION ISLAND: BIG CONFERENCE
CENTRE. The work is a process of renovation that leaves a visible
residue. The floor is cleaned with a combination of clear alcohol
and glitter. It is necessary to get on your hands and knees and use
a rag to swirl the liquid mixture on to the floor. The process may
be repeated whenever the user of the work feels that it might be
necessary.
LIAM GILLICK, c/o Atle Gerhardsen, Oslo, 1998

gold- und silberfarbene Glitzerpartikel, 0,5 Liter klarer Alkohol
variabel, Mindestmenge 100 Gramm von jeder Sorte Glitzerpartikel
Der Titel verweist direkt auf den Zustand einer der Figuren in dem
Buch DISCUSSION ISLAND: BIG CONFERENCE CENTRE. Die
Arbeit ist ein Renovierungsprozeß, der sichtbare Rückstände hin-
terläßt. Der Fußboden wird mit einer Mischung aus klarem Alkohol
und Glitzerpartikeln gereinigt. Es ist erforderlich, sich hinzuknien
und einen Lappen zu benutzen, um die flüssige Mischung auf dem
Boden zu verteilen. Der Prozeß kann wiederholt werden, wenn
immer der Benutzer der Arbeit dies für notwendig hält.
LIAM GILLICK, c/o Atle Gerhardsen, Oslo

LYING DOWN IN A PLACE THAT MIGHT HAVE ONCE HELD A BED BUT NOW ONLY OFFERED SOME SOFT DENTED FURNITURE
1998
six lengths of BEAUTY QUEEN Indian chiffon georgette
each 120 cm x 400 cm, cables, fittings
height minimum 240 cm with each cable placed at a horizontal
interval of 20 cm, width minimum 240 cm
A soft cloth improvised screen that should be placed in the window
of a room, or in extreme circumstances may be hung in front of a
wall. An image of a moment of confusion. The work acts as a layered
screen, echoing the aluminium and Plexiglas structures that were
devised before the writing of the book. As a post-text structure,
it is more improvised.
LIAM GILLICK, c/o Atle Gerhardsen, Oslo

sechs Bahnen indischer Chiffon-Georgette BEAUTY QUEEN,
je 120 x 400 cm, Kabel, Halterungen
Höhe mindestens 240 cm, jedes Kabel in einem horizontalen
Abstand von 20 cm, Breite mindestens 240 cm
Eine mit weichem Stoff improvisierte Abtrennung, die in einem
Fenster oder, unter extremen Umständen, vor einer Wand
aufgehängt werden kann. Ein Bild eines Moments der Irritation.
Die Arbeit funktioniert als geschichtete Abtrennung und erinnert
an die Konstruktionen aus Aluminium und Plexiglas, die vor dem
Schreiben des Buches konzipiert wurden. Als nach dem Text
entstandene Konstruktion ist sie improvisierter.
LIAM GILLICK, c/o Atle Gerhardsen, Oslo

REVERSAL PLATFORM
1999
milled aluminium, Plexiglas, cables, fittings
height variable length 360 cm, width 240 cm
A discussion platform that hangs free in the centre of a chosen
space. The work presents a deliberately tenuous relation to the
architecture of the chosen space.
A CONTINUING INVESTIGATION INTO THE RELEVANCE OF
ABSTRACTION, Andrea Rosen Gallery, New York, 1999

gewalztes Aluminium, Plexiglas, Kabel, Halterungen
Höhe variabel, Länge 360 cm, Breite 240 cm
Diskussionsplattform, die frei in der Mitte eines Raums hängt.
Die Arbeit zeigt einen bewußt schwachen Bezug zur Architektur
des gewählten Raums.
A CONTINUING INVESTIGATION INTO THE RELEVANCE OF
ABSTRACTION, Andrea Rosen Gallery, New York, 1999

—

REPORT SCREEN
1999
anodised aluminium, Plexiglas
height 60 cm, width 360 cm, depth 40 cm
A low free-standing screen that is derived from considerations
of the tools that contribute to decision making processes.
LIAM GILLICK, Kunsthaus Glarus, 1999

eloxiertes Aluminium, Plexiglas
Höhe 60 cm, Breite 360 cm, Tiefe 40 cm
Eine freistehende, niedrige Trennwand, abgeleitet von
Überlegungen zu den Instrumenten, die zu Entscheidungs-
findungsprozessen beitragen.
LIAM GILLICK, Kunsthaus Glarus, 1999

TERMINAL SCREEN
1999
anodised aluminium, Plexiglas
height 240 cm, width 360 cm, depth 60 cm
A large free-standing screen that is derived from considerations
of distanced receipt and transfer of information.
LIAM GILLICK, Kunsthaus Glarus, 1999

eloxiertes Aluminium, Plexiglas
Höhe 240 cm, Breite 360 cm, Tiefe 60 cm
Eine große freistehende Trennwand, abgeleitet von
Überlegungen zu einer distanzierten Rezeption und Übermittlung
von Informationen.
LIAM GILLICK, Kunsthaus Glarus, 1999

COMPRESSION SCREEN
1999
anodised aluminium, Plexiglas
height 240 cm, width 360 cm, depth 60 cm
A large free-standing screen that is derived from considerations
the potential of compressed information transferral.
LIAM GILLICK, Kunsthaus Glarus, 1999

eloxiertes Aluminium, Plexiglas
Höhe 240 cm, Breite 360 cm, Tiefe 60 cm
Eine große freistehende Trennwand, abgeleitet von Überlegungen
zu den Möglichkeiten der Übermittlung komprimierter
Informationen.
LIAM GILLICK, Kunsthaus Glarus, 1999

LIAISON SCREEN
1999
anodised aluminium, Plexiglas
height 60 cm, width 300 cm, depth 40 cm
A low free-standing screen that is derived from considerations
of temporary social and economic liaisons.
LIAM GILLICK, Rüdiger Schöttle, Munich, 1999

eloxiertes Aluminium, Plexiglas
Höhe 60 cm, Breite 300 cm, Tiefe 40 cm
Eine niedrige, freistehende Trennwand, abgeleitet von
Überlegungen zu zeitlich begrenzter sozialer und wirtschaftlicher
Zusammenarbeit.
LIAM GILLICK, Rüdiger Schöttle, München, 1999

REGULATION SCREEN
1999
anodised aluminium, Plexiglas
height 200 cm, length 300 cm, width 60 cm
A free-standing screen which defines a divided zone where it
might be possible to consider limits and organisation.
LIAM GILLICK, Rüdiger Schöttle, Munich, 1999

eloxiertes Aluminium, Plexiglas
Höhe 200 cm, Länge 300 cm, Breite 60 cm
Eine freistehende Trennwand, die eine unterteilte Zone definiert,
in der es möglich sein könnte, über Grenzen und Organisation
nachzudenken.
LIAM GILLICK, Rüdiger Schöttle, München, 1999

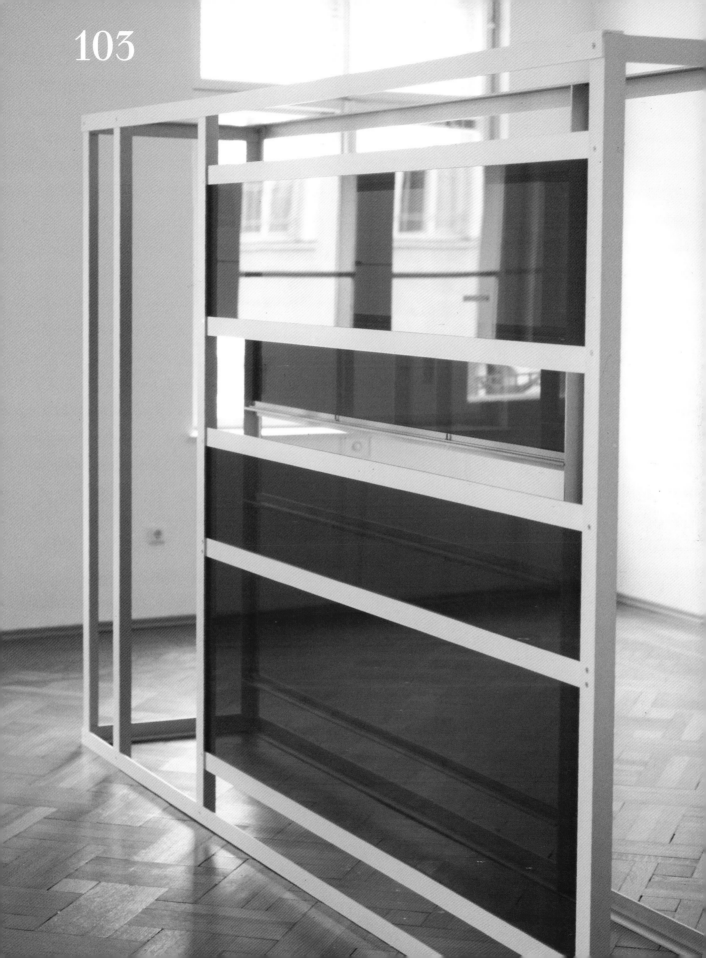

**SCHMERZ IN EINEM GEBÄUDE/PAIN IN A
BUILDING/DOLEUR DANS UN IMMEUBLE**
1999
necklace, puppet fabric in various shades supposedly equivalent
to various ethic types
variable
The work comprises a series of folded sheets of cloth bought
from a Rudolf Steiner craft shop. A necklace is constructed from
metal letters that reads SCHMERZ IN EINEM GEBÄUDE.
The work is a promotional device that refers to the potential of
a movie that could be made with the same title as the artwork.
LIAM GILLICK, Rüdiger Schöttle, Munich, 1999

Halskette, Stoff für Puppen verschiedener Hautfarbe, die
angeblich verschiedenen ethnischen Gruppen entsprechen
variabel
Die Arbeit umfaßt eine Reihe gefalteter Stoffbahnen, die in
einem Geschäft für Rudolf-Steiner-Kunsthandwerk gekauft wurden.
Metallbuchstaben, die die Wörter SCHMERZ IN EINEM GEBÄUDE
bilden, sind zu einer Halskette zusammengesetzt. Die Arbeit ist eine
Werbemaßnahme, die auf die Möglichkeit verweist, einen Film mit
demselben Titel als Kunstwerk zu drehen.
LIAM GILLICK, Rüdiger Schöttle, München, 1999

FOYER TABLE
1999
plywood, black Formica, vase, chromed steel, Coca-Cola
variable
A table designed by the artist and fabricated by "Neosynthesis",
an Athens based design company. A low table constructed from four
layers of plywood which have been faced with black Formica. The
edges of the plywood are left bare to expose the wood. Each layer
is cut to the same pattern with curved corners of different radius.
Each layer is placed on top of the previous one after being turned
through 90 degrees. The layers are separated by chromed steel
tube which is fixed with chromed steel cups to the table elements.
A simple large straight glass is placed on top in one corner. The
vase is half filled with Coca-Cola. The table is designed to function
best in a foyer space.
OBJECTHOOD 00, Hellenic American Union, Athens, 1999

Sperrholz, schwarzes Resopal, Vase, verchromter Stahl, Coca-Cola
variabel
Ein vom Künstler entworfener und von „Neosynthesis", einer
Athener Design-Firma, gebauter Tisch. Ein niedriger Tisch aus vier
übereinander liegenden, mit Resopal beschichteten Sperrholzplatten.
Die Schnittkanten des Holzes bleiben unbeschichtet, damit das
Holz sichtbar ist. Jede Platte hat dieselbe Form mit unterschiedlich
abgerundeten Ecken. Die Platten werden aufeinander gelegt,
nachdem sie jeweils um 90 Grad gedreht wurden. Sie werden von
einem verchromten Stahlrohr auseinander gehalten, das mit
verchromten Stahlringen an den einzelnen Elementen des Tischs
befestigt ist. Ein einfaches gerades Glas steht auf der oberen
Platte in einer Ecke. Die Vase ist zur Hälfte mit Coca-Cola gefüllt.
Am besten funktioniert der Tisch in einem Foyer.
OBJECTHOOD 00, Hellenic American Union, Athen, 1999

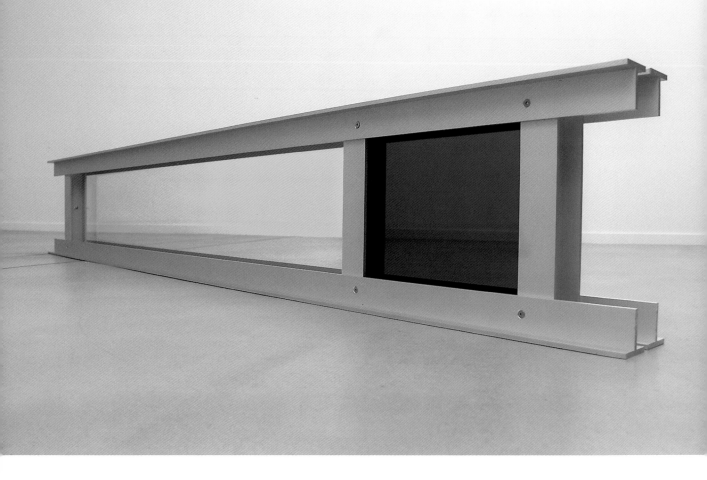

ELEVATION SCREEN
1999
anodised aluminium, Plexiglas
height 30 cm, width 200 cm, depth 10 cm
A small free-standing screen that functions as a sample prototype
for a potentially larger structure.
ETCETERA, Spacex Gallery, Exeter/NEW YORK – LONDON,
Taché-Levy, Brussels / ESSENTIAL THINGS, (curated by Guy
Mannes Abbott), Robert Prime, London

eloxiertes Aluminium, Plexiglas
Höhe 30 cm, Breite 200 cm, Tiefe 10 cm
Eine kleine, freistehende Trennwand, die als Modell für eine
möglicherweise größere Konstruktion dient.
ETCETERA, Spacex Gallery, Exeter/NEW YORK – LONDON,
Taché-Levy, Brüssel / ESSENTIAL THINGS, (curated by Guy
Mannes Abbott), Robert Prime, London

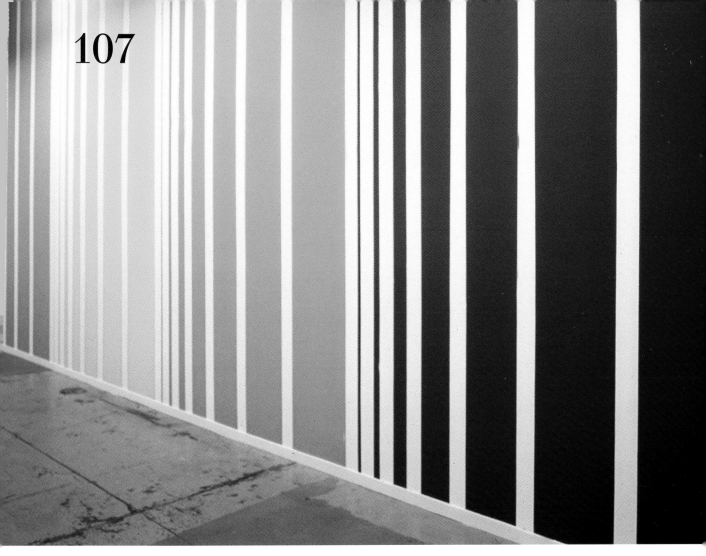

64TH FLOOR LOBBY DIAGRAM
1999
acrylic paint
variable
A wall diagram that could be understood as functioning best
in a potential lobby situation.
CONSTRUCTIVISM: LIFE INTO ART, Brisbane, 1999

Acrylfarbe
variabel
Ein Wanddiagramm, von dem man annehmen könnte, daß es
am besten in einer Lobby-Umgebung funktioniert.
CONSTRUCTIVISM: LIFE INTO ART, Brisbane, 1999

109

DAVID (PROVISIONAL BACKDROP TITLE PROJECTION)
1999
chipboard, coloured hessian
three sets of panels height 240 cm, width 50 cm/height 220 cm,
width 50 cm/height 200 cm, width 50 cm
A wall constructed from chipboard covered with coloured hessian
that prevents the use of the majority of the space of a large room.
The wall forms a boundary that permits the control of sound quality
and forms a potential backdrop for the projection of film titles.
DAVID, Frankfurter Kunstverein, 1999

Spanplatte, farbiges Sackleinen
drei Sets jeweils zusammengehörender Tafeln, Höhe 240 cm, Breite
50 cm/Höhe 220 cm, Breite 50 cm/Höhe 200 cm, Breite 50 cm
Eine aus Spanplatten konstruierte und mit farbigem Sackleinen
bespannte Wand, die den überwiegenden Teil eines großen Raums
unzugänglich macht. Die Wand bildet eine Grenze, die ein
Kontrollieren der Klangqualität ermöglicht, und einen möglichen
Hintergrund für die Projektion von Filmtiteln.
DAVID, Frankfurter Kunstverein, 1999

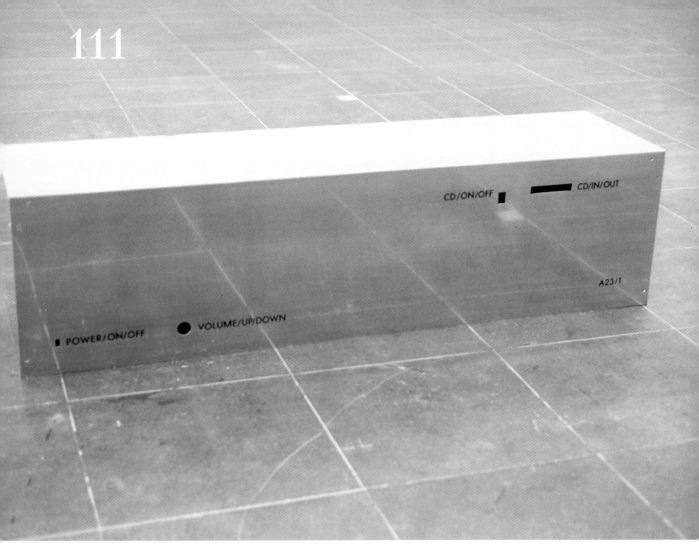

DAVID (PROTOTYPE SOUND SYSTEM)
1999
laser-cut brushed aluminium
height 50 cm, width 200 cm, depth 50 cm
The casing for a potential hi-fi system, the work is designed to
carry a specific set of interior working parts yet in this form may
be viewed as a prototype or prop.
DAVID, Frankfurter Kunstverein, 1999

lasergeschnittenes, gebürstetes Aluminium
Höhe 50 cm, Breite 200 cm, Tiefe 50 cm
Gehäuse für eine mögliche Hi-Fi-Anlage, das bestimmte technische
Teile aufnehmen soll, in dieser Form jedoch als Prototyp oder
Requisit betrachtet werden kann.
DAVID, Frankfurter Kunstverein, 1999

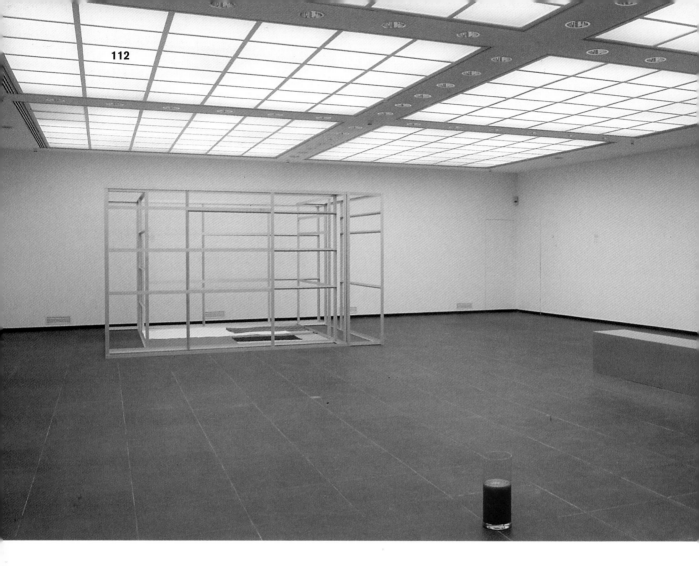

DAVID (PROTOTYPE SOUND SYSTEM)
1999
laser-cut brushed aluminium, height 50 cm, width 200 cm,
depth 50 cm
The casing for a potential hi-fi system, the work is designed
to carry a specific set of interior working parts yet in this form
may be viewed as a prototype or prop.
DAVID, Frankfurter Kunstverein, 1999

lasergeschnittenes, gebürstetes Aluminium
Höhe 50 cm, Breite 200 cm, Tiefe 50 cm
Gehäuse für eine mögliche Hi-Fi-Anlage, das bestimmte technische
Teile aufnehmen soll, in dieser Form jedoch als Prototyp oder
Requisit betrachtet werden kann.
DAVID, Frankfurter Kunstverein, 1999

DAVID (TEMPORARY LOCATION RIG)
1999
anodised aluminium, Indian cotton
four screens each height 240 cm, width 360 cm, depth 30 cm
A set of four screens and a number of sheets of coloured Indian
cotton that can be arranged in a number of different permutations.
The work may function as a potential back-drop for other activity.
DAVID, Frankfurter Kunstverein, 1999

eloxiertes Aluminium, indische Baumwolle
vier Trennwände, jeweils Höhe 240 cm, Breite 360 cm,
Tiefe 30 cm
Vier Trennwände und eine Anzahl von Bahnen farbiger indischer
Baumwolle, die verschieden angeordnet werden können. Die Arbeit
kann als möglicher Hintergrund für andere Aktivitäten dienen.
DAVID, Frankfurter Kunstverein, 1999

DAVID (HE DOESN'T TURN TO SEE HER)
1999
big glass, Bloody Mary
variable
A large straight glass that contains a Bloody Mary. The work is
the key to the Kubrick filter that has been applied to the exhibition
DAVID, in that it makes specific reference to the potential ending
of a film Kubrick did not have the time to make before his death.
DAVID, Frankfurter Kunstverein, 1999

großes Glas, Bloody Mary
variabel
Ein großes gerades Glas mit Bloody Mary. Die Arbeit ist der
Schlüssel zu dem der Ausstellung DAVID vorgeschalteten Kubrick-
Filter, indem sie spezielle Bezüge zum möglichen Ende eines Films
herstellt, den Kubrick vor seinem Tod nicht mehr drehen konnte.
DAVID, Frankfurter Kunstverein, 1999

APPLIED RESIGNATION PLATFORM
1999
Plexiglas panels applied to existing structure
length 1600 cm, width 800 cm, each panel length 100 cm,
width 100 cm
A large panelled ceiling that may be viewed as an applied
discussion platform. The work is a permanent loan to the Frankfurter
Kunstverein and may be installed or de-installed at the discretion
of the users of the space.
DAVID, Frankfurter Kunstverein, 1999

Plexiglasscheiben, in eine vorhandene Konstruktion eingepaßt
Länge 1600 cm, Breite 800 cm, jede Scheibe Länge 100 cm,
Breite 100 cm
Eine große getäfelte Decke, die als angebrachte Diskussionsplatt-
form betrachtet werden kann. Die Arbeit ist eine Dauerleihgabe an
den Frankfurter Kunstverein. Installation oder Abbau liegen im
Ermessen der Benutzer des Raums.
DAVID, Frankfurter Kunstverein, 1999

DAVID (SOUNDTRACKS)
1999
hi-fi system, mini-disc
variable
A series of potential soundtracks produced on software in
development that has no "undo" function. The soundtracks are
played through an optical connection to an amplifier that has no
equalisation therefore producing a relatively unmediated version
of the original mixes.
DAVID, Frankfurter Kunstverein, 1999

Hi-Fi-Anlage, Mini-Disk
variabel
Eine Reihe möglicher Soundtracks, produziert mit einer noch in
der Entwicklung befindlichen Software, die keine Löschfunktion
hat. Die Soundtracks werden mit Hilfe einer optischen Verbindung
zu einem Verstärker übertragen, der keinen Equalizer hat und
daher eine relativ unausbalancierte Fassung der Originalmischung
produziert.
DAVID, Frankfurter Kunstverein, 1999

THING YOU NEED, YOU COME TO ME, I'M YOUR MAN." AND STEVEN SAYS: "WELL, YOU KNOW, I ALWAYS WANTED TO MEET STANLEY KUBRICK. DO YOU THINK YOU COULD ARRANGE THAT?" AND GABRIEL LOOKS AT HIM AND SAYS:"YOU KNOW, STEVEN, OF ALL THE THINGS THAT YOU COULD ASK FOR, WHY WOULD YOU ASK FOR THAT? YOU KNOW THAT STANLEY DOESN'T TAKE MEETINGS." "WELL, YOU SAID THAT IF THERE WAS ANYTHING I WANTED." GABRIEL SAYS: "I'M REALLY SORRY. I CAN'T DO THAT." SO NOW HE'S SHOWING HIM AROUND HEAVEN AND STEVEN SEES THIS GUY WEARING AN ARMY JACKET WITH A BEARD RIDING A BICYCLE AND STEVEN SAYS TO GABRIEL: "OH, MY GOD, LOOK, OVER THERE, THAT'S STANLEY KUBRICK. COULDN'T WE JUST STOP HIM AND SAY HELLO?" AND GABRIEL PULLS STEVEN TO THE SIDE AND SAYS: "THAT'S NOT STANLEY KUBRICK, THAT'S GOD - HE JUST THINKS HE'S STANLEY KUBRICK."

117

**PROTOTYPE DESIGN FOR CONFERENCE ROOM
(WITH JOKE BY MATTHEW MODINE ARRANGED BY
MARKUS WEISBECK)**
1999
chipboard, hessian, plastic lettering
variable
A prototype conference room, that was used during the exhibition
DAVID for various public events including a conference on art
criticism organised by Christoph Blase. The space features a joke
by Matthew Modine that has been arranged and designed by
Markus Weisbeck.
DAVID, Frankfurter Kunstverein, 1999

Spanplatte, Sackleinen, Kunststoffbuchstaben
variabel
Prototyp für einen Konferenzraum, der während der Ausstellung
DAVID für verschiedene öffentliche Veranstaltungen genutzt wurde,
unter anderem für eine von Christoph Blase organisierte Konferenz
zum Thema Kunstkritik. Der Raum zeigt einen Witz von Matthew
Modine, der von Markus Weisbeck gestaltet und angebracht wurde.
DAVID, Frankfurter Kunstverein, 1999

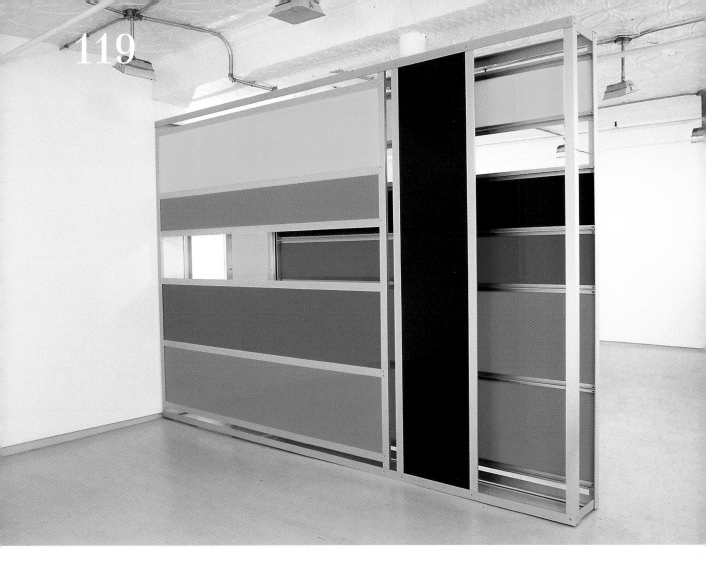

ISOLATION PLATFORM
1999
anodised aluminium, Plexiglas, cables, fittings
height variable length 120 cm, width 120 cm
A discussion platform that projects a space for reflection.

eloxiertes Aluminium, Plexiglas, Kabel, Halterungen
Höhe variabel, Länge 120 cm, Breite 120 cm
Diskussionsplattform, die einen Raum zum Reflektieren bietet.

DELAY SCREEN
1999
anodised aluminium, Plexiglas
height 240 cm, width 360 cm, depth 30 cm
A large screen that defines a space where it might be possible
to reassess the speed of decision making. The work also formed
a temporary wall during the show JONATHAN MONK at Casey
Kaplan, New York.
JONATHAN MONK, Casey Kaplan, 1999

eloxiertes Aluminium, Plexiglas
Höhe 240 cm, Breite 360 cm, Tiefe 30 cm
Eine große Trennwand, die einen Raum definiert, in dem es
möglich sein könnte, die Geschwindigkeit des Treffens von Ent-
scheidungen neu zu überdenken. Außerdem bildete die Arbeit
vorübergehend eine Wand während der Ausstellung JONATHAN
MONK bei Casey Kaplan, New York.
JONATHAN MONK, Casey Kaplan, 1999

APPLIED COMPLEX SCREEN
2000
anodised aluminium, Plexiglas
height 195 cm, width 360 cm, depth 5 cm
Single skinned screen applied to the office window adjacent to the main entrance of the Hayward Gallery. The original light fittings within the office have been restored and the lamps replaced with those that approximate daylight. The screen may be seen as an applied work that extends earlier discussions and presents some practical reassessments during a time when the future of the structure of the Hayward Gallery is open to change.
WHO CONTROLS THE NEAR FUTURE? Hayward Gallery Turnaround Project, 2000

eloxiertes Aluminium, Plexiglas
Höhe 195 cm, Breite 360 cm, Tiefe 5 cm
Einzelner bespannter Wandschirm, angebracht vor dem Bürofenster neben dem Haupteingang der Hayward Gallery. Die ursprünglichen Lampenfassungen im Büro wurden erneuert und die Lampen durch solche ersetzt, deren Licht nahezu natürlichem entspricht. Der Schirm kann als angewandte Arbeit betrachtet werden, die in einer Zeit, in der die Zukunft der baulichen Gegebenheiten der Hayward Gallery für Veränderungen offen ist, frühere Diskussionen ausweitet und ein Neuüberdenken praktischer Möglichkeiten darstellt.
WHO CONTROLS THE NEAR FUTURE?, Hayward Gallery Turnaround Project, 2000

**INSTRUCTIONS/IL MISTERO DEI 100 DOLLARI
SCOMPARSI**
Gio' Marconi, Milan
1992

A number of artists were invited to submit a written or drawn
instruction by letter or fax to the organiser indicating work to be
executed at Gio' Marconi gallery, Milan, during November/
December 1992. The works proposed were all carried out by the
artist and presented as a group show. The exhibition structure was
intended to test certain assumptions about the neo-conceptual
nature of the work by many of those invited to contribute
working ideas.

Eine Reihe von Künstlern wurde aufgefordert, dem Organisator per
Post oder Fax in schriftlicher oder gezeichneter Form Anweisungen
für Arbeiten einzureichen, die im November/Dezember 1992 in
der Galerie Gio' Marconi in Mailand ausgeführt werden sollten.
Die vorgeschlagenen Arbeiten wurden alle vom Künstler realisiert
und als Gruppenausstellung präsentiert. Mit dieser Struktur der
Ausstellung sollten bestimmte Annahmen über den neo-konzeptu-
ellen Charakter der Arbeit vieler der zu dieser Ausstellung
Eingeladenen überprüft werden.

Contributing Artists:
Beiträge von:

Angela Bulloch
Adam Chodzko
Matthew Collings
Jeremy Deller
Liam Gillick
Douglas Gordon
Gary Hume
Michael Landy
Jonathan Monk
Simon Patterson
Brendan Quick
Philip Riley
Caroline Russell
Giorgio Sadotti
Gavin Turk
Gillian Wearing

ERASMUS IS LATE
1995
Illustrations by Gillian Gillick
Book Works, London
84 pp
edition 1000
ISBN 1-870699-17-3

IBUKA!
1995
Künstlerhaus Stuttgart
60 pp
edition 500

123

STOPPAGE

1995

CCC, Tours, and Villa Arson, Nice

(original catalogue text)

We live in a time when the notion of fractured time is inherent in analysis of our supposed cultural malaise. Stoppage attempts to address such a basic premise about our inability to concentrate by shifting attention away from the sound-bite and towards something that might be more accurately described as a soundtrack for living. The pieces proposed here are not installed to be consumed, they exist so that people can get used to them, mark time, even use the gallery while pursuing other actions. The show rejects an occupation of space alone by completely filling certain areas. It is intended to be relatively unobtrusive while we get on with whatever we have to do. My role in all this is to compile and produce the work, and consider the way in which we might deal with the technical problems. I will attempt to find the best equipment and the right way to do things. In this way, my solo show will reflect my interest in parallel constructions. Some kind of mediated soundtrack will emerge, to be produced on CD later for home use. In the gallery the work will be played using a MINI DISC system. This will allow the tracks to be programmed and works to be repeated or looped in a potentially endless manner.

Wir leben in einer Zeit, in der das Gefühl von zersplitterter Zeit Bestandteil der Analyse unserer angeblichen kulturellen Malaise ist. Stoppage versucht, eine solche Grundannahme über unsere Unfähigkeit zur Konzentration aufzugreifen, indem sie die Aufmerksamkeit von der Klangschärfe weg und auf etwas hin lenkt, das vielleicht präziser als Soundtrack zum Leben beschrieben werden kann. Die hier vorgeschlagenen Arbeiten sind nicht installiert worden, um konsumiert zu werden. Sie existieren, damit Menschen sich an sie gewöhnen, auf der Stelle treten oder sogar den Ausstellungsraum nutzen können, während sie anderen Aktivitäten nachgehen. Die Ausstellung lehnt eine Besetzung von Raum allein durch völliges Anfüllen bestimmter Bereiche ab. Sie soll relativ unauffällig sein, während wir mit dem weitermachen, was wir zu tun haben. Meine Rolle bei all dem besteht darin, die Arbeiten zusammenzustellen, zu produzieren und darüber nachzudenken, wie wir mit technischen Problemen umgehen. Ich werde versuchen, die beste Ausrüstung zu bekommen und die Dinge richtig zu machen. Auf diese Weise wird meine Einzelausstellung mein Interesse an parallelen Konstruktionen spiegeln. Es wird eine Art Soundtrack entstehen, der später für den privaten Gebrauch als CD produziert wird. In der Ausstellung werden die Arbeiten auf einer Mini-Disk-

Anlage abgespielt werden. Das ermöglicht es, die Stücke zu programmieren und zu wiederholen oder als Endlosschleife abzuspielen.

Liam Gillick, Mai 1995

Contributing Artists:
Beiträge von:

Laura Stein
Dominique Gonzalez-Foerster
Elizabeth Wright
Lothar Hempel
Cerith Wyn-Evans
Sam Samore
Georgina Starr
Laura Ruggeri
Rirkrit Tiravanija
Liam Gillick
Philippe Parreno
Sam Taylor-Wood
Angela Bulloch
Pierre Bismuth
Paul Mittleman
Keith Farquhar
Pierre Huygue
Jorge Pardo

LIAM GILLICK AND PHILIPPE PARRENO
LE LABYRINTHE MORAL/THE MORAL MAZE
1995
Le Consortium, Dijon

(from original exhibition outline)
The creation of a number of environments in which a series of
investigations may take place. The basic idea is to invite a number
of "witnesses" to come and stay in Dijon and present themselves to
the panel in order to explain their position. During the presen-
tations the panel will be posing a number of questions to the
witnesses. Whereas the standard symposium format tends towards
a clear cut free-for-all, this project transfers the weight onto the
person invited to present their views. The invited participants would
include political strategists, economists, designers and those involved
in mediating promotional tools from the world of advertising and
corporate strategy. Each person would be invited alone to spend time
with the artists involved and would leave Dijon again before the
next expert arrived. The questioning time would be at least one
working day. The project would not be closed to the public, but
the exhibition space would not be clearly open either.

LE LABYRINTHE MORAL has been constructed in order to create
a structure within which it is possible to establish certain positions.
The pressure is not put on the person invited to present some kind
of autonomous paper, but rather the situation should be reactive
and investigative. Therefore in the case of a reluctant or reserved
speaker it should still be possible to establish some kind of progress,
all dependent upon the skill and abilities of the panel.

(aus der ursprünglichen Projektskizzierung)
Herstellung einer Anzahl von Environments, in denen eine Reihe von
Untersuchungen stattfinden können. Die Gründidee ist, „Zeugen"
einzuladen, nach Dijon zu kommen und sich dem Podium zu stellen,
um ihre Position darzulegen. Das Podium wird den Zeugen eine
Reihe von Fragen stellen. Während sich bei einem normalen Sym-
posion in der Regel jeder beteiligen kann, verlagert dieses Projekt
das Hauptgewicht auf die Person, die eingeladen wurde, ihre An-
sichten zu präsentieren. Zu den Teilnehmern, die eingeladen werden
sollen, gehören politische Strategen, Wirtschaftswissenschaftler,
Designer und Personen, die mit der Vermittlung des Instrumentariums
der Werbung und der Firmenstrategie zu tun haben. Jede Person
wird einzeln eingeladen, Zeit mit den beteiligten Künstlern zu ver-
bringen, und wird Dijon verlassen, bevor die nächste ankommt.
Die Befragung erstreckt sich über mindestens einen Arbeitstag.

Das Projekt wird nicht unter Ausschluß der Öffentlichkeit stattfin-
den, doch wird der Ausstellungsraum auch nicht deutlich für jeden
offen sein.

LE LABYRINTHE MORAL wurde geschaffen, um eine Struktur
aufzubauen, innerhalb derer es möglich ist, bestimmte Positionen
zu etablieren. Auf die eingeladene Person wird kein Druck aus-
geübt, eine Art eigenständiges Papier vorzulegen, sondern die
Situation soll vielmehr reaktiv und investigativ gehalten werden.
Daher sollte es im Fall einer Person, die sich nur widerwillig oder
zurückhaltend äußert, dennoch möglich sein, einen gewissen
Fortschritt zu erreichen, was jedoch vom Geschick und den
Fähigkeiten des Podiums abhängt.

Contributing Artists:
Beiträge von:

Angela Bulloch
Liam Gillick
Maurizio Cattelan
Philippe Parreno
Pierre Huygue
Lothar Hempel
Carsten Höller
Dominique Gonzalez-Foerster
Douglas Gordon

125

THE TRIAL OF POL POT
Le Magasin, Grenoble
1998

Supervised by Terry Atkinson, Pierre Huygue, Pierre Joseph,
Thomas Mulcaire, Rebecca Gordon-Nesbitt, Gabriel Kuri, Josephine
Pryde, Carsten Höller, Rirkrit Tiravanija, Ronald Jones, Zeigam
Azizov, Adrian Schiesser, Douglas Gordon

THE TRIAL OF POL POT is not concerned to document a specific
historical event. THE TRIAL OF POL POT concerns the construction
of rogue identity and the way it is mediated. The project occupies
the zone between straight reportage and the creation of narrative
fictions. As an exhibition it involves the inscription of ideas and
the construction of unplayable characterisations directly upon the
walls of Le Magasin.

THE TRIAL OF POL POT is an exhibition structure based on a
research project by Liam Gillick and Philippe Parreno. The artists
circulated a discussion document to a number of supervisors.
Following their own research and the suggestions of the super-
visors a number of graphic solutions were proposed for the entire
space of Le Magasin. A vinyl cutting machine was acquired and the
layouts for the galleries have been translated directly from the
computer screen to the walls of the building.

Lighting has been adjusted and modifications are still being made
to the discursive layouts at the suggestion of the supervisors.

In addition, each supervisor has been invited to propose a singular
solution to the gallery space. These ideas will be distributed as free
copyright/public domain art works to visitors to the exhibition.

A puppet show, every Wednesday, will act as a guide for children.

Supervisoren: Terry Atkinson, Pierre Huygue, Pierre Joseph,
Thomas Mulcaire, Rebecca Gordon-Nesbitt, Gabriel Kuri, Josephine
Pryde, Carsten Höller, Rirkrit Tiravanija, Ronald Jones, Zeigam
Azizov, Adrian Schiesser, Douglas Gordon

Das Anliegen von THE TRIAL OF POL POT ist nicht, ein bestimmtes
historisches Ereignis zu dokumentieren. Bei THE TRIAL OF POL
POT geht es um die Konstruktion der Identität eines Verbrechers
und die Form, in der diese vermittelt wird. Das Projekt besetzt den
Bereich zwischen nüchterner Reportage und erzählerischer Fiktion.
Als Ausstellung schließt es das Aufschreiben von Ideen und die
Konstruktion unspielbarer Charakterisierungen direkt auf den
Wänden des Magasin ein.

THE TRIAL OF POL POT ist eine Ausstellungsstruktur, die auf
einem Forschungsprojekt von Liam Gillick und Philippe Parreno
basiert. Die Künstler reichten ein Diskussionsdokument an eine
Reihe von Supervisoren weiter. Aufgrund der eigenen Forschungen
und der Vorschläge der Supervisoren entstanden Entwürfe für
grafische Lösungen für den gesamten Raum von Le Magasin.
Eine Vinyl-Schneidemaschine wurde erworben, und die Entwürfe
für die Ausstellungsräume wurden direkt vom Computerbildschirm
auf die Wände des Gebäudes übertragen.

Die Beleuchtung wurde angepaßt, und der diskursive Entwurf wird
immer noch auf Vorschläge der Supervisoren hin abgeändert.

Zusätzlich wurde jeder Supervisor aufgefordert, eine einzigartige
Lösung für den Ausstellungsraum vorzuschlagen. Diese Ideen wer-
den als urheberrechtlich nicht geschützte/Public Domain-Kunst-
werke an die Ausstellungsbesucher verteilt werden.

Jeden Mittwoch wird eine Puppenvorstellung stattfinden, die als
Führung für Kinder dient.

Oldnewtown
Casey Kaplan, New York.
1999

Contributing Artists
Kai Althoff
Kirsten Berkeley
Cosima von Bonin
Keith Farquhar
Dominique Gonzalez-Foerster
Lothar Hempel
Georg Herold
Nahoko Kudo
Gabriel Kuri
Christina Mackie
Simon Periton
Peter Saville
Andreas Schulze
Gary Webb
Lawrence Weiner
Pae White

MATTHEW BRANNON AND LIAM GILLICK
EIN RÜCKBLICK AUS DEM JAHRE 2000 AUF 1887
1999
Galerie für Zeitgenössische Kunst, Leipzig
196 Seiten
Auflage 500
A reprint of the book LOOKING BACKWARD 2000–1887 for
the Galerie für Zeitgenössische Kunst Leipzig in collaboration with
Susanne Gaensheimer. Copies of the book were given out at the
opening of the exhibition. The cover is designed by Matthew Brannon.
1+3 = 4 x 1, Galerie für Zeitgenössische Kunst, Leipzig
ISBN 3-9805959-5-1

Neudruck der deutschen Übersetzung des Buches LOOKING
BACKWARD 2000–1887 für die Galerie für Zeitgenössische
Kunst Leipzig in Zusammenarbeit mit Susanne Gaensheimer.
Bei der Eröffnung der Ausstellung wurden Exemplare des Buchs
verteilt. Umschlaggestaltung von Matthew Brannon.
1+3 = 4 x 1, Galerie für Zeitgenössische Kunst, Leipzig
ISBN 3-9805959-5-1

131 **Parallel Structures** For his first London exhibition at Karsten Schubert Gallery in 1989, Liam Gillick presented four suites of drawings of buildings. These had been done on computer, each being printed out on a standard A4 sheet of paper. In their form the buildings match the descriptive and representational possibilities and limitations of the programme used to depict them: rectilinear facades, flat roofs and so on. At first glance the designs appear coherent and familiar. They fit comfortably with the image of a kind of international modernism that one associates with Le Corbusier, Mies van der Rohe and with the general principles of Constructivism and De Stijl. Closer inspection reveals slight errors, imperfections and structural solecisms. Roofs don't quite meet walls, for example, in a manner that condemns the design to an existence purely on paper. Unlike the accepted role of paper architecture, the "blue skies" tactic of giving free reign to the imagination in order to project present capability into future possibility, these putative structures present a more ambivalent attitude, both to the past – the architectural lexicon upon which they are drawing – and to any future in which they might aspire to concrete existence. For while the employment of available technology to explore the potential of a well-established formal grammar can be seen as an acknowledgement that the facts of the present situation are given to us and are not in themselves deniable, everything else about those facts – how they are interpreted and put to use – is open to debate. The historical account of architectural form that describes the path of its development in the modern period as inevitable and unavoidable is called into question by the practical unworkability of Gillick's designs. If, say, Constructivism can be loosed from its fixed position as a definite stage in this history, we are left free to think more directly about some of the factors within it, to loose them too and to put their mobility to new purpose. The relationships that might be set up between idea and reality, between artistic logic and social responsibility, and between usefulness and aesthetic value become matters of negotiation again. Gillick's buildings are unrealisable in the strict sense, yet what they concern, the consideration of space, volume, the intersection of planes, openings and closures, habitation, business, security, safety and so on, are no less present as material for discussion as a result. What is already clear in these early drawings is this desire to treat the events of history, not as things that are merely past and gone (albeit that they are well-documented and, in that sense, retrievable), but as elements that are more directly usable in the processes of thinking and acting within the present. Gillick's attempt to produce architecture in this work is by no means an idle or flippant gesture. Equally, though, it is important to understand that it does not signal a wish either to be an architect or to practice architecture in any straightforward way. It is, rather, an example of what he calls "displacement activity", a way of working in parallel to accepted patterns of professional behaviour –

Parallele Strukturen In seiner ersten Ausstellung in London 1989 in der Galerie Karsten Schubert präsentierte Liam Gillick drei Serien mit Gebäudezeichnungen. Sie waren auf einem Computer erstellt worden und jeweils auf einem DIN-A4-Blatt ausgedruckt. In ihrer Form entsprechen die Gebäude den Darstellungsmöglichkeiten und -grenzen des Programms, mit dem sie gezeichnet wurden: geradlinige Fassaden, Flachdächer und so weiter. Auf den ersten Blick erscheinen die Zeichnungen schlüssig und vertraut. Sie entsprechen durchaus den Vorstellungen von der Art internationaler Moderne, wie sie mit Le Corbusier, Mies van der Rohe, allgemein den Prinzipien des Konstruktivismus und De Stijl verbunden werden. Bei näherer Betrachtung zeigen sich jedoch kleinere Irrtümer, Mängel und Konstruktionsfehler. Dächer schließen beispielsweise nicht direkt an Wände, was den Entwurf dazu verurteilt, allein auf dem Papier zu existieren. Im Gegensatz zur akzeptierten Rolle einer nur auf dem Papier vorhandenen Architektur, nämlich dem „Ins Blaue Hinein", der Taktik, der Vorstellungskraft freien Lauf zu lassen, um heute Machbares in zukünftig Mögliches zu projizieren, zeigen diese vermeintlichen Bauwerken eine ambivalentere Haltung sowohl gegenüber der Vergangenheit – dem Architekturlexikon, auf das sie sich stützen – wie auch gegenüber jedweder Zukunft, in der sie nach einer konkreten Existenz streben mögen. Denn während die Anwendung verfügbarer Technologie, um das Potential einer etablierten Formengrammatik zu untersuchen, als Eingeständnis der Tatsache gelten kann, daß uns die Umstände der heutigen Situation gegeben sind und an sich nicht geleugnet werden können, bleibt alles andere im Hinblick auf diese Umstände – wie sie interpretiert und genutzt werden – diskutierbar. Die historische Darstellung der architektonischen Form, die den Weg ihrer Entwicklung in der Moderne als unausweichlich und unvermeidbar beschreibt, wird von der Tatsache, daß Gillicks Zeichnungen nicht in die Praxis umsetzbar sind, in Frage gestellt. Wenn zum Beispiel der Konstruktivismus aus seiner festgelegten Position als definitives Stadium in dieser Geschichte herausgelöst werden kann, haben wir die Freiheit, direkter über einige der Faktoren innerhalb dieser Geschichte nachzudenken, sie ebenfalls herauszulösen und ihre Beweglichkeit einem neuen Zweck zuzuführen. Die Beziehungen, die man zwischen Idee und Realität, zwischen künstlerischer Logik und sozialer Verantwortung sowie zwischen Nützlichkeit und ästhetischem Wert herstellen könnte, werden so wieder verhandelbar. Gillicks Gebäude sind streng genommen nicht zu realisieren, doch das, worum es geht, nämlich die Überlegungen zu Raum, Volumen, der Überschneidung von Flächen, Öffnungen und geschlossenen Flächen, Wohnräumen, Geschäftsräumen, Sicherheit und so weiter, ist als Diskussionspunkt nicht weniger präsent als es ein Resultat wäre. Was bereits in diesen frühen Zeichnungen sichtbar wird, ist der Wunsch, Ereignisse der Geschichte nicht als lediglich vergangene zu

132 architect, reporter, designer, and so on – that allows for questions to be asked without the concomitant need to arrive at a unitary and definitive solution. (1)

In the early 1990s, Gillick worked on a number of occasions in collaboration with Henry Bond. The two artists constituted themselves as a news team, with Bond taking photographs for, and Gillick writing the text of the series of DOCUMENTS they produced. In a manner that parallels the non-architectural architecture of the architectural drawings, Bond and Gillick's position vis à vis the press was not simple. They were not a real news team, because their images and reports were not intended for newspaper consumption and were never published in that way. Neither, however, were they pretending to be, or acting as a news team merely in order to make some direct comment upon the nature of newsgathering and the fact that the media play an enormous role in constructing our image of the world and our sense of what is important within it. This comment is there, but only as part of a larger pattern of issues connecting the activity of news-finding to the places in which the stories are discovered, documented and displayed. All of the work of this kind was closely linked to the site of its original showing. Rather than acting as newshounds, Bond and Gillick took the Press Association list of pre-arranged photo-calls and press conferences for the city in which they were working and attended them. Certain things, then, had been decided in advance by others, including not only what the story was, but also the fact that a particular event was worthy of being treated as a story at all. What they collected at the beginning of the day was a set of instructions detailing where to go and what to do, a sheet of paper informing them how that city saw itself fitting in to the larger configuration of perceptions, attitudes and phenomena that make up the world. Reframing such stories by means, say, of an unglamorous photograph of a conference room coupled with an extract of a statement or conversation, once more exposed not just the facts, but also the mechanisms whereby those facts had become valorised, to further scrutiny. The space within which this scrutiny is made possible is the space of art. How the press functions is one of the things placed under consideration by these works, but while the DOCUMENTS share some formal characteristics with things that are encountered elsewhere, it is their independence from the restrictions of that other context while remaining linked to it that allows for reflection upon how things have come to be the way they are and how, as a consequence, things might proceed from here. This attitude is distinct from prevalent notions about how art might be "like" real life. Ultimately these can be traced back to the Duchampian gesture of designating the readymade object a work of art, a gesture which licences the spectator to decide that what is being looked at or otherwise experienced is art. The "parallel" activity seen throughout

behandeln (auch wenn sie gut dokumentiert und in dem Sinne abrufbar sind), sondern als Elemente, die in Prozessen des Denkens und Handelns in der Gegenwart direkter verwendbar sind. Gillicks Versuch, in diesen Arbeiten Architektur zu schaffen, ist keinesfalls eine leere oder leichtfertige Geste. Gleichwohl ist es wichtig zu erkennen, daß sie nicht den Wunsch signalisieren, Architekt zu sein oder in einer direkten Weise Architektur zu praktizieren. Sie sind vielmehr ein Beispiel dafür, was er eine „Ersatzbefriedigung" nennt, nämlich eine Art, parallel zu akzeptierten professionellen Verhaltensmustern – denen eines Architekten, Reporters, Designers und so weiter – zu arbeiten, die es erlauben, Fragen zu stellen, ohne dabei zu einer einheitlichen und definitiven Lösung kommen zu müssen. (1)

Anfang der 90er Jahre arbeitete Gillick mehrfach mit Henry Bond zusammen. Die beiden Künstler bezeichneten sich selbst als Reporterteam, in dem Bond die Fotos machte und Gillick den Text zu einer Serie von ihnen produzierter DOCUMENTS schrieb. In einer der nichtarchitektonischen Architektur der Architekturzeichnungen entsprechenden Weise war Bonds und Gillicks Position gegenüber der Presse nicht einfach. Sie bildeten aber kein wirkliches Reporterteam, denn ihre Bilder und Berichte waren nicht für die Zeitung gedacht und wurden auch nie in dieser Form publiziert. Nun sprachen sie allerdings auch nie davon, ein Reporterteam zu sein, noch agierten sie als solches, um nur einen direkten Kommentar zum Wesen des Nachrichtensammelns abzugeben oder zu der Tatsache, daß die Medien für unser Weltbild und unser Gefühl dafür, was darin wichtig ist, eine enorme Rolle spielen. Vielmehr ist dieser Kommentar Teil eines größeren Fragenkomplexes, der das Auffinden von Nachrichten mit den Orten verknüpft, an denen sie entdeckt, dokumentiert oder präsentiert werden. Alle diese sind eng mit dem Ort ihrer ursprünglichen Präsentation verbunden. Bond und Gillick agierten nicht so sehr als Nachrichtenjäger, vielmehr besorgten sie sich die Liste der vom Presseverband arrangierten Fototermine und Pressekonferenzen in der Stadt, in der sie gerade arbeiteten, und gingen dann dort hin. Bestimmte Dinge waren so bereits im vorhinein durch andere entschieden worden, nicht nur, was Story ist, sondern auch die Tatsache, daß ein spezielles Ereignis überhaupt für wert befunden wird, als Story behandelt zu werden. Was sie zu Beginn eines Tages sammelten, waren detaillierte Anweisungen, wohin sie sich zu begeben und was sie zu tun hatten, ein Blatt Papier, das sie darüber informierte, wie die jeweilige Stadt sich selbst in die größere Struktur von Wahrnehmungen, Haltungen und Phänomenen einordnete, die die Welt ausmachen. Solche Stories zum Beispiel durch das nüchterne Foto eines Konferenzraumes mit dem Auszug aus einem Statement oder einem Gespräch abzustecken, setzte erneut nicht nur die Fakten, sondern auch die Mechanismen, durch die diese Fakten aufgewertet worden waren, einer genaueren

133 Gillick's work in general, on the other hand, "produces a kind of half-object that can function quite well within my context as an object that has significance, but not because it has an 'auratic' value, seeks to project essentialist concepts or because of a neo-Duchampian application of meaning to temporarily art-like structures." (2)

Thinking about how things might proceed from here, thinking about the near future, is a consistent preoccupation. It concerns, in effect, the taking of decisions about "what is to be done." There may be an element of this that has to do with strategies, with mapping out a path through a sequence of imagined events and processes in order to arrive at a goal, but equally there is as much of it in the minutiae of life, in the pragmatics of daily existence. Gillick works in the middle ground. The middle marks the difference between extremes – of opinion, degree of organisation, value, and so on. It holds them apart, but also provides a bridge, offers the chance of a meeting of minds, a reconciliation or compromise. The present is a middle ground linking past and future: the near future is now, as it were. We are at the level of making a cup of tea as much as we are looking at the plotting of a revolution.

"Hanging around in the middle ground," Gillick said of Erasmus Darwin, the central character in the text ERASMUS IS LATE. (3) This Erasmus is not the one found in all the biographical dictionaries, the eighteenth century physician, poet, gardener and proselytiser on behalf of temperance. It is his grandson, the elder brother of Charles, who, although familiar with the investigative impulse behind the systematic examination of facts and ideas that would eventually lead his younger sibling to THE ORIGIN OF SPECIES, nevertheless chose to remain independent of its power, opting instead for the exploration of similar territory as an opium-taking free thinker. The text recounts the conversation and events at and around a dinner party being given by Erasmus for several other figures. Like him, they have been at the centre of certain events while not themselves being central to them: Murry Wilson and Elsie McLuhan, parents of the Beach Boys' Brian Wilson and the media commentator Marshall McLuhan respectively, Robert McNamara, Kennedy's Secretary of Defence, Masaru Ibuka, a co-founder of Sony, and Harriet Martineau, the nineteenth century pamphleteer. Central figures have, as Gillick remarks, often become central "due to compromise and an ability to communicate." The people around Darwin's table might not be so good at direct communication, but they exemplify what is frequently the case, namely, that such secondary characters "are often the ones who have the interesting ideas which are too difficult to get across effectively." (4) Geographically and temporally dispersed in their real lives, they meet here in Darwin's dining room for food and discussion. In UNDERSTANDING MEDIA, Marshall

Untersuchung aus. Der Raum, in dem diese genauere Untersuchung möglich wird, ist die Kunst. Wie die Presse funktioniert, ist dabei einer der von diesen Arbeiten untersuchten Umstände. Doch während die Documents einige formale Charakteristiken mit Dingen teilen, denen man auch anderswo begegnet, ist es ihre Unabhängigkeit von den Beschränkungen jenes anderen Kontextes – mit dem sie gleichzeitig verbunden bleiben –, die eine Reflexion darüber erlaubt, wie die Dinge zu dem geworden sind, was sie sind, und wie, als Konsequenz daraus, sie sich von hier aus entwickeln könnten. Diese Haltung unterscheidet sich deutlich von den weitverbreiteten Vorstellungen, wie die Kunst „wie" das richtige Leben sein könnte. Letztlich sind diese Vorstellungen auf Duchamps Geste, ein Readymade zum Kunstwerk zu erklären, zurückzuführen, eine Geste, die dem Betrachter die Entscheidung zubilligt, daß das, was er betrachtet oder in anderer Form erlebt, Kunst ist. Die in Gillicks ganzem Werk vertretenen „parallelen" Aktivitäten „produzieren eine Art Halbobjekt, das in meinem Kontext relativ gut als Objekt mit Bedeutung funktionieren kann, aber nicht, weil es einen ‚auratischen' Wert hätte oder essentialistische Konzepte zu projizieren suchte, oder wegen einer neo-duchampschen Anwendung von Bedeutung auf vorübergehend kunstähnliche Strukturen." (2)

Darüber nachzudenken, wie Dinge von hier aus weitergehen könnten, also über die nahe Zukunft, ist etwas, womit Gillick sich ständig beschäftigt. Das betrifft im Endeffekt die Entscheidungen darüber, „was zu tun ist". Es mag dabei ein Element geben, das mit Strategien zu tun hat, mit der Festlegung eines Pfades durch eine Folge vorgestellter Ereignisse und Prozesse, um zu einem Ziel zu kommen, das im gleichen Maße in den Kleinigkeiten des Lebens, den pragmatischen Dingen der täglichen Existenz vorkommt. Gillick arbeitet auf einer mittleren Ebene. Diese Mitte markiert den Unterschied zwischen Extremen – der Meinung, des Organisationsgrads, des Werts und so weiter. Sie hält sie auseinander, bildet aber auch eine Brücke, bietet die Chance zu einer Begegnung der Geister, einer Aussöhnung oder einem Kompromiß. Die Gegenwart ist eine mittlere Ebene, die Vergangenheit und Zukunft miteinander verbindet: die nahe Zukunft ist sozusagen jetzt. Wir befinden uns also genauso auf der Ebene des Teekochens wie auf der, einer Verschwörung zu einer Revolution zuzusehen.

„Er hängt im Mittelgrund herum", sagt Gillick über Erasmus Darwin, die zentrale Figur in seinem Text ERASMUS IS LATE. (3) Dieser Erasmus ist nicht der, den man in allen biographischen Lexika findet, also jener Arzt, Dichter, Gärtner und Verfechter des Maßhaltens aus dem 18. Jahrhundert. Er ist vielmehr dessen Enkel, der ältere Bruder von Charles, der, obgleich vertraut mit dem investigativen Impuls hinter der Untersuchung von Fakten und Ideen, welcher seinen jüngeren Bruder zur ENTSTEHUNG DER ARTEN führte,

134　　McLuhan mentions A. N. Whitehead's suggestion that the great discovery of the nineteenth century was the discovery of the technique of discovery. This he places in contrast to Bertrand Russell's view that the great discovery of the twentieth century was the technique of the suspended judgement. (5) The earlier model sees the identification of the thing to be discovered, from which a reverse process traces back through the steps of production until the point is reached from where it would be necessary to begin in order to construct the thing to be discovered. This would work just as well in the case of art – a poem intended to embody a particular idea or emotion, for example – as in the field of science with its devising of experiments to test hypotheses. Suspended judgement, on the other hand, involves the identification of possible future situations that can be avoided by present action. Erasmus Darwin, as characterised in Gillick's text, uses the second of these techniques as a means to examine the methodology and logic of the first. It is a process that self-evidently involves playing with and across time. While his dinner guests talk and wait for him to arrive, their host is, in fact, wandering around central London and visiting the clubs, wine bars, artists' projects, computer and hi-fi shops and the subways of the contemporary city. In spite of his physical absence, Darwin is able to communicate with the others in his opium-induced state. Written in 1995, the narrative moves with fluidity between 1810 and 1997, often seeming to enfold all three dates at once. The significance of 1810 is that it precedes the development of the current Western economic system. It marks, for Gillick, the last moment before the mob transformed itself into the masses, before labour organised itself, thereby becoming one term in the dialectical process of capitalist progress: "The key to everything is an understanding that a desire to predict the future is central to the development of a particular form of free-marketeering. A focus for progress. But a process that can happen in reverse, become mythologised or even forgotten." (6) Assembled in an upstairs room of the house in Great Marlborough Street these characters set about reversing the process, dismantling the certainties of an accepted capitalist reality in an effort to provide an alternative reading of that pre-Marxist period to the largely nostalgic one that prevails today, and which offers little in the way of a useful model.

ERASMUS IS LATE is the second of three major texts written during the 1990s. The first was McNamara, a film script whose narrative centres on the activities of Kennedy's Secretary of Defence in and around Washington in the early 1960s. Much of the action takes place in the system of tunnels running under the White House: "If you want to fight, go underground." (7) Real figures, including McNamara, Herman Kahn, Director of the RAND Institute and the economist J.K. Galbraith, become the characters in a fictionalised account of events that could only be imagined, constructed

dennoch beschloß, von der Kraft dieses Impulses unabhängig zu bleiben und sich statt dessen entschied, als opiumrauchender Freidenker ein ähnliches Gebiet zu erforschen. Der Text berichtet von den Gesprächen und Ereignissen während und im Umfeld eines Abendessens, das Erasmus für verschiedene Personen gibt. Wie er standen sie im Zentrum bestimmter Ereignisse, ohne selbst darin eine zentrale Rolle zu spielen: Murry Wilson und Elsie McLuhan, er Vater des Beach Boys Brian Wilson, sie Mutter des Medienkritikers Marshall McLuhan, Robert McNamara, Kennedys Verteidigungsminister, Masanu Ibuka, Mitbegründer von Sony, und Harriet Martineau, Verfasserin von Flugblättern im 19. Jahrhundert. Zentrale Figuren sind, wie Gillick bemerkt, häufig dazu geworden „aufgrund von Kompromissen und einer Fähigkeit zur Kommunikation" zu solchen geworden. Die Menschen an Darwins Tisch mögen in der direkten Kommunikation nicht so gut gewesen sein, aber sie sind Beispiel für das, was häufig der Fall ist, daß nämlich sekundäre Figuren „oft diejenigen sind, die die interessanten Ideen haben, diese aber zu schwierig wirkungsvoll rüberzubringen sind". (4) Die in ihrem wirklichen Leben geographisch und zeitlich weit voneinander entfernten Personen treffen sich hier in Darwins Eßzimmer zum Essen und um zu diskutieren. In UNDERSTANDING MEDIA erwähnt Marshall McLuhan A.M. Whiteheads Standpunkt, die größte Entdeckung des 19. Jahrhunderts sei die Entdeckung der Technik des Entdeckens gewesen. Er stellt dem Bertrand Russels Ansicht gegenüber, daß die größte Entdeckung des 20. Jahrhunderts die Technik des aufgeschobenen Urteils gewesen sei. (5) Das erstere Modell betrachtet die Identifizierung des Dings als das zu Entdeckende, von der aus ein umgekehrter Prozeß durch die Produktionsschritte zurückführt, bis der Punkt erreicht ist, von dem aus zu beginnen es nötig wäre, um das zu entdeckende Ding zu konstruieren. Das würde genauso gut im Falle von Kunst funktionieren – zum Beispiel bei einem Gedicht, das eine bestimmte Idee oder Emotion umschreiben soll – wie im Bereich der Wissenschaft, die sich Experimente ausdenkt, um Hypothesen zu testen. Das aufgeschobene Urteil hingegen bezieht die Identifizierung möglicher zukünftiger Situationen mit ein, die durch gegenwärtiges Handeln vermieden werden können. Erasmus Darwin, so wie Gillick ihn in seinem Text darstellt, benutzt die zweite dieser Techniken, um die Methodologie und Logik der ersten zu untersuchen, ein Prozeß, der selbstverständlich ein Spiel mit der Zeit einschließt. Während seine Gäste sich unterhalten und auf ihn warten, wandert er tatsächlich durch die Innenstadt Londons, besucht die Clubs, Vinotheken, Künstlerprojekte, Computer- und Hifi-Läden und die U-Bahn der heutigen Stadt. Trotz seiner körperlichen Abwesenheit ist Darwin in der Lage, in seinem vom Opium verursachten Zustand mit den anderen zu kommunizieren. Diese 1995 geschriebene Erzählung bewegt sich fließend zwischen 1810 und 1997 hin und her, wobei

and interpreted as they are with the benefit of hindsight. As is the way with such things, the script went through several revisions, during the course of which process a number of related or parallel works were produced: a poster, headed notepaper designed for several of the film's characters, a soundtrack, possible costume items, a table that could be a prop or that could equally well furnish the opportunity to sit around and discuss the state of the script, and so on. In 1994, Gillick employed an animation house to turn the opening scene of the script's fifth draft into a cartoon film. When exhibited, it is shown on a Brionvega Algol TVC 11R television, the set designed by Marco Zanuso and Richard Sapper in 1963/4, the time at which the film takes place. Furthermore, at the time the film was made, the designers were considering relaunching the model using the same casing but with new internal workings. The historical characteristics of the object used as a means of display, therefore, correspond to the nature of the film's story, a story that narrates events of the early 1960s from the perspective of the mid-1990s with all the benefits of hindsight that such a time span accrues. But there is more than mere formal mirroring in play here. The Brionvega, and the Knoll table on which it invariably sits, carry the discourse of design into the space of the work. This is not design as opposed to art, not a matter of having to choose either function or aesthetics, but a further level at which the task of decoding and recoding can operate: "Things I picked up from working a lot with people like Philippe Parreno or Dominique Gonzalez-Foerster shocked me first when I came across their work. They were prepared to embrace certain issues that were still seen as binary problems, like the issue of design, or the question of the 'look' and its decoding, and how to play with such ideas." (8) As well as Parreno and Gonzalez-Foerster, this aspect of Gillick's work suggests a shared area of interest (if not exactly a similarity of approach or sensibility) with others including Jorge Pardo, Angela Bulloch, Tobias Rehberger, Carsten Höller and Dan Peterman.

McNAMARA and ERASMUS IS LATE acted as a "condensed core of ideas" out of which a large number of works were developed. Masaru Ibuka, in fact, was the stimulus for a whole group of "Ibuka! Realisations". These environments and two and three-dimensional pieces circled around a separate book, Ibuka!, that formed the basis for a projected musical. As usual, what is "realised" in these works is not the project itself. Nothing is completed or brought to a conclusion, because the action never moves unequivocally into the realm of the musical. An announcement is made, a backdrop designed and stages built, but these things hover between their theatrical role and a situation prior to, or outside that, in which they are able to generate an environment where the staging of the musical could be discussed. So, the backdrop is also a promotional banner, the stages

sie häufig alle drei Zeitpunkte auf einmal zu umfassen scheint. Das Bedeutende an 1810 ist, daß dieses Jahr der Entwicklung des aktuellen westlichen Wirtschaftssystems vorausgeht. Für Gillick ist dies der letzte Moment, bevor der Mob zur Masse, bevor die Arbeit sich organisierte und so zu einem der Begriffe des dialektischen Prozesses des kapitalistischen Fortschritts wurde: „Der Schlüssel zu allem ist, zu verstehen, daß der Wunsch, die Zukunft vorauszusagen, für die Entwicklung einer speziellen Form des freien Handels von zentraler Bedeutung ist. Ein Zentrum für den Fortschritt. Aber ein Prozeß, der auch umgekehrt stattfinden, mythologisiert oder sogar vergessen werden kann." (6) Die in einem Raum im Obergeschoß des Hauses in der Great Marlborough Street versammelten Figuren machen sich daran, den Prozeß umzukehren, die Sicherheit einer akzeptierten kapitalistischen Realität zu demontieren, im Bemühen, eine Interpretation jener vormarxistischen Phase zu liefern, die zur heute vorherrschenden, weitgehend nostalgischen und im Hinblick auf ein nützliches Modell nur wenig anbietenden Lesart eine Alternative darstellen könnte.

ERASMUS IS LATE ist der zweite von drei großen Texten, die Gillick in den 90er Jahren geschrieben hat. Der erste war McNAMARA, ein Filmdrehbuch, dessen Erzählung um Kennedys Verteidigungsminister und seine Aktivitäten in und um Washington in den frühen 60er Jahren kreist. Ein großer Teil der Handlung spielt im Tunnelsystem unter dem Weißen Haus: „Wenn Du kämpfen willst, geh in den Untergrund." (7) Reale Personen, darunter McNamara, Herman Kahn, Direktor des RAND-Instituts, und der Wirtschaftswissenschaftler J.K. Galbraith, werden zu Figuren in einem romanhaft gestalteten Bericht über Ereignisse, die erst aus heutiger Sicht, also im Rückblick, ausgedacht, konstruiert und interpretiert werden können. Wie bei solchen Dingen häufig der Fall, wurde das Drehbuch mehrfach überarbeitet, und während dieses Prozesses entstanden eine Reihe von damit verbundenen oder parallelen Arbeiten: ein Plakat, persönliches Briefpapier für mehrere der Filmfiguren, ein Soundtrack, mögliche Kostümteile, ein Tisch, der als Requisit, aber genauso dazu dienen konnte, sich daran zu setzen und den Stand des Drehbuchs zu diskutieren, und so weiter. 1994 beauftragte Gillick eine Animationsfirma damit, die Eröffnungsszene der fünften Fassung des Drehbuchs in einen Zeichentrickfilm umzusetzen. Als er diesen Film im Rahmen einer Ausstellung präsentierte, wurde dieser auf einem Brionvega Algol TVC 11R-Fernseher gezeigt, jenem Gerät, das Marco Zanuso und Richard Sapper 1963/64 entworfen hatten, also in dem Jahr, in dem dieser Film spielt. Darüber hinaus dachten die beiden Designer zu jener Zeit, als dieser Film gemacht wurde, gerade darüber nach, das Gerätemodell neu herauszubringen, mit demselben Gehäuse, jedoch mit einem neuen Innenleben. Die historischen, charakteristischen Merkmale des für die Vorführung benutzen Gegenstands

136 are also coffee tables: "There is no 'The' idea, there are maybe 20,000 ideas flickering between the illusion of the present and the illusion of the past." The third text, BIG CONFERENCE CENTRE, differed from the first two in that it came after the gallery works and installations associated with it rather than before. After McNAMARA and ERASMUS IS LATE, "it seemed perverse not to try to deal also with the illusion of the future." (9) This was done from the mid-1990s onwards through the creation of a series of "What If? Scenarios" involving, among other things, a variety of Think Tanks, Wall Panels, Curtains, Platforms and Screens – prototypical designs setting out a context for activity on a proposed "Discussion Island": "The 'Discussion Island' articulates the blurred relationship between people and effects in order to consolidate a concept of the future within a post-utopian context." (10)

The screens and platforms continue Gillick's relationship with the discourse of architecture, confirming that it is not so much architecture itself, as it is the larger notion of the constructed world that interests him. They are structurally simple – rectangular aluminium frames with internal subdivisions, some of which hold sheets of Plexiglas. The colours that are used in any instance are dependent upon the range that happens to be available from local suppliers. Like the majority of his work, each structure is therefore specific to its site, although Gillick stresses that this does not mean that the work is "site specific" in the sense used by some of those engaged in producing Public Art. Unlike site specific work, which looks to its location for legitimation as a work of art, and which therefore loses its meaning if it is moved, Gillick's screens and platforms can be installed in any number of places since it is the relationship between the site and the space posited by the work that is the crucial factor. The platforms always extend out from a wall. That is, they abut the existing structure and thus have an anchor in the realm of facts. Whatever may happen on one or other side of them, take place underneath them, or through them, can thus only occur as part of a dialogue with what is given. The generic form of these screens and platforms and the materials from which they are made unavoidably recalls certain other art, particularly the Minimalism of Donald Judd. To bracket Gillick with that work, though, would be to presume that it is in their material – the aluminium and the Plexiglas – that their chief importance lies. It is, on the contrary, their "functional potential" that needs to be highlighted. At DOCUMENTA X, for example, Gillick exhibited two DISCUSSION ISLAND works, a DEVELOPMENT SCREEN and a RESIGNATION PLATFORM, siting them in space that largely served as a corridor between two other galleries, or, "between one set of thinking and another set of thinking." (11) Taken on their own it might have been possible to concentrate on their physical and formal qualities in relation to the MINUS OBJECTS of

entsprechen also der Story des Films, Ereignissen aus den frühen 60er Jahren, und zwar aus der Perspektive der 90er Jahre mit all den Vorteilen des Rückblicks, die sich aus einer solchen Zeitspanne ergeben. Doch bietet die Geschichte mehr als nur eine formale Widerspiegelung im Spiel. Der Brionvega und der Knoll-Tisch, auf dem dieser ausnahmslos steht, tragen den Design-Diskurs in den Raum der Arbeit hinein. Hier geht es nicht um Design im Gegensatz zur Kunst, nicht um eine Frage der Entscheidung zwischen Funktion und Ästhetik, sondern um eine zusätzliche Ebene, auf der die Aufgabe des Dekodierens und Neukodierens durchgeführt werden kann: „Dinge, die ich mir dadurch aneignete, daß ich viel mit Leuten wie Philippe Parreno oder Dominique Gonzalez-Foerster zusammenarbeitete, schockierten mich zunächst, wenn ich auf ihre Arbeiten stieß. Sie waren darauf vorbereitet, bestimmte Fragestellungen aufzugreifen, die immer noch als binäre Probleme betrachtet wurden, wie Fragen des Designs oder die Frage des ‚Looks' und seiner Dekodierung und wie man mit solchen Ideen spielt." (8) Genau wie im Fall von Parreno und Gonzalez-Foerster deutet dieser Aspekt in Gillicks Arbeit auch ein mit Jorge Pardo, Angela Bulloch, Tobias Rehberger, Carsten Höller, Dan Peterman und anderen geteiltes Interessengebiet an (wenn schon keine Übereinstimmung in der Herangehensweise oder der Sensibilität).

MCNAMARA und ERASMUS IS LATE fungierten als „verdichteter Kern von Ideen", aus dem heraus sich eine große Anzahl von Arbeiten entwickelten. Masaru Ibuka zum Beispiel war Auslöser für eine ganze Gruppe von „Ibuka!-Realisationen". Diese Environments und zwei- wie dreidimensionalen Arbeiten kreisten um ein separates Buch mit dem Titel IBUKA!, das die Grundlage für ein Musical-Projekt bildete. Wie üblich ist das, was in diesen Arbeiten „realisiert" wird, nicht das Projekt selbst. Nichts wird vollendet oder zum Abschluß gebracht, denn die Handlung bewegt sich nie eindeutig in das Reich des Musicals hinein. Es gibt eine Ankündigung, ein Bühnenhintergrund wird entworfen, Bühnen werden gebaut, aber all diese Dinge schweben zwischen ihrer Rolle für das Theater und einer Situation, die vor oder außerhalb derjenigen liegt, in der sie in der Lage wären, eine Umgebung hervorzubringen, in der die Inszenierung des Musicals diskutiert werden könnte. So wird der Hintergrund gleichzeitig zum Werbebanner, und die Bühnen werden zu Couchtischen: „Es gibt nicht ‚die' Idee, es gibt vielleicht 20.000 Ideen, die zwischen der Illusion der Gegenwart und der Illusion der Vergangenheit hin und her zucken." Der dritte Text, BIG CONFERENCE CENTRE, unterscheidet sich von den ersten beiden dadurch, daß er erst nach den mit ihm verknüpften ausgestellten Arbeiten und Installationen entstand. Nach MCNAMARA und ERASMUS IS LATE „schien es abwegig, nicht zu versuchen, sich auch mit der Illusion der Zukunft zu beschäftigen". (9)

Michelangelo Pistoletto in the adjacent room. In addition, however, Gillick had introduced two further works to the exhibition. Above a building close to the administration's offices he altered a digital clock which, in reference to ERASMUS IS LATE, flipped between the time in 1997 and the time in 1810. At the same time Gillick introduced some extra, anachronistic material into the documenta archive to be discovered by future researchers into the history of the exhibition. Throwing time out of joint in this way makes it much more difficult to see the screens and platforms as just one more set of objects in a line of objects stretching back through Judd, Barnett Newman, Piet Mondrian and beyond. They are by way of allowing and encouraging work, not absorbing admiring thoughts. Another element in some of the "What If? Scenarios" is glitter. For the exhibition, KAMIKAZE, Berlin, in 1998, one of Gillick's instructions was to wash the floor with water into which glitter had been sprinkled. The resulting spread of gold specks throughout the space is pervasive evidence of its being a place in which worthwhile work gets done. Gillick is well aware of, and eager to exploit the critical potential of minimalism and conceptualism, but it is a matter of reframing, not of influence. The need to select and reinterpret rather than to pay homage is recognition of Adorno's conundrum that: "Art wills what has never existed so far, but at the same time all art is one big déja vu, for the shadow of the past looms over everything." (12) The rigour of the screens together with the smear of the glitter rub up against and disturb previous "pairings" and the historical argument that leads us to see them in that way: the order of Carl Andre's EQUIVALENTS and the chaos of his scatter pieces, for example, or the simplicity of Robert Morris' GESTALT FORMS juxtaposed with the anti-form felt works. Judd's own contention that interest rather than quality was the primary yardstick in making judgements about art was itself an attempt to disengage his practice from the dictates of a European philosophical tradition that underpinned those art historical accounts which, like modern political, economic, biological and other discourses, were built around the idea of progress. (13) Practices based upon conversational exchange, such as that of Art & Language, also bear an affinity to Gillick's project, particularly insofar as Art & Language strenuously resisted efforts by the institutionalised museum and art market system to rationalise their ideas and to assimilate the group.

"The work we [Art & Language] were doing [in the 1960s] and would do refused this opportunity not in favour of alienated marginality but in favour of another place of production outside of the new management's distributive demands. The place was not to be a 'space' but a discursive circumstance. I say we didn't want alienated marginality but there is in Conceptual Art a kind of Marshall Plan European character, a kind of parodistic manifestation of the meanings of the dominated, the refusal of the opportunities of Cold

Das geschah seit Mitte der 90er Jahre durch die Entwicklung einer Reihe von WHAT IF? SCENARIOS, zu denen unter anderem eine Vielzahl von „Think Tanks" zählten. Wandtafeln, Vorhänge, Plattformen und Trennwände – Prototypen von Entwürfen als Rahmen für eine Handlung auf einer „Discussion Island": „Die ‚Discussion Islands' formulieren die unklare Beziehung zwischen Menschen und Effekten, um ein Zukunftskonzept innerhalb eines postutopischen Kontextes zu konsolidieren." (10)

Die Trennwände und Plattformen setzen Gillicks Beziehung zum Architekturdiskurs fort, indem sie bestätigen, daß sein Interesse nicht so sehr der Architektur selbst, als vielmehr der umfassenderen Idee von der konstruierten Welt gilt. Ihre Konstruktion ist einfach: rechteckige Aluminiumrahmen mit Innenaufteilung, bei denen einige Fächer mit Plexiglasscheiben gefüllt sind. Die verwendeten Farben hängen von dem ab, was der jeweilige örtliche Handel anbietet. So ist jede Konstruktion, wie der Großteil von Gillicks Arbeiten, standortspezifisch, wobei Gillick betont, daß damit nicht „standortspezifisch" in dem Sinne gemeint ist, wie einige Produzenten von Kunst im öffentlischen Raum diesen Begriff verwenden. Im Gegensatz zu standortspezifischen Arbeiten, die auf ihren Standort zählen, um sich als Kunstwerk zu legitimieren, und so ihre Bedeutung verlieren, wenn sie nicht dort plaziert werden, können Gillicks Trennwände und Plattformen an jedem beliebigen Ort aufgestellt werden, denn bei ihnen ist der entscheidende Faktor die von der Arbeit postulierte Beziehung zwischen Standort und Raum. Die Plattformen erstrecken sich immer von einer der Wände aus. Das heißt, sie stoßen an die bestehende Konstruktion an und sind so im Reich der Fakten verankert. Was immer auf der einen oder anderen Seite von ihnen, unter ihnen oder durch sie hindurch geschehen oder stattfinden mag, kann somit nur als Teil eines Dialogs mit den Gegebenheiten gelten. Die allgemein übliche Form dieser Trennwände und Plattformen und die Materialien, aus denen sie bestehen, lassen unweigerlich an andere Kunstwerke denken, vor allem an die minimalistischen Arbeiten Donald Judds. Gillick mit dessen Werk in Verbindung zu bringen, würde allerdings bedeuten, anzunehmen, daß seine Hauptbedeutung im Material – nämlich dem Aluminium und Plexiglas – liegt. Es ist jedoch im Gegenteil ihr „funktionales Potential", das beleuchtet werden muß. Auf der DOCUMENTA X stellte Gillick zum Beispiel zwei DISCUSSION ISLAND-Arbeiten, einen DEVELOPMENT SCREEN und eine RESIGNATION PLATFORM aus und plazierte sie in einem Raum, der in erster Linie als Korridor zwischen zwei anderen Ausstellungsräumen oder „zwischen einer Denkrichtung und einer anderen Denkrichtung" (11) diente. Für sich allein genommen hätten sie vielleicht dazu führen können, daß man sich lediglich auf ihre physikalischen und formalen Eigenschaften in bezug auf Michelangelo Pistolettos MINUS OBJECTS im angrenzenden

War 'spaces'. It wasn't a more extreme stance, it was playing it again before the abyss. Post-minimalism, on the other hand, took the Cold War opportunities: why bother with sweaty, dusty old art when you can just design an exhibition, stuff a gallery, be your own curator. The producer was transformed into the curator and this work is still prevalent and fuelled by a small calculation: the wilder and wackier the work the more it needs the institution." (14)

For many artists of the 1960s and 70s, the investigation of the question, "What is art?", necessitated the adoption of a distinct stance in opposition to orthodox views. However it may have been the case that such stances themselves quickly became the academic orthodoxy, they were, in their original intent, nevertheless adopted over against the prevailing centre. In prefiguring his putative DISCUSSION ISLAND, Gillick's structures engage the viewer in reflection on the nature and possible forms of dialogue. They are, in other words, concerned with activity which takes place on that same middle ground over which Erasmus wanders in his opium haze. Occupation of the middle ground has little to do with extreme, oppositional stances, and much more to do with accommodating others and making allowances. The titles of the various gallery structures associated with the WHAT IF? SCENARIO and the chapter headings of BIG CONFERENCE CENTRE tell the same story: conciliation, compromise, negotiation, delay, consensus, revision, concentration, dialogue, assessment. By staying in the middle, in between everything else, there remains the possibility that things can be caught before they become "fixed within a politicised discourse." (15) It is here in the activity of discussion rather than as a consequence of an initial rejection of hitherto accepted arguments that the value and usefulness of ideas can be called into question and rendered unstable. Noticing the walls of a room early on in BIG CONFERENCE CENTRE, for instance, requires a comment and leads to the decision to call them "Coca-Cola coloured". (16) What descriptive language is being used when one's surroundings are classified according to the colour of a soft drink? What corporate landscape is being inhabited, what spoken about life style and expectations, what said about the history of art, of design, of interior decoration, what understood about globalisation and shared experience? Thought flips from paranoia in the face of ungraspable macro-economic systems to comfort and familiarity in the company of the everyday and the trivial. A THINK TANK is constructed from three sheets of dark brown and one of cream Plexiglas: an independent forum for the exchange of ideas or a pint of Guinness down the pub. This is the sensuous moment, whose importance Adorno emphasises, because "while it is riveted to the transitory here and now, it also points to that status of independence that every particular work has… The utopia anticipated by artistic form

Raum konzentriert. Gillick hatte jedoch noch zwei weitere Arbeiten zur Ausstellung eingereicht. Über einem Gebäude in der Nähe der Verwaltungsbüros installierte er eine digitale Uhr, die, bezugnehmend auf ERASMUS IS LATE, zwischen 1997 und 1810 hin und her sprang. Gleichzeitig fügte er dem documenta-Archiv zusätzliches, anachronistisches Material hinzu, das von zukünftigen Forschern, die sich mit der Geschichte der Ausstellung beschäftigen, entdeckt werden soll. Wenn die Zeit so aus ihren Angeln gehoben wird, fällt es sehr viel schwerer, die Trennwände und Plattformen lediglich als weitere Objektgruppe auf der von Judd und Barnett Newman über Piet Mondrian und einer noch weiter zurückreichenden Linie von Objekten zu sehen. Es sind Arbeiten, die Möglichkeiten bieten und ermutigen, sie absorbieren nicht bewundernde Gedanken. Ein anderes Element in einigen der „What if? Scenarios" sind Glitzerpartikel. Eine von Gillicks Anweisungen für die Ausstellung KAMIKAZE, Berlin, von 1998 lautete, den Boden mit Wasser zu wischen, in das Glitzerpartikel gestreut waren. Das Ergebnis, ein von Wand zu Wand goldgesprenkelter Boden, ist eindringlicher Beweis dafür, daß es sich hier um einen Raum handelt, in dem lohnende Arbeit geleistet wird. Gillick ist sich des „kritischen Potentials von Minimalismus und Konzeptualismus" bewußt und begierig, es zu nutzen, „aber das ist eine Frage der Neuformulierung, nicht des Einflusses. Das Bedürfnis, nicht so sehr Respekt zu erweisen, als vielmehr auszuwählen und neu zu interpretieren, ist Anerkennung des Rätsels Adornos: ‚Kunst will das, was noch nicht war, doch alles, was sie ist, war schon. Den Schatten des Gewesenen vermag sie nicht zu überspringen.'" (12) Die Strenge der Trennwände in Kombination mit dem Glitzerfilm reibt sich an früheren „Paarungen" und stört sie wie auch das historische Argument, das uns dazu bringt, sie so zu sehen: die Ordnung von Carl Andres EQUIVALENTS und das Chaos seiner „Streuungen" zum Beispiel, oder die Schlichtheit der GESTALTFORMEN von Robert Morris im Gegensatz zu den Antiform-Filzarbeiten. Judds eigenes Argument, daß die Meßlatte bei der Beurteilung von Kunst vor allem das von ihr ausgelöste Interesse, und weniger Qualität sei, war ein Versuch, seine eigene Arbeit vom Diktat einer europäischen philosophischen Tradition abzusetzen, die jene kunsthistorischen Darstellungen untermauerte, die wie die modernen Diskurse über Politik, Wirtschaft, Biologie und andere Bereiche um die Idee des Fortschritts herum aufgebaut waren. (13) Auch auf Gesprächsaustausch basierende Praktiken, wie die von Art & Language, haben eine Affinität zu Gillicks Arbeit, vor allem insofern als Art & Language hartnäckig den Bemühungen der institutionalisierten Museen und des Kunstmarksystems widerstand, ihre Ideen zu rationalisieren und die Gruppe zu assimilieren.

„Die Arbeit, die wir (Art & Language) (in den 60er Jahren) machten und machen wollten, schlug diese Gelegenheit nicht zugunsten einer entfremdeten Marginalität, sondern

is the idea that things at long last ought to come into their own." (17)

Spaces, interventions into those spaces, objects placed and/or arranged in those spaces, activities, texts, sites for planned or imaginable events and occurrences – all of these together constitute a complex, a constellation of potentialities. Gillick uses the term "scenario" to describe this complex. The word holds within itself the idea of a scene with its attendant theatrical or filmic overtones, but while it is true that the placement of a screen or a false ceiling does define a certain area of floor or ground, distinguishing it from the surrounding space and designating it as a place on and in which something might happen, to insist on the notion of the stage or set would be to distance things too much from that other construct, "reality". One reference that is hard to escape altogether when identifying the way in which self-consciousness is engendered when encountering Gillick's disposition of screens, platforms, furniture and other objects, is the idea of theatricality invoked by Michael Fried in his 1967 essay, ART AND OBJECTHOOD. Fried's view in that essay is a critical one, but the characteristics of Minimal or, to use his term, Literal art he identifies, that it exists for a viewer rather than in a wholly self-contained manner for itself, and that in view of that existence for another, it is "empty", are substantial ones. The charge of emptiness denotes the absence of significant, enduring content irrespective either of the presence of a viewer or of any consideration of the context within which his or her viewing might be taking place. There is, therefore, an implication that something needs to take place in order for the work to be completed as a work of art. The viewer would necessarily become complicit in such a completion, being co-opted into the process of art making. Fried contends that: "Someone has merely to enter the room in which a literalist work has been placed to become that beholder, that audience of one – almost as though the work in question has been waiting for him, and inasmuch as literalist work depends on the beholder, is incomplete without him, it has been waiting for him." (18) Fried's argument is over the essential qualities of modernist art. Specific art forms – painting, music, sculpture and so on – defeat that all-embracing theatricality within which boundaries between such forms seem to be becoming increasingly vague and indistinct. The PROTOTYPE DESIGN FOR CONFERENCE ROOM (WITH JOKE BY MATTHEW MODINE) which made up one of the galleries in the exhibition, DAVID, at the Frankfurter Kunstverein in 1999 was not just an art work in embryo, needing speakers and an audience in order to fulfil its destination. There were objects placed around the floor, but these were not explicitly offered as seats to be occupied by members of the public. The fact that they were sat on, were identified as so many things that could be quite easily taken to be seats, was interesting, useful, gratifying, convenient and so on, but not

zugunsten eines anderen Produktionsortes außerhalb der Vertriebsanforderungen des neuen Managements aus. Der Ort sollte kein ‚Raum', sondern ein diskursiver Umstand sein. Ich sage, wir wollten keine entfremdete Marginalität, aber die Konzeptkunst hat ein bißchen den Charakter eines europäischen Marshall-Plans, einer parodistischen Manifestation der Bedeutungen des Dominierten, des Ausschlagens der Gelegenheiten der ‚Räume' des Kalten Krieges. Es war keine extremere Haltung, sie spielte sie wieder vor dem Abgrund. Der Postminimalismus andererseits ergriff die Gelegenheiten des Kalten Krieges: Warum sich mit verschwitzter, staubiger alter Kunst abplagen, wenn man einfach eine Ausstellung entwerfen, eine Galerie vollstopfen, sein eigener Ausstellungsmacher sein kann. Der Produzent verwandelte sich in den Ausstellungsmacher, und diese Arbeit ist immer noch weit verbreitet und wird von kleinlicher Berechnung angetrieben: Je wilder und verrückter die Arbeit, desto dringender braucht sie die Institution." (14)

Für viele Künstler der 60er und 70er Jahre machte die Untersuchung der Frage „Was ist Kunst?" eine deutlich oppositionelle Haltung gegenüber den orthodoxen Sichtweisen nötig. Was immer dazu geführt haben mag, daß diese Haltung selbst schnell zur akademischen Orthodoxie wurde, in ihrer ursprünglichen Absicht war sie immer gegen das vorherrschende Zentrum eingenommen worden. Als Vorwegnahme seiner vermeintlichen „Diskussionsinsel" veranlassen Gillicks Konstruktionen den Betrachter, über das Wesen und die möglichen Formen des Dialogs nachzudenken. Mit anderen Worten, sie sind mit den Aktivitäten beschäftigt, die auf derselben mittleren Ebene stattfinden, auf der Erasmus in seinem Opiumrausch wandert. Besetzung der mittleren Ebene hat wenig mit extremen, oppositionellen Haltungen zu tun, und sehr viel mehr damit, anderen entgegenzukommen und Zugeständnisse zu machen. Die Titel der verschiedenen mit den „What if? Scenarios" verknüpften Konstruktionen von Ausstellungsräumen und die Kapitelüberschriften in BIG CONFERENCE CENTRE erzählen die gleiche Geschichte: Besänftigung, Kompromiß, Verhandlung, Verzögerung, Konsens, Revision, Konzentration, Dialog, Festlegung. Indem man in der Mitte, zwischen allem anderen bleibt, bleibt auch die Möglichkeit bestehen, die Dinge einzufangen, bevor sie „innerhalb eines politischen Diskurses" (15) festgelegt werden. Hier in der eigentlichen Diskussion, und weniger als Folge einer anfänglichen Ablehnung bis dahin akzeptierter Argumente, können der Wert und die Nützlichkeit von Ideen in Frage gestellt werden. Die Wände eines Raums am Anfang von BIG CONFERENCE CENTRE zur Kenntnis zu nehmen macht einen Kommentar erforderlich und führt zu der Entscheidung, sie als „Coca-Cola-farben" (16) zu bezeichnen. Was für eine beschreibende Sprache benutzt man, wenn die eigene Umgebung nach der Farbe eines alkoholfreien Getränks klassifiziert wird? Welche

a requirement. Just as the specificity of Gillick's works moves the argument away from the "site specificity" of Public Art, PROTOTYPE DESIGN FOR A CONFERENCE ROOM cannot be understood as an installation in the commonly accepted sense of the term that derives from the theatrical condition analysed by Fried. Nor is it KONTEXT KUNST, art that makes particular reference to its conditions of production as a way, among other things, of avoiding charges of formalism. (19) Gillick thinks more in terms of "applied art", which is to say "thinking applied to a specific place or set of concepts," and not, to repeat, art as design, or design instead of art. (20)

DAVID was, if not precisely intended as a film set, at the very least conceived as something more than a collection of distinct and autonomous artworks. The name, which marks a departure from the manner in which Gillick had hitherto referred to social structures in the titling of works, is a reference to one of Stanley Kubrick's uncompleted projects, a plan to produce another science fiction film following 2001. Its theme, artificial intelligence, was to have been explored through the story of a couple who lose their daughter. The daughter's place in the family is taken by a boy robot until such time as medical science has advanced sufficiently to allow the cryogenically-preserved daughter to be revived. David, the robot, is then no longer needed and is sent away. Far in the future he is rediscovered and his brain content downloaded, leading him to relive his life and to attempt to return to his "parents". Kubrick and his work are implicated in the exhibition both through this allusion to the unfinished AI film, and in other ways. The joke attributed to Matthew Modine is written across two walls of the gallery installed as a PROTOTYPE DESIGN FOR CONFERENCE ROOM. It suggests that, in heaven as on earth, the infamously retiring Kubrick may remain unapproachable, but by way of recompense you might be lucky enough to bump into a megalomaniac God who just thinks he's Kubrick. There are, too, a series of photographs taken on the sixties housing estate in Thamesmead, south east London, that provided the location for A CLOCKWORK ORANGE, the film that is still unavailable in the UK having been withdrawn by Kubrick over fears that it would exert a negative influence on social behaviour. This does not, though, imply any specific interest on Gillick's part in making an exhibition that would provide a commentary on Kubrick's cinema. He is no more the frustrated film director than he is the architect manqué, the hopeful furniture designer or the would-be reporter. It is the broader underlying themes inherent in the material that are more important: memory and the family, the extent to which thinking about the future alters that future, the examination of whether certain situations can be revisited in order to provide the context for narratives of "social interaction and collapse" relevant to today. (21) That having been said, Gillick does acknowledge architecture and film as two areas

Firmenlandschaft wird bewohnt, was über Lebensstil und Erwartungen gesprochen, was über die Geschichte von Kunst, Design und Innenausstattung gesagt, was von Globalisierung und gemeinsamer Erfahrung verstanden? Der Gedanke fliegt von der Paranoia angesichts unbegreifbarer makroökonomischer Systeme zu Trost und Vertrautheit in der Umgebung des Alltäglichen und des Trivialen. Ein „Think Tank" hat drei Seiten aus dunkelbraunem und eine aus cremefarbenem Plexiglas: ein unabhängiges Forum für den Austausch von Ideen oder ein Glas Guinness in der Kneipe. Das ist das „unabdingbare sinnliche Moment an den Kunstwerken", dessen Bedeutung Adorno betont: „… es trägt ihr Jetzt und Hier, darin bewahrt trotz aller Vermittlung sich auch einige Selbständigkeit;… Utopie ist jedes Kunstwerk, soweit es durch seine Form antezipiert, was endlich es selber wäre …" (17)

Räume, Eingriffe in diese Räume, in diesen Räumen plazierte und/oder arrangierte Objekte, Aktivitäten, Texte, Plätze für geplante oder vorstellbare Ereignisse und Vorkommnisse – all das zusammen konstituiert einen Komplex, eine Konstellation von Möglichkeiten. Gillick verwendet den Begriff „Szenario", um diesen Komplex zu beschreiben. Das Wort beinhaltet die Idee einer Szene mit den damit verbundenen Assoziationen an Theater oder Film. Doch obwohl es zutrifft, daß das Aufstellen einer Trennwand oder das Anbringen einer falschen Decke in der Tat einen bestimmten Bereich eines Bodens definiert, ihn vom umgebenden Raum absetzt und ihn zu einem Ort erklärt, an dem etwas geschehen könnte, würde ein Insistieren auf dem Gedanken von Bühne oder Kulisse bedeuten, die Dinge zu weit von jenem anderen Konstrukt, nämlich der Realität, zu entfernen. Ein Bezug, dem man sich nur schwer völlig entziehen kann, wenn man erkennt, in welcher Art Selbstbewußtheit entsteht, wenn man auf Gillicks Anordnung von Trennwänden, Plattformen, Möbeln und anderen Objekten trifft, ist der von Michael Fried in seinem 1967 erschienenen Aufsatz ART AND OBJECTHOOD dargelegte Gedanke des Theatermäßigen. Fried vertritt in diesem Aufsatz einen kritischen Standpunkt, aber das charakteristische Merkmal der Minimal, oder, um seinen Begriff zu verwenden, der „literal", also nüchternen Kunst, daß sie nämlich für einen Betrachter existiert, und nicht in einer völlig sich selbst genügenden Art und Weise für sich selbst steht, und daß sie angesichts dieser Existenz für einen anderen „leer" ist, ist von substantieller Bedeutung. Der Vorwurf der Leere bezeichnet das Nichtvorhandensein eines signifikanten, andauernden Inhalts unabhängig von der Anwesenheit eines Betrachters oder irgendeiner Berücksichtigung des Kontextes, in dem das Betrachten stattfinden könnte. Das impliziert, daß etwas stattfinden muß, damit die Arbeit als Kunstwerk vollständig ist. Der Betrachter würde zwangsläufig zum Mitverantwortlichen an dieser Vervollständigung, zum Prozeß des Kunstschaffens hinzugezogen.

of particular interest to him: "Cinema and architecture are two problematic areas for me because artists use them a lot as models for something they have lost, or never had in the first place – firstly a large public, and secondly the creation of places for that mythical public to go to and use without even having to think much about it." (22) Elsewhere, in keeping with the tactic of "displacement activity" and the examination of secondary historical figures, he speaks of "distraction" as one of the keys that might assist in the understanding of his work. (23) Taken together these two points are reminiscent of Walter Benjamin's thesis that cinema and architecture are the two stereotypically modern art forms insofar as their reception is "consummated by a collectivity in a state of distraction." (24) The Thamesmead sequence of "location shots" shows the trees, grass and lakes of the original landscaped development remaining as a monument to the utopian social vision of the 1960s. Within this landscape the flats, houses and walkways structure an apparently almost unpopulated environment that, for all its tranquillity, cannot mask the collapse of that vision. A more extended sequence of images taken in this location exist as a two-projector slide sequence, PAIN IN A BUILDING. Thrown onto the same wall, the images overlap and interfere with each other, providing disjunctive rearrangements of the estate's features. The work's title echoes a phrase from the beginning of BIG CONFERENCE CENTRE where it explains the actions of a figure who hurls himself repeatedly at a 22nd floor plate glass window before crashing through and falling to his death on the roof of a car. The constructed world has its failures and breakdowns but will yet be something else again, if only to fail and break down once more. "Art's utopia," said Adorno, "the counterfactual yet-to-come, is draped in black. It goes on being a recollection of the possible with a critical edge against the real; it is a kind of imaginary restitution of that catastrophe which is world history; it is freedom which did not come to pass under the spell of necessity and which may well not come to pass ever at all." (25)

Michael Archer

(1) Grammel, Sören, Watching A Film That Is Not Taking Place, unpublished interview with Liam Gillick, 1999.
(2) Ibid.
(3) Gillick, Liam, McNamara Papers, Erasmus and Ibuka! Realisations, The What If? Scenarios, catalogue to an exhibition at Le Consortium, Dijon and Kunstverein, Hamburg, 1997, p. 112.
(4) Troncy, Eric, Were People This Dumb Before TV?, unpublished interview with Liam Gillick, 1997.
(5) McLuhan, Marshall, Understanding Media, Sphere, London, 1967, p. 73.
(6) Gillick, Liam, Erasmus Is Late, Book Works, London, 1995, p. 39.
(7) Erasmus Is Late, p. 46.
(8) Troncy.
(9) Ibid.
(10) McNamara Papers, p. 82.
(11) Grammel.

Fried behauptet: „Jemand muß den Raum, in dem sich eine literalistische Arbeit befindet, lediglich betreten, um dieser Beschauer, dieses aus einer Person bestehende Publikum zu werden – beinahe so, als habe die fragliche Arbeit auf ihn gewartet, und da literalistische Kunst vom Beschauer abhängig, ohne ihn unvollständig ist, hat sie auf ihn gewartet." (18) Frieds Argumentation geht über die wesentlichen Eigenschaften moderner Kunst hinaus. Spezielle Kunstformen – Malerei, Musik, Skulptur und so weiter – verweigern sich dieser alles umfassenden Theatermäßigkeit, innerhalb derer Grenzen zwischen solchen Formen zunehmend unbestimmter und undeutlicher werden. PROTOTYPE DESIGN FOR CONFERENCE ROOM (WITH JOKE BY MATTHEW MODINE), einer der Räume in der Ausstellung DAVID im Frankfurter Kunstverein 1999, war nicht nur ein Kunstwerk im Embryonalzustand, das Sprecher und ein Publikum brauchte, um sein Schicksal zu erfüllen. Auf dem ganzen Boden verteilt waren Objekte, die jedoch nicht ausdrücklich als Sitzgelegenheiten für Zuschauer angeboten wurden. Die Tatsache, daß auf ihnen gesessen wurde, daß sie, wie so viele Dinge, die man ganz leicht für Sitzgelegenheiten halten konnte, erkannt wurden, war interessant, nützlich, erfreulich, praktisch und so weiter, aber nicht notwendig. Genauso wie die Spezifizität von Gillicks Arbeiten die Argumentation von der „Standortspezifizität" von Kunst im öffentlichen Raum wegführt, ist PROTOTYPE DESIGN FOR CONFERENCE ROOM nicht als Installation in der gemeinhin akzeptierten Bedeutung dieses Begriffs zu verstehen, die sich von den von Fried analysierten Bedingungen des Theaters herleitet. Und es ist auch keine KONTEXT-KUNST, eine Kunst, die unter anderem besonders auf ihre Produktionsbedingungen verweist, um dem Vorwurf des Formalismus zu entgehen. (19) Gillick denkt mehr in Begriffen „angewandter Kunst", also „Denken angewandt auf einen speziellen Ort oder eine spezielle Gruppe von Konzepten", und nicht, um es noch einmal zu wiederholen, an Kunst als Design oder Design statt Kunst. (20)

DAVID war, wenn schon nicht direkt als Filmkulisse, so doch zumindest als etwas mehr denn eine Sammlung unterschiedlicher und autonomer Kunstwerke konzipiert. Der Name, der eine Abkehr Gillicks von seiner bis dahin üblichen Praxis, in den Titeln seiner Arbeiten auf soziale Strukturen zu verweisen, darstellt, bezieht sich auf ein unvollendetes Projekt von Stanley Kubrick, nämlich einen weiteren Science-Fiction-Film im Anschluß an 2001. Das Thema, künstliche Intelligenz, sollte anhand der Geschichte eines Paares, das seine Tochter verliert, untersucht werden. Den Platz der Tochter in der Familie nimmt ein Roboter in Gestalt eines Jungen ein, und zwar so lange, bis die medizinische Entwicklung so weit fortgeschritten ist, daß die kryogenisch konservierte Tochter wiederbelebt werden kann. David, der Roboter, wird nun nicht mehr gebraucht und weggeschickt. Sehr viel später wird er wiedergefunden

(12) Adorno, Theodor, Aesthetic Theory, RKP, London, 1984, p. 195.
(13) Judd, Donald, Specific Objects, Arts Yearbook 8, 1965, reprinted in Judd, Donald, Complete Writings 1959-1975, Nova Scotia & New York, 1975, p. 184: A work needs only to be interesting.
(14) Aliaga, Juan Vicente & Cortès, Josè (eds.), Arte Conceptual Revisado/Conceptual Art Revisited, Universidad Politecnica de Valencia, 1990, p. 177.
(15) Gillick, Liam, Big Conference Centre/Das Grosse Konferenzzentrum, Kunstverein, Ludwigsburg and Orchard Gallery, Derry, 1997, p. 66.
(16) Big Conference Centre, p. 6.
(17) Adorno, p. 195.
(18) Fried, Michael, Art and Objecthood, Artforum, June 1967, reprinted in Gregory Battcock (ed.), Minimal Art, Dutton, New York, 1968, p. 141.
(19) Gillick, Liam, Context Kunstlers, Art Monthly, 177, June 1994, pp. 10-12. The putative category Gillick discusses in this article is named after the exhibition, Kontext Kunst: The Art of the 90s, organised by Peter Weibel at the Künstlerhaus and Fabrik Lastenstrasse, Graz, 1993.
(20) Grammel.
(21) Ibid.
(22) Troncy.
(23) Grammel.
(24) Benjamin, Walter, The Work of Art in the Age of Mechanical Reproduction, section XV, Illuminations (ed. H. Arendt), Fontana, London, 1973, pp. 241-3.
(25) Adorno, p. 196.

und der Inhalt seines Gehirns überspielt, was dazu führt, daß er sein Leben noch einmal lebt und versucht, zu seinen „Eltern" zurückzukehren. Kubrick und sein Werk sind in dieser Ausstellung implizit enthalten, und zwar einmal aufgrund dieser Anspielung auf einen unvollendeten Film über künstliche Intelligenz, wie auch auf andere Weise. Der Matthew Modine zugeschriebene Witz ist auf zwei Wände des als PROTOTYPE DESIGN FOR CONFERENCE ROOM installierten Ausstellungsraums geschrieben. Er besagt, daß Kubrick, der sich auf infame Weise zurückgezogen hat, im Himmel wie auf der Erde vielleicht unerreichbar bleiben mag, daß man aber als Entschädigung vielleicht das Glück haben könnte, auf einen megalomanischen Gott zu treffen, der denkt, er sei Kubrick. Außerdem gibt es eine Reihe von Fotografien, aufgenommen in der in den 60er Jahren erbauten Wohnsiedlung in Thamesmead im Südosten Londons, in der A CLOCKWORK ORANGE gedreht wurde, jener Film, der in Großbritannien nach wie vor nicht erhältlich ist, weil Kubrick ihn aus Angst, er könne einen schlechten Einfluß auf das Sozialverhalten ausüben, zurückgezogen hatte. Das impliziert allerdings keinerlei spezielles Interesse Gillicks, eine Ausstellung zu machen, die einen Kommentar zu Kubricks Filmen abgibt. Er ist genauso wenig frustrierter Filmregisseur wie verkannter Architekt, hoffnungsvoller Möbeldesigner oder Pseudo-Reporter. Es sind die größeren, im Material enthaltenen zugrundeliegenden Themen, die wichtiger sind: Erinnerung und Familie, das Ausmaß, in dem ein Nachdenken über die Zukunft diese verändert, die Untersuchung, ob bestimmte Situationen noch einmal aufgesucht werden können, um den Rahmen für Erzählungen von „sozialer Interaktion und Zusammenbruch" zu liefern, die für uns heute relevant sind. (21) Da das gesagt ist, erkennt Gillick Architektur und Film als zwei Bereiche an, die für ihn von besonderem Interesse sind. „Kino und Architektur sind für mich zwei problematische Gebiete, weil Künstler sie häufig als Vorbild für etwas benutzen, das sie verloren haben oder nie hatten: Erstens ein großes Publikum, und zweitens das Schaffen von Orten, zu denen dieses mythische Publikum gehen und die es benutzen kann, ohne viel darüber nachdenken zu müssen." (22) An anderer Stelle spricht er, im Zusammenhang mit der Taktik der „Aktivität des Verschiebens" und der Untersuchung zweitrangiger historischer Figuren von „Ablenkung" als einem der Schlüssel, die zum Verständnis seiner Arbeit beitragen könnten. (23) Zusammengenommen erinnern diese beiden Punkte an Walter Benjamins These, daß Kino und Architektur insofern die beiden Stereotypen moderner Kunstformen seien, als ihre „Rezeption in der Zerstreuung und durch das Kollektivum erfolgt" (24). Die Thamesmead-Folge von „Drehort-Aufnahmen" zeigt die Bäume, das Gras und die Seen der ursprünglichen landschaftlichen Gestaltung als Monument der utopischen sozialen Vision der 60er Jahre. Innerhalb dieser Landschaft strukturieren die Wohnungen, Häuser und Gehwege eine augenscheinlich

nahezu unbewohnte Umgebung, die, bei all ihrer Ruhe, den Zusammenbruch dieser Vision nicht kaschieren kann. Eine umfangreichere Folge von Bildern von diesem Ort existiert als Diafolge für zwei Projektoren mit dem Titel PAIN IN A BUILDING. Die auf dieselbe Wand projizierten Bilder überlappen und verschwimmen ineinander und liefern so disjunktive Neuanordnungen der charakteristischen Merkmale der Siedlung. Der Titel der Arbeit wiederholt einen Satz vom Anfang des Textes BIG CONFERENCE CENTRE, der das Handeln eines Mannes erklärt, der sich im 22. Stock eines Gebäudes wiederholt gegen eine Fensterscheibe wirft, bis er diese durchbricht und auf dem Dach eines Autos zu Tode kommt. Die konstruierte Welt hat ihre Versager und Zusammenbrüche, und sie wird doch wieder etwas anderes werden, wenn auch nur, um erneut zu versagen und zusammenzubrechen. „Weil aber", sagt Adorno, „der Kunst ihre Utopie, das noch nicht Seiende, schwarz verhängt ist, bleibt sie durch all ihre Vermittlung hindurch Erinnerung, die an das Mögliche gegen das Wirkliche, das jenes verdrängte, etwas wie die imaginäre Wiedergutmachung der Katastrophe Weltgeschichte, Freiheit, die im Bann der Necessität nicht geworden, und von der ungewiß ist, ob sie wird." (25)

Michael Archer

(1) Vgl. Sören Grammel, Watching A Film That Is Not Taking Place, unveröffentlichtes Interview mit Liam Gillick, 1999.
(2) Ebda.
(3) Vgl. Liam Gillick, McNamara Papers, Ersamus and Ibuka! Realisations, The What If? Scenarios, Katalog zur Ausstellung in Le Consortium, Dijon und im Kunstverein Hamburg, 1997, S. 112.
(4) Vgl. Eric Troncy, Were People This Dumb Before TV?, unveröffentlichtes Interview mit Liam Gillick, 1997.
(5) Vgl. Marshall McLuhan, Understanding Media, Sphere, London 1967, S. 73.
(6) Vgl. Liam Gillick, Erasmus Is Late, Book Works, London 1995, S. 39.
(7) Ebda., S. 46.
(8) Vgl. Anm. 3.
(9) Ebda.
(10) Vgl. Anm. 2, McNamara Papers, S. 82.
(11) Vgl. Anm. 1.
(12) Theodor W. Adorno, Ästhetische Theorie, Gesammelte Schriften, Bd. 7, Frankfurt am Main 1970, S. 203.
(13) Vgl. Donald Judd, Specific Objects, in: Arts Yearbook 8, 1965, wiederabgedruckt in Donald Judd, Complete Writings 1959–1975, Nova Scotia & New York 1975, S. 184: A work needs only to be interesting.
(14) Vgl. Juan Vicente Allaga/José Cortés (Hrsg.), Arte Conceptual Revisado/ Conceptual Art Revisited, Valencia 1990, S. 177.
(15) Liam Gillick, Big Conference Centre/Das Große Konferenzzentrum, Kunstverein Ludwigsburg und Orchard Gallery, Derry 1997, S. 66/176.
(16) Ebda., S. 98.
(17) Vgl. Anm. 11, S. 203.
(18) Vgl. Michael Fried, Art and Objecthood, in: Artforum, Juni 1967, wiederabgedruckt in Gregory Battock (Hrsg.), Minimal Art, New York 1968, S. 141.
(19) Vgl. Liam Gillick, Context Kunstlers, in: Art Monthly, 177, Juni 1994, S. 10-12. Die von Gillick in diesem Artikel erörterte vermeintliche Kategorie wurde nach der von Peter Weibel im Künstlerhaus und Fabrik Lastenstraße, Graz, 1993 organisierten Ausstellung Kontext Kunst: The Art of the 90s' benannt.
(20) Vgl. Anm. 1.
(21) Ebda.
(22) Vgl. Anm. 3.
(23) Vgl. Anm. 1.
(24) Walter Benjamin, Das Kunstwerk im Zeitalter seiner technischen Reproduzierbarkeit, ausgewählte Schriften 1, Suhrkamp, Frankfurt am Main 1977, S. 166.
(25) Vgl. Anm. 11, S. 204.

DIAGRAM FOR A PLATFORM
1999

WINDOW DESIGNS
1998
Prague

BIG CONFERENCE CENTRE
DAS GROSSE KONFERENZZENTRUM

LIAM GILLICK

UP ON THE TWENTY SECOND FLOOR
LIAM GILLICK
chez Air de Paris
du 25 avril 1998 au 20 mai 1998

32 rue Louise Weiss • 75013 • Paris • France
Tél +33 01 44 23 02 77 • Fax +33 01 53 61 22 84

INVITATION CARD
1998
Air de Paris

BOOK COVER
1997
(Sarah Morris)

Wieder ein
wunderschöner
Tag in der City.

DESIGN FOR A SHOPPING BAG
1999

DIAGRAM FOR A SCREEN
1999

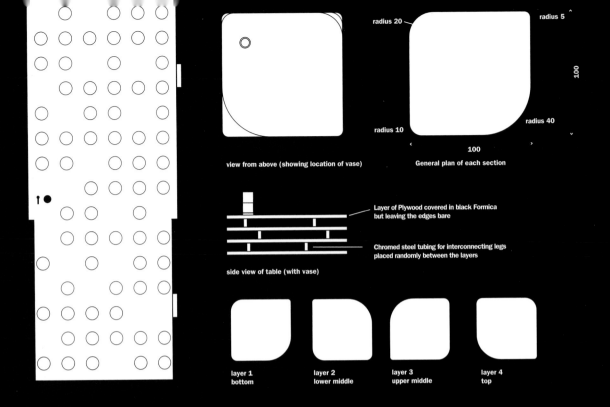

view from above (showing location of vase)

General plan of each section

radius 20

radius 5

radius 10

radius 40

100

100

Layer of Plywood covered in black Formica
but leaving the edges bare

Chromed steel tubing for interconnecting legs
placed randomly between the layers

side view of table (with vase)

layer 1
bottom

layer 2
lower middle

layer 3
upper middle

layer 4
top

DESIGN FOR A DOOR
1997
Dijon

TECHNICAL SPECIFICATION FOR A TABLE
1999

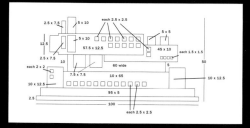

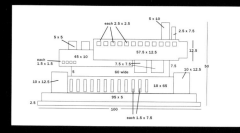

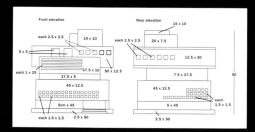

PLANS FOR A BIG CONFERENCE CENTRE
1998

LOGO FOR "ART LOVERS" EXHIBITION
1999

At the story's conclusion, the people who are still around use David's memory to reconstruct the apartment where he lived with his parents. Because his memories are subjective, the mother is much more vividly realised than the father, and his step-sister's room is not there at all: it is just a hole in the wall. The whole thing ends with David preparing a Bloody Mary for his mother, the juice is brighter red than in real life. He hears her voice and that's it. We don't see him turn to see her.

POSTER
1998

POSTER
1999

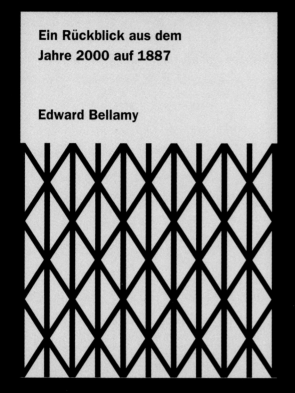

BOOK COVER
1998
(with Matthew Brannon)

BOOK COVER
1997
Zürich

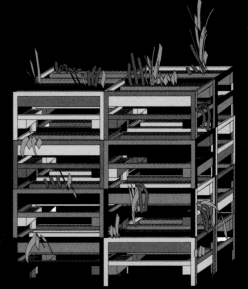

LOGO FOR FRANKFURTER KUNSTVEREIN
1998

PUBLIC PROJECT
1999
Berlin

153

A person alone in a room
with Coca-Cola coloured walls.

Ein Person allein in einem Raum
mit Coca-Cola-farbenen Wänden.

Alors, les gens étaient-ils abrutis à ce point avant la télévision?
Were people this dumb before TV?

WALL TEXT
1998
Vienna

BILLBOARD
1999
Berlin

1) Conceptual art is an art form exclusively confined to the late 1960s and early 1970s.
2) Few conceptual artists considered themselves only idea based or part of a group of conceptual artists.
3) Conceptual art is the logical extension of the increasing tendency towards pure expression in art that began with the advent of modernism.
4) Conceptual art is essentially a North American construct.
5) Conceptual art introduces the idea of speeding up the way in which art ideas can be consumed.
6) The development of conceptual art owes as much to the established culture as to the counter culture.
7) All the most well known conceptual artists were men.
8) Conceptual art is an urban construct.
9) Conceptual artists remain interested in questions of context.
10) Conceptual artists tended to believe that they were cultural workers and should be correctly rewarded for their work.
11) All the most interesting art being made today owes a debt to the way conceptual art challenged the conditions of production and reception as much as it embodied a particular aesthetic and formal implosion.
12) Conceptual artists started to consider time as much as space.
13) Conceptual art tends to carry a critique of the nature of art within the collapsed formalism of its presentation.
14) Conceptual artists tended to be concerned about the idea of being artists.
15) Conceptual art tried to be democratic or at least make a point about the way art can proceed beyond craft and traditional skills.
16) Conceptual artists usually had beards.
17) Conceptual artists worked in a specific neo-Marxist, anti-war context.
18) Conceptual art could be long winded, pedantic and written in legalistic language.
19) The best conceptual art is linked to a set of ideas about creating an intellectual umbrella under which to work that can project into the future. Therefore, some conceptual art can be understood as functioning equally well then, now and into the foreseeable future.
20) Conceptual art is pragmatic.
21) Conceptual artists are concerned to clarify who did what first.
22) Conceptual artists cannot function in isolation.
23) Conceptual artists tried to transcend national boundaries.
24) Conceptual artists liked making lists.
25) Conceptual art relies on social interaction.
26) Conceptual art fails to reach the highest prices at auction.
27) Conceptual artists remain engaged with the art world.
28) Conceptual artists tend to dislike the idea of different generations, ages, nationalities or backgrounds making a difference to the potential of art.
29) Good conceptual art is always more interesting than a painting but cannot be good without the history of painting.
30) Hardcore conceptual art was rarely funny, but related work is often hilarious.
31) Conceptual art rarely carried an overtly didactic message about a specific social or political problem while an awareness of such problems is implicit in its construction.
32) Conceptual artists are not usually so interested in the good/bad dilemma so much as examining the whole idea of good/bad in the first place.
33) Good conceptual art is unsentimental but can provoke emotional responses.
34) Most conceptual art is relatively uncomplicated when you first encounter it while on reflection complicating your relation to art.
35) Conceptual art is less obscure than Renaissance painting.
36) Most conceptual artists are still around and can be questioned in person about any of the above statements.

POSTER FOR BÜRO FRIEDRICH
1999
Berlin

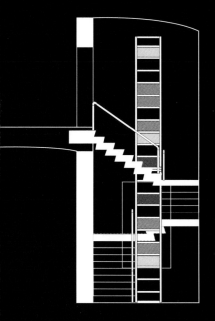
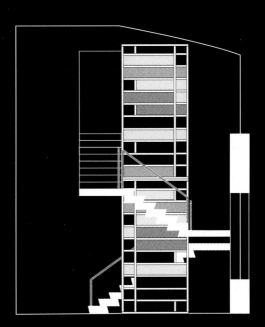

PROPOSAL FOR PRIVATE HOUSE
1999

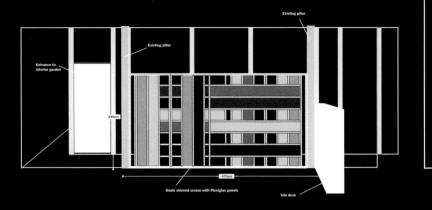

1. **Discussion**
2. **Negotiation**
3. **Routine**
4. **Ambience**
5. **Delay**
6. **Compromise**

Liam Gillick
Discussion Island
A What If? Scenario Report
25.2.97 - 7.12.97
Eröffnung 23.2.97
11 uhr (lecture in English)

Kunstverein Ludwigsburg
Franckstraße 4
D-71636 Ludwigsburg
Di - Fr 15.00 - 20.00
Sa, So 11.00 - 17.00

COMISSION
1999
Leipzig

INVITATION CARD
1997
Ludwigsburg

McNamara
"He stayed in the
sixtieth and seventieth
percentiles right
through this year."

Kahn
". . . nobody says
percentiles
Bob, nobody,
not yet."

AC
DC

JOY DIVISION

TRANSMISSION

LOVE WILL TEAR US APART

ATMOSPHERE

ROCKER
RIFF
RAFF
WHOLE
LOTTA
ROSIE
HIGH
VOLTAGE
PROBLEM
CHILD

McNAMARA POSTER
1994

AC/DC – JOY DIVISION HOUSE
1992
Milan

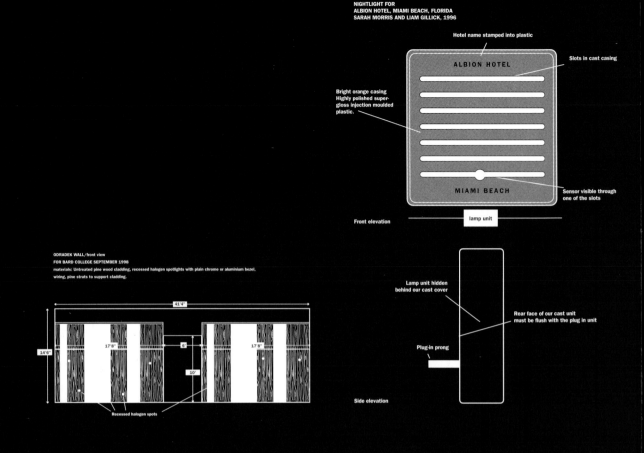

NIGHTLIGHT FOR
ALBION HOTEL, MIAMI BEACH, FLORIDA
SARAH MORRIS AND LIAM GILLICK, 1996

Hotel name stamped into plastic

ALBION HOTEL

Slots in cast casing

Bright orange casing
Highly polished super-
gloss injection moulded
plastic.

MIAMI BEACH

Sensor visible through
one of the slots

Front elevation

lamp unit

ODRADEK WALL/front view
FOR BARD COLLEGE SEPTEMBER 1998
materials: Untreated pine wood cladding, recessed halogen spotlights with plain chrome or aluminium bezel,
wiring, pine struts to support cladding.

Lamp unit hidden
behind our cast cover

Rear face of our cast unit
must be flush with the plug in unit

Plug-in prong

41'4"

14'6"

17'8"

6'

17'8"

10'

Recessed halogen spots

Side elevation

ODRADEK WALL
1998

NIGHTLIGHT FOR ALBION HOTEL
1996
Miami Beach, Florida

159

EXIHIBITION PLANS
1998
Berlin

PUBLIC PROJECT
1999
(with Jeppe Anderssen)

COMISSION
1999
Stuttgart

The Winter School

Last year . 1996. A winter scenario. Befor e the main event.
A moment spar ed for thinking back to another time. 1971.
A new str uctur e could have been cr eated, a kind of school.

A place to set action into action.
A projection into the near future. Changing everything. It's just that no-one can remember the details. Three people are looking for the original report. And they'll have to shift and flicker in order to reclaim that old forward-thinking.

It's 1971. In a room, overlooking the lake, a series of reports are being written. But we only have access to fragments of this emerging structure. The voice of the report co-ordinator is indistinct and presently hard to identify. For the moment we will only be able to make out the first few lines. First a cough and then. "Discussion Island is a lost Celtic place, no longer missing. Clans maintained this shared site, each taking turns to farm it in yearly rotation. In the event of any dispute between them, people gathered on Discussion Island to thrash out and reorganise crisis. An example of a desire for negotiated solutions that is part of a suppressed history. In parallel to this we now have a report that exposes an interest in people and situations where the location for action and analysis is focused upon the centre. A reclamation of the near future through an understanding of the middle ground."

It's 1996. If you want to find the centre of things then go to sleep. Not a coma sleep, but an active break towards reorganisation. In this story there are three people, all heading off in different directions. We will see their travels and feel the complexity of their negotiations. They are trying to think ahead. They are all trying to reclaim the idea of projection. Projection as a tool, the predictive meanderings that maintain us all within a state of thrall. Reclaiming the near future at a time when we might believe that there is no point. And the first person is dreaming, if that is what it should be called. Half asleep and half awake. We are dealing with an individual this time. There

are no longer any groups. Half asleep and half awake. Slipping thoughts. There is no bed here but everything is comfortable enough. We are a long way from any cities. A great distance from any other buildings. But there is no isolation this time. There are only fragments in the sleep state. And it is a half sleep and half wake that is only sustained by small possibilities and elements of negotiation. So the first person is only half with us. Thinking about a number of objects and images from the recent past. In order to move ahead, it might be necessary to reflect just before the slumber. A good time for addressing those things that have only just happened. It seems as if this is the first person's role. It is a good moment to start a winter school. Off season, out of sync.

It's still 1971. And on the lake outside the report room a man is struggling with a boat. It's distracting. Turning from the window and away from those concerns, a little more of the report may now be read. "So we are exposed to a persistent use of the phrase "the middle ground". It is important to understand such a term in relation to the socio-economic structure of the society in general and necessary to trap it in a report that is caught within a fiction. The middle ground, a broad, expanding area where you find negotiation, strategy, bureaucracy, compromise, planning and projection. An area long recognised as that which is crucial to maintaining the deferment of solutions that lies at the heart of the liberal capitalist dynamic of promise and potential."

It's 1996. Something must be started. Images and objects from the recent past. Pens, televisions and trousers? A series of questions leads to the problem of whether or not there is the real possibility of seeing any of these things clearly any longer. At least that's the problem for this first person. So let's slip away from the

difficulties and the person that bears them and move around the outside of the place where the first person is caught between at least two states. We are circling the area of awaking. Now it is more like thinking aloud, but without the moving or speaking. Clear and precise. If only someone would arrive and explain that there is very little time left. There has to be a winter school. That is clear at least. An antidote within a series of shared moments, a smile plays across the person's lips as their thoughts turn to incomplete stratagems, all of them developing around a beautiful, decorated fir tree.

We approach that first person again. But this time, we start from quite a distance and we move in fast. Picking up the pace. It's as if we hadn't noticed before, there is a panel over-head. Multiple and bright colours are working away. Caught in the middle ground. Half awake. Half not awake. While considering the implications of bureaucracy, compromise and negotiation. As we know by now, the first person is trying to be more precise and those thoughts are slipping once again. Try and pin down some moments where a winter school can work. Just before the main events. 1971, a year to remember. Now try that list again. A Brionvega television, a Bic Biro, velvet or corduroy? Try to collate a complete list of the things you would need in order to break through a progression of ideas. Times when the winter school could have gone into action but no-one had a timetable. Leave the first person for a while. Under a canopy, safe and sound, everything is happening.

It's 1971. Away from the window a fire is now roaring. And the report co-ordinator places something vague into the flames. Holding a fixed gaze while the yellow flicker licks at an ambiguity. Just to see what will happen. A little test. A little boredom? Heat builds up and then a shout

from the lake pulls the reporter back to attention. Read on. "This area is enormous and attempts to embrace us all. It is presented as the way things are but is clearly fought for. Put forward as the equilibrium into which structures naturally fall but clearly needs maintenance and continual action to keep it broad. The central zone is well recognised and in its earlier form was fought through the establishment of clear cut battle lines with which to attack the bourgeois sensibilities that were seen to prop it up. We all know this form of barricade development. And we also know it is useless as a straightforward tool."

It's 1996 again. So shift away from number one and embrace mobility. Move through a series of streets. There are elements of the situation and environment that are recognisable. All of these elements need to be described. But some of the objects that we come across appear to function in parallel to our sense of the present. Yet there has to be some attempt to list it all down. A catching of all the parts and pieces. This task will have to be done before the winter school can really get under way.

The second person is in a bar. Pan around it for a minute or two. Dark crescents under every eye. They look up and away. This person came in about three minutes ago and made a winding interrupted trip to the bar. Stopping frequently to look and

greet people. The second person is speaking to everyone they come across today. Talking up to the limit of distance and prepared to press on. And at every point there is some drawing back. A neat technique to defer the speaking process. All promise. They don't realise that the bar is not public, it's private. On the way through and out the other side, it soon becomes clear that the bar is a part of a house. Away on the other side is a work place, somewhere for the second person to get things done. Someone who thinks ahead at all times. For it is the moment to come up with a number of future scenarios. But hide them. Conceal them for a while, behind the familiarity of such engaging company.

We're back in 1971. Something has to happen in the winter time. Is there more in

the fragmented report? "This broad swathe of activity is generally seen as anything other than valuable territory for investigation. It is not mimicking the engagements of the middle ground that I am interested in, but the possibility of investigating the thrall within which the middle ground of strategised projection holds the potentially dynamised social and political structures that surround us. And along with any understanding of the middle ground must come a time based conception of the role social and economic projection has played in guiding the development of our situation. A day to day addiction to trends and the forecasting."

It's 1996 for the last time and soon to be 97. The third person is in an airplane travelling across a developed, well marked landscape. This person is making a series of mental side-steps all of which look towards alternative options in relation to the landscape below. This person also investigates the possibility of expansion rather than merely development. All of these ideas are noted on a number of sick bags with a borrowed pen. Things are moving faster now. We cut between the first, second and third person increasingly quickly. They start to argue and contradict each other without ever meeting. They are faced with no option and they are coming together. Closer and closer. It is winter and they arrive in a city. They pass each other by at the station without recognition and head off in different directions towards the flat muted tones of the immediate countryside. The Winter School is no longer only an option, it is a necessity.

1971. And in the house by the lake the sky is darkening. The days are short at this time of year. The report will be finished soon. Out of sync.
But just in time.

POSTER
1997
Geneva

163

LIAM GILLICK
Born 1964, Aylesbury, U.K.
Lives and works in London and New York.

EDUCATION
1983/84
Hertfordshire College of Art
1984/87
Goldsmiths College, University of London.

AWARDS
1998
Paul Cassirer Award, Berlin.

SOLO-EXHIBITIONS
1989
84 Diagrams, Karsten Schubert Ltd, London.

1991
Documents (with Henry Bond), Karsten Schubert Ltd, London.
Documents (with Henry Bond), A.P.A.C., Nevers.
Documents (with Henry Bond), Gio' Marconi, Milan.

1992
McNamara, Hog Bikes and GRSSPR, Air de Paris, Nice.

1993
Documents (with Henry Bond), CCA, Glasgow.
An Old Song and a New Drink (with Angela Bulloch), Air de Paris, Paris.

1994
McNamara, Schipper & Krome, Köln.
Documents (with Henry Bond), Ars Futura, Zurich.
Liam Gillick, Interim Art, London.

1995
Ibuka! (Part 1), Air de Paris, Paris.
Ibuka! (Part 2), Künstlerhaus, Stuttgart.
Ibuka!, Galerie Emi Fontana, Milan.
Part Three, Basilico Fine Arts, New York.
Documents (with Henry Bond), Kunstverein Elsterpark, Leipzig.

1996
Erasmus is Late 'versus' The What If? Scenario, Schipper & Krome, Berlin.
Liam Gillick, Raum Aktuelle Kunst, Vienna.
The What If? Scenario, Robert Prime, London.
Documents (with Henry Bond), Schipper & Krome, Cologne.

1997
Discussion Island, Basilico Fine Arts, New York.
Discussion Island – A What if? Scenario Report, Kunstverein, Ludwigsburg.
A House in Long Island, Forde, Éspace d'art contemporain, L'Usine, Geneva.
Another Shop in Tottenham Court Road, Transmission Gallery, Glasgow.
McNamara Papers, Erasmus and Ibuka Realisations, The What If?
Scenarios, Le Consortium, Dijon.
Reclutamento!, Emi Fontana, Milan.

1998
Liam Gillick, Kunstverein in Hamburg.
Up on the twenty-second floor, Air de Paris, Paris.
When Purity Was Paramount, British Council, Prague.
Big Conference Centre, Orchard Gallery, Derry.
Liam Gillick, Robert Prime, London.
Révision: Liam Gillick, Villa Arson, Nice.
When do we need more tractors?, Schipper & Krome, Berlin.
The Trial of Pol Pot, (with Philippe Parreno), Le Magasin, Grenoble.
Liam Gillick, c/o Atle Gerhardsen Oslo.

1999
Liam Gillick, Kunsthaus Glarus, Glarus.
Liam Gillick, Rüdiger Schöttle, Munich.
David, Frankfurter Kunstverein, Frankfurt.

2000
Who Controls the Near Future? Hayward Gallery Turnaround Project, London.
Liam Gillick, Charlotte Lund, Stockholm.
Liammm Gilllick, Schipper und Krome, Berlin.
Consultation Filter, Westfälischer Kunstverein, Münster.
Liam Gillick, Arnolfini, Bristol.

SELECTED GROUP EXHIBITIONS
1990
The Multiple Projects Room, Air de Paris, Nice.

1991
No Man's Time, CNAC, Villa Arson, Nice.
Air de Paris à Paris, Air de Paris, Paris.
The Multiple Projects Room, Air de Paris, Nice.

1992
Tatoo, Air de Paris/Urbi et Orbi, Paris/Daniel Buchholz, Cologne/
Andrea Rosen, New York.
Molteplici Culture, (selected by Giorgio Verzotti), Folklore Museum, Rome.
Lying on top of a building the clouds look no nearer than they had when I was lying in the street, Monika Sprüth, Köln/Esther Schipper, Cologne/Le Case d'Arte, Milan.
Manifesto, (curated by Benjamin Weil), Daniel Buchholz, Cologne/Castello di Rivara, Turin/Wacoal Arts Centre, Tokyo/Urbi et Orbi, Paris.
Etats Specifique, Musée d'art moderne, Le Havre.
The Speaker Project, ICA, London.
12 British Artists, Barbara Gladstone/Stein Gladstone, New York.
Group Show, Esther Schipper, Cologne.
Instructions, Gio' Marconi, Milan.
ON, Interim Art, London.

1993
Terratorio Italiano, (curated by Giacinto di Pietrantonio), Milan.
Claire Barclay, Henry Bond, Roderick Buchanan, Liam Gillick, Ross Sinclair, Gesellschaft für Aktuelle Kunst, (curated by Tom Eccles) Bremen.
Travelogue, (curated by Jackie McAllister), Hochschule fur Angewandte Kunst, Vienna.
Los Angeles International, Esther Schipper at Christopher Grimes, Los Angeles.
Wonderful Life, Lisson Gallery, London.
Group Show, Esther Schipper, Cologne.
The London Photo Race, Friesenwall 120, Cologne.
Futura Book, Air de Paris, Nice.
Points de Vue, Galerie Pierre Nouvion, Monaco.
Manifesto, (curated by Benjamin Weil), Hohenthal und Bergen, Munich.
Backstage, (curated by Stephan Schmidt-Wulffen & Barbara Steiner), Kunstverein in Hamburg.
Two out of four dimensions, Centre 181, London.
Dokumentation uber, arbeiten von, Esther Schipper, Cologne.
Unplugged, (curated by Nicolas Bourriaud), Cologne.

1994
Don't Look Now, (curated by Joshua Decter), Thread Waxing Space, New York.
Backstage, Kunstmuseum Luzern.
Surface de Réparations, (curated by Eric Troncy), FRAC Bourgogne, Dijon.
Cocktail I, Kunstverein in Hamburg.
Public Domain, (curated by Jorge Ribalta), Centro' Santa Monica, Barcelona.
Grand Prix, (curated by Axel Huber), Monaco.
Rue des Marins, Air de Paris, Nice.
Mechanical Reproduction, (curated by Jack Jaeger), Galerie van Gelder, Amsterdam.
WM/Karaoke, (curated by Georg Herold), Portikus, Frankfurt.
Other Men's Flowers, (curated by Joshua Compston), Hoxton Square, London.
Miniatures, The Agency, London.
Das Archiv, Forum Stadtpark, Graz.
Lost Paradise, (curated by Barbara Steiner), Kunstraum, Vienna.
Surface de Réparations 2, FRAC Bourgogne, Dijon.
The Institute of Cultural Anxiety, (curated by Jeremy Millar), ICA, London.

1995
Möbius Strip, Basilico Fine Arts, New York.
Bad Times, (curated by Jonathan Monk), CCA, Glasgow.
In Search of the Miraculous, Starkmann Library Services, London.
Faction, Royal Danish Academy of Arts, Copenhagen.
The Moral Maze, Le Consortium, Dijon.
Stoppage, CCC, Tours.
Collection fin XX, FRAC Poitou Charentes, Angoulème.
Summer Fling, Basilico Fine Arts, New York.
Stoppage, Villa Arson, Nice.
Karaoke, (curated by Georg Herold), South London Art Gallery.
Ideal Standard Summertime, Lisson Gallery, London.
Reserve-Lager-Storage, Ohl, Brusselles.
Filmcuts, Neugerriemschneider, Berlin.
New British Art, Museum Sztuki, Lodz.
Brilliant, (curated by Richard Flood), Walker Art Centre, Minneapolis.
Trailer, (curated by Barbara Steiner), Mediapark, Cologne.

1996
Co-operators, Southampton City Art Gallery, Southampton.
Traffic, (curated by Nicolas Bourriaud), CAPC, Bordeaux.

Kiss This, (curated by Jeremy Deller), Focalpoint Gallery, Southend.
Marche à l'ombre, Air de Paris, Paris.
Departure Lounge, The Clocktower, New York.
Everyday Holiday, Le Magasin, Grenoble.
Der Umbau Raum, Künstlerhaus, Stuttgart.
Dinner, (organised by Giorgio Sadotti), Cubitt Gallery, London.
Some Drawings From London, Princelet Street, London.
Nach Weimar, (curated by Nicolaus Schafhausen and Klaus Biesenbach),
Landesmuseum, Weimar.
How Will We Behave?, Robert Prime, London.
Escape Attempts, Globe, Copenhagen.
Life/Live, Musée d'Art Moderne de la Ville de Paris, Paris.
Such is Life, Serpentine London/Palais des Beaux Arts, Brussels/Herzliya Museum of Art.
Itinerant Texts, Camden Arts Centre, London.
Lost For Words, Coins Coffee Store, London.
All in One, Schipper & Krome, Cologne.
A Scattering Matrix, (curated by Jane Hart), Richard Heller Gallery, Los Angeles.
Found Footage, Tanja Grunert & Klemens Gasser, Cologne.
Glass Shelf Show, ICA, London.
Supastore de Luxe, Up & Co., New York.
Limited Edition Artist's Books Since 1990, Brooke Alexander, New York.

1997
Life/Live, Centro Cultural de Belém, Lisbon.
Temps de Pose, Temps de Parole, Musée de l'Echevinage, Saintes
Des Livres d'Artistes, L'école d'art de Grenoble, Grenoble.
Ajar, Galleri F15, Jeløy.
Enter: audience, artist, institution, (curated by Barbara Steiner),
Kunstmuseum Luzern.
Space Oddities, Canary Wharf Window Gallery, London.
Moment Ginza, (co-ordinated by Dominique Gonzalez-Foerster), Le Magasin, Grenoble.
I Met A Man Who Wasn't There, Basilico Fine Arts, New York.
504, (curated by John Armleder), Kunsthalle Braunschweig.
documenta X, Kassel.
Enterprise, ICA, Boston.
Group Show, Robert Prime, London.
Ireland and Europe, Sculptors Society of Ireland, Dublin.
Group Show, Vaknin Schwartz, Atlanta.
Heaven – a Private View, PS1, Long Island.
Hospital, Galerie Max Hetzler, Berlin.
Kunst… Arbeit, SüdWest LB, Stuttgart.
Other Men's Flowers, The British School at Rome, Rome.
Maxwell's Demon, Margo Leavin, Los Angeles.
Work in Progress and or Finished, Ubermain, Los Angeles.
Group Show, Air de Paris, Paris.
Group Show, Schipper & Krome, Berlin.

1998
Liam Gillick, John Miller, Joe Scanlan, RAK, Vienna.
Fast Forward, Kunstverein in Hamburg.
Artist/Author: Contemporary Artists' Books, American Federation of Arts
touring show, Weatherspoon Art Gallery, Greensboro/The Emerson Gallery, Clinton/
The Museum of Contemporary Art, Chicago/Lowe Art Museum, Coral Gables/
Western Gallery, Bellingham/University Art Gallery, Amherst.
Interactive, An Exhibition of Contemporary British Sculpture, Amerada Hess, London.
A to Z, (curated by Matthew Higgs), The Approach, London.
Construction Drawings, (curated by Klaus Biesenback), PS1, New York.
Arena – Sport und Kunst, Galerie im Rathaus, Munich.
Inglenook, (curated by Evette Brachman), Feigen Contemporary, New York.
In-significants, Stockholm, Sweden.
Kamikaze, Galerie im Marstall, Berlin.
London Calling, The British School at Rome & Galleria Nazionale d'Arte Moderna, Rome.
Fuori Uso '98, Mercati Ortofrutticoli, Pescara.
Videostore, (organised by Nicolas Tremblay and Stephanie Moisdon),
Brick and Kicks, Vienna.
UK – Maximum Diversity, Galerie Krinzinger, Bregenz/Vienna.
The Erotic Sublime, Thaddeaus Ropac, Salzburg.
Entropy, (curated by Wilhelm Schürmann), Ludwigforum, Aachen.
Places to Stay 4 P(rinted) M(atter), Büro Friedrich, Berlin.
Weather Everything, (curated by Eric Troncy), Galerie für Zeitgenössische Kunst, Leipzig.
Odradek, (curated by Thomas Mulcaire), Bard College, New York.
Mise en Scène, Grazer Kunstverein, Graz.
Minimal–Maximal, Neues Museum Weserburg, Bremen.
Ghosts, Le Consortium, Dijon.
Dijon/Le Consortium.coll, Centre Georges Pompidou, Paris.
Cluster Bomb, Morrison Judd, London.
The Project of the 2nd December, Salon 3, London.
Projections, de Appel, Amsterdam.
1+3 = 4 x 1, Galerie für Zeitgenössische Kunst, Leipzig.

1999
Konstructionszeichnungen, Kunst-Werke, Berlin.
Pl@ytimes, École supérieure d'art de Grenoble, Grenoble.
Oldnewtown, Casey Kaplan, New York.
Xn, Maison de la culture, Chalon.
Continued Investigation of the Relevance of Abstraction, Andrea Rosen Gallery, New York.
Nur Wasser, Neumühlen, Hamburg.
12 Artists, 12 Rooms, Thaddeaus Ropac, Salzburg.
Air de Paris: works by AND/OR informations about, Grazer Kunstverein.
Tang, Turner and Runyon, Dallas.
Plug-ins, Salon 3, London.
Etcetera, Spacex Gallery, Exeter.
Out of Sight – A cross-reference exhibition, Büro Friedrich, Berlin.
Essential Things, (curated by Guy Mannes Abbott), Robert Prime, London.
Laboratorium, Antwerpen Open, Antwerp.
In The Midst of Things, University of Central England, Bourneville.
Le Capitale, (curated by Nicolas Bourriaud), Centre regionale d'art contemporain, Sete.
The Space is Everywhere, Villa Merkel, Esslingen.
Objecthood OO, Athens.
Tent, Rotterdam.
Constructivism: Life into Art, Brisbane.
Shopping, FAT, London.
Fantasy Heckler, (curated by Padraig Timoney), Tracey, Liverpool Biennial.
Art Lovers, (curated by Marcia Fortes), Tracey, Liverpool Biennial.
Transmute, (curated by Joshua Decter), MCA Chicago.
New York–London, Taché-Levy, Brussels.
Get Together–Art As Teamwork, Kunsthalle, Vienna.
1999 East Wing Collection, Courtauld Institute of Art, London.
Jonathan Monk, Casey Kaplan, New York.
705 Wings of Freedom, (curated by Uwe Wiesner), Berlin.
Officina e Europa, Bologna.
Une histoire parmi d'autres, collection Michel Poltevin, FRAC Nord-Pas de Calais.
Space, Schipper & Krome, Berlin.

2000
Stortorget i Kalmar, Statens Konstråds Galleri, Kalmar.
Continuum 001, CCA, Glasgow.
The British Art Show, Arts Council Touring Exhibition.
What If? Moderna Museet, Stockholm.
Intelligence, Tate Gallery, London.

PUBLICATIONS
1991
Documents, London and Nevers, One-Off Press and A.P.A.C.
Technique Anglaise, (ed. Liam Gillick & Andrew Renton), London, Thames & Hudson.
No Man's Time, Nice, Villa Arson.
Gazette, Cologne, Galerie Esther Schipper.

1992
Molteplici Culture, (ed. Christov-Bakargiev), Rome.
Etats Specifiques, Musée d'art moderne, Le Havre.
12 British Artists, Barbara Gladstone/Stein Gladstone, New York.
240 Minutens, (ed. Georg Graw & Lothar Hempel), Cologne.
Instructions, (ed. Liam Gillick), Gio' Marconi, Milan.
ON, London, Interim Art.

1993
Documentario 2, (ed. Di Pietrantonio), Milan.
Claire Barclay, Henry Bond, Roderick Buchanan, Liam Gillick, Ross Sinclair,
Bremen, Gesellschaft für Aktuelle Kunst.
Travelogue, Vienna, Hochschule fur Angewandte Kunst.
Fotofeis, Glasgow, International Photography Festival.
Love is no Four Letter Word, Lothar Hempel, Cologne, Esther Schipper.
Backstage, Kunstverein in Hamburg.
Ideal Place, Nevers, (ed. Eric Troncy).

1994
Don't Look Now, New York, Threadwaxing Space.
Backstage, Kunstmuseum Luzern.
Public Domain, Barcelona, Centro' Santa Monica.
Mechanical Reproduction, Amsterdam, Galerie Van Gelder.
Other Men's Flowers, London, FN/Booth-Clibborn.
McNamara, Cologne, project for Nummer.
McNamara, New York, project for New Observations.
Liam Gets a Serial Killer Annoyed, Sydney, project for Art & Text.
Sunshine, Köln, Jahresring.
Like Sure, Or Not, Stockholm, project for Palleten.
The Institute of Cultural Anxiety, London, ICA.

165

1995

Möbius Strip, New York, Basilico Fine Arts.
Faction, Copenhagen, Royal Danish Academy of Arts.
Lost Paradise, (ed. Barbara Steiner), Vienna/Stuttgart, Oktagon.
Stoppage (CD), Nice, Tours and London, CCC/Villa Arson.
Erasmus is Late, London, Book Works.
Ibukal, Stuttgart, Künstlerhaus.
Grim, (project with Douglas Gordon), Parkett.
Collection fin XX, Angoulème, FRAC Poitou Charentes.
We Are Medi(eval), (with Angela Bulloch), Frankfurt, Portikus.
Camera Austria, Graz, Forum Stadtpark.
New Art From Britain, Lodz, Museum Stzuki.
Surface de Réparations, Dijon, FRAC Bourgogne.
Brilliant, Minneapolis, Walker Art Centre.
Prime Time #1, Dijon, Le Consortium.

1996

Co-operators, Southampton City Art Gallery.
Traffic, Bordeaux, CAPC.
Do It, Reykyavik, Kjarvalsstadir.
Everyday Holiday, Grenoble, Le Magasin.
Nach Weimar, Weimar, Cantz.
Herausgeber, Vienna, Kunstraum Wien.
Escape Attempts, Copenhagen, Globe.
Life/Live, Paris, Musée d'Art Moderne de la Ville de Paris.
Book Works – A partial history and source book, London, Book Works.
Lost For Words, London, Toby Mott.
Found Footage, Cologne, Tanja Grunert & Klemens Gasser.
A Scattering Matrix, Los Angeles, Richard Heller Gallery.
Echoes – contemporary art at the age of endless conclusions, New York,
The Monacelli Press.

1997

Des Livres d'Artistes, Grenoble, L'école d'art de Grenoble.
Ajar, Jeloy, Galleri F15.
Blimey!, London, 21.
Unbuilt Worlds: Unrealised Artists Projects, Munster, Cantz.
Politics and Poetics, Kassel – documenta, Cantz.
Short Guide, Kassel – documenta, Cantz.
Schipper und Krome, Berlin, Schipper & Krome.
McNamara Papers, Erasmus and Ibuka Realisations, The What if?
Scenarios, Dijon, Le Consortium, Hamburg, Kunstverein.
Erasme est en retard, Dijon, Les Presses du Réel.
Enterprise, Boston, ICA.
Ireland and Europe, Dublin, Sculptors Society of Ireland.
Andreas Schulze, Kunstverein Ludwigsburg, Cantz.
Armleder, Milan, Fondazione Antonio Ratti.
Moving Targets, Louisa Buck, London, Tate Gallery.
Hospital, Berlin, Galerie Max Hetzler.
Kunst… Arbeit, Stuttgart, SüdWest LB/Cantz.
Big Conference Centre/Das Grosse Konferenzzentrum, Ludwigsburg/
Derry, Kunstverein Ludwigsburg, Orchard Gallery.

1998

Artist/Author: Contemporary Artist's Book (ed. Cornelia Lauf/Clive Phillpot),
New York, American Federation of Arts.
Interactive, An Exhibition of Contemporary British Sculpture, London, Amerada Hess.
Art from Britain, Hamburg, Sammlung Goetz.
L'île de discussion/le grand centre de conférence, Nice/Dijon,
Villa Arson/Les presses du réel.
Mise en Scène, Graz, Grazer Kunstverein.
Minimal-Maximal, Bremen, Neues Museum Weserburg.
X Mal Documenta X, Kassel, Kunsthochschule der Universität Gesamthochschule.
Dominique Gonzalez-Foerster, Pierre Huyghe, Philippe Parreno, Paris, ARC,
Musée d'Art Moderne de la Ville de Paris.
Cream, London, Phaidon Press.
Le colonel moutarde dans la bibliothèque avec le chandelier,
Eric Troncy, Dijon, Les presses du réel.
Absurd, Paris, Self Service.
Dijon/Le Consortium.coll, Dijon/Paris, Les presses du réel/Centre Georges Pompidou.
Fuori Uso '98, Mostrato, Pescara, Edizioni Arte Nova.
Ein Rückblick aus dem Jahre 2000 auf 1887, Edward Bellamy, Leipzig,
Galerie für Zeitgenössische Kunst.
Zing Magazine, Volume 2, Fall.
øjeblikket, The Meaning of Site, Copenhagen.
Innerscapes, (edited by Maurizio Pellegrin), Trieste, Contemporanea.

1999

UK Maximum Diversity, Vienna, Galerie Krinzinger.
Pl@ytimes, Grenoble, Ecole du Magasin.
Weather Everything, Leipzig, Cantz/Galerie für Zeitgenössische Kunst.
Independent Spaces, Geneva, JRP éditions.
Servicio Publico, Barcelona, Ediciones Universidad de Salamanca.
Seven Wonders of the World, London, Book Works.
Designs for a four storey building, New York, Open City.
Art at the turn of the millenium, Cologne, Taschen.
Esthétique Relationnelle, Nicolas Bourriaud, Dijon, Les presses du réel.
Calender, Glarus, Kunsthaus.
Objecthood OO, Athens, American Hellenic Union.
Le Capital, Sète, Centre régional d'art contemporain.
The Space is Everywhere, Esslingen, Villa Merkel.
La Memoire, The French Academy in Rome.
Get Together/Art As Teamwork, Vienna, Kunsthalle.
Habitat Art Club, London, Habitat.
5 or 6, New York, Lukas and Sternberg.
Perché, Rome, Magazzino d'arte moderna.
Laboratorium, Antwerp, Antwerpen Open.
Art Lovers, Liverpool, Tracey: Liverpool Biennial.

SELECTED REVIEWS

1991

Rose Jennings, Documents: Karsten Schubert Ltd, City Limits, February 7–14.
Michael Archer, Documents: Karsten Schubert Ltd, Artforum, March.
Ian Jeffrey, Bond & Gillick, Art Monthly, March, 144.
Clifford Myerson, Documents & Details, Art Monthly, April, 145.
Carolyn Christov-Bakargiev, Someone Everywhere, Flash Art, Summer.
Tim Hilton, Composition with Old Hat, Guardian, August 14.
Frontlines: No Man's Time, Artscribe, September.
Jean Yves Jouannais, Villa Arson, Art Press 162, October.
Giorgio Verzotti, No Man's Time, Artforum, November.
Michael Archer, Audio Arts Issues and Debates I, Audio Arts.
Andrew Wilson, Technique Anglaise, The Art Newspaper, November.
Eric Troncy, No Man's Time, Flash Art International, December.
Meyer Raphael Rubinstein, Technique Anglaise, Arts, November.
Michael Archer, Technique Anglaise, Artforum, December.

1992

Giacinto di Pietrantonio, Bond & Gillick, Gio' Marconi, Flash Art Italia, Feb/March.
Maureen Paley interviewed by David Brittain, Creative Camera, 313.
Giacinto di Pietrantonio, Bond & Gillick, Gio' Marconi, Flash Art, April.
Henry Bond & Liam Gillick, Press Kitsch, Flash Art International 165, July/Aug.
Eric Troncy, London Calling, Flash Art International 165, July/Aug.
Giorgio Verzotti, News From Nowhere, Artforum, July/Aug.
Elizabeth Lebovici, L'art piège a l'anglaise, Libération, July 7.
Mark Thomson, États Spécifique, Art Monthly, July/Aug.
Robert Pinto, Molteplici Culture, Flash Art International, October.
Francesco Bonami, Twelve British Artists, Flash Art International, November.
Peter Schjeldhal, Twelve British Artists, Frieze, Nov/Dec, Issue 7.

1993

Amedeo Martegani, Liam Gillick, Flash Art Italia, January.
David Lillington, ON, Time Out, Jan 13th.
Jutta Schenk-Sorge, Zwölf Junge Britische Künstler, Kunstforum 120.
Interview with Liam Gillick, Flash Art International, January.
Frederick Ted Castle, Occurances-NY, Art Monthly, February.
Eric Troncy, Wall Drawings & Murals, Flash Art International, May.
Nicolas Bourriaud, Modelized Politics, Flash Art, Summer.
David Lillington, True Brit, Time Out, July 28th.
Ray McKenzie, Views from the Edge, Scottish Photography Bulletin, October.
Henry Bond and Liam Gillick, The List, July 2nd–15th.
James Odling-Smee, Wonderful Life, Art Monthly, October.
Mat Collings, Art Break, Observer, October 17th.
Liam Gillick, A Guide to Video Conferencing Systems and the Role of the Building
Worker in Relation to the Contemporary Art Exhibition (Backstage),
Documents, No. 4, October.

1994

Benjamin Weil, Backstage, Flash Art International, Jan/Feb.
Liam Gillick/Ken Lum, Global Art, Flash Art International, Jan/Feb.
Radio Interview, Luzern, February.
Mark James, Freeze, BBC 1, Omnibus, February 22nd.
Nathalie Bouley, Les Parcours d'illusions…, Le Bien Public, February 23.
Roland Topor, Surface de Réparations, Art & Aktoer, February, No. 5.
Nicolas Bourriaud, Au Moment du Penalty, Globe, 9–15 February.
Nicolas Bourriaud, Surface de Réparations, Art Press, No. 190.
Eric Troncy, Suface de Réperations, Omnibus, June.
Fritz Billeter, Schnörkel und Schleifchen, Tages-Anzeiger, February 28.
Arte Guerrero, El País, March 14.

Olga Spiegel, Fotographos de Londres…, La Vanguardia, March 14.
Christian Besson, Surface de Réperations, Flash Art International, May–June.
Helena Papadopoulos, Don't Look Now, Flash Art International, May–June.
Simon Grant, World Cup Football Karaoke, Art Monthly, September.
Paradies Verloren, Die Presse, October 22.
Verdoppelt, durchleuchtet, Kleine Zeitung (Graz), October 12.
Brigitte Borchhardt-Birnbaumer, Ein Neues Ausstellungsmodell,
Wiener Zeitung, October 14.
Wolfgang Zinggl, Tee Trinken mit Künstlern, Falter, October 28.
Schipper & Krome, Neue Bildende Kunst, November.
Mark Currah, Time Out, December.

1995
Franz Niegelhell, Sammeln und Speichern, PAKT, January.
Michael Hauffen, Das Archiv, Kunstforum, January.
Justin Hoffman, Das Archiv, Artis, February–March.
Zapp Magazine, Möbius Strip, Issue 4.
Arno Gisinger, Das Archiv, Eikon, April.
Liam Gillick, The Insitute of Cultural Anxiety, Blueprint.
Project, (Jake & Dinos Chapman), Art & Text, May.
Nicolas Bourriaud, Pour une ésthetique rélationnelle, Documents, No. 7.
Sabine Maida, Sur un air de Darwin, Le quotidien de Paris, May 15.
Philippe Parreno, Une exposition serait-elle un cinéma sans caméra?, Libération, May 27.
Liam Gillick, Kunstlerporträts, Neue Bildende Kunst, June–August.
Liam Gillick, When Are You Leaving?, Art & Design, May.
Eric Troncy, Liam Gillick, Flash Art International, Summer.
Sabine Krebber, Romantisch und Verwundbar, Stuttgarter Nachrichten, July 1.
Forget about the ball and get on with the game, (with Rirkrit Tiravanija), Parkett 44, Summer.
Adrian Searle, Karaoke, Time Out, July 26.
Sarah Kent, Ideal Standard Summertime, Time Out, July 26.
Philip Sanderson, Ideal Standard Summertime, Art Monthly, September, No. 189.
Erasmus is Late, La Repubblica, September 15.
Christoph Blase, Ibuka!, Springer, Issue 4.
Martin Maloney, Grunge Corp, Art Forum, November.
Jeffrey Kastner, Brilliant?, Art Monthly, Dec/Jan 1995–96.
Lynn McRitchie, Brilliant, Financial Times.
Karmel, Liam Gillick, New York Times, December 8.
Stuart Servetan, Liam Gillick, New York Press, Dec 6–18.
Anne Doran, Part Three, Time Out, New York, Dec 13–20.
Matthew Collings, My Brilliant Repartee, Modern Painters, Winter.
Peter Herbstreuth, Leipzig: Fotografie im Kunstverein Elsterpark,
Kunst Bulletin, 12/95.

1996
Iain Gale/Georgina Starr, Where does British Art go from Here?, Independent, Jan 2.
Neal Brown, Ideal Standard Summertime, Frieze 26, January/February.
Adrian Dannat, Brilliant, Flash Art, January/February
Simon Ford, Myth Making, Art Monthly, March, 194.
Michael Archer, No Politics Please We're British, Art Monthly, March, 194.
John Tozer, Co-operators, Art Monthly, March, 194.
Rainald Schumacher, Liam Gillick, Springer, 1/96.
Matthew Ritchie, Liam Gillick: Part Three, Performing Arts Journal.
Georg Schöllhammer, Kuratiert von:, Springer, March.
Brigitte Werneburg, Das Virus Heißt Political Correctness, Taz, 9/10 March.
Barbara Steiner, If…If…If… a lot of possibilities, Palettes, No. 223.
Philippe Parreno, McNamara – A film by Liam Gillick, Paletten, No. 223.
Andreas Spiegl, Traffic – CAPC, Art Press, No. 212, April.
Hans Knoll, Parallelwelten und frottierte Schilde, Der Standard, 18 April.
Johanna Hofleitner, Augestellt in Wien, Die Presse, 19 April.
Liam Gillick, Der Standard, 2 May.
Lynne McRitchie, Brillliant, Art in America, May.
Simon Ford, Der Mythos vom Young British Artist, Texte zur Kunst, No. 22, May.
Martin Herbert, Liam Gillick, Time Out, May 15 – 22.
Liam Gillick, The Corruption of Time (Looking Back at Future Art),
Flash Art, May/June, No. 188.
Godfrey Worsdale, Liam Gilllick, Art Monthly, June, No. 197.
Juan Cruz, Some Drawings from London, Art Monthly, July/August, No. 198.
Lars Bang Larson, Traffic, Flash Art, Summer, No. 189.
Barbara Steiner, Traffic, Springer, Band II, Heft 2.
Verena Kuni, Der Umbau-Raum, Springer, Band II, Heft 2.
Jennifer Higgie, Liam Gillick, Frieze, Issue 30.
Carl Freedman, Some Drawings From London, Frieze, Issue 30.
Barbara Steiner, Film as a method of Thinking and Working, Paletten, No. 224.
Marie de Brugerolle, Renaissance du Magasin, Art Press, October, No. 217.
Elizabeth Lebovici, Grand déballage d'art britannique, Libération, 10th Oct.
Jelka Sutej Adamic, Liam Gillick, Delo, 11th Oct.
Angela Vettese, Giovani Inglesi Aspettano Godot, Il Sole, 13th Oct.
Michael Krome, Liam Gillick, Kunstzeitung, No. 3, Nov.
La crème anglaise s'éxpose à Paris, Le Figaro, 26th Nov.

Robert Fleck, Die Wahren Helden sind die Väter, Art, December.
Pierre Restany, New Orientations in Art, Domus.

1997
Peter de Jonge, The Rubell's in Miami, Harper's Bazaar, February.
Jesse Kornbluth, Is South Beach Big Enough for Two Hotel Kings?,
New York Times, 16th Feb.
Die Zukunft als künstlerisch-humanes Spielkonzept,
Ludwigsburger Kreiszeitung, 22nd Feb.
Überliefertes Aufbrechen, Neue Luzerner Zeitung, 12th April.
"Enter – Audience, Artist, Institution" Ausgestellt, Luzern Heute, 12th April.
Gregory Volk, Liam Gillick at Basilico Fine Arts, Art in America, June.
Dominique Nahas, I met a man who wasn't there, Review, July/August.
Elizabeth Mangini, I met a man who wasn't there, The Exhibitionist, Aug/Sept.
documenta X, The Guardian. The Financial Times. Art Forum. Kunstforum. Art Monthly.
Zeigam Azizov, Liam Gillick and his Parallel Activities, Omnibus, October.
Nadine Gayet-Descendre, Nouvelle vie pour PS1, L'Oeil, No. 490, November.
Ann Doran, School's In, Time Out, New York, 6–13 November.
Marc-Olivier Wahler, Habiter un lieu d'art, Kunst Bulletin, December.
Eric Troncy, We're people this dumb before television: Interview with Liam Gillick,
Documents sur l'art, No. 11.
Christoph Tannert, Zwischen Hospital und Hotel, Berliner Zeitung, Dec 20th.
Brigitte Werneburg, The Good Beuys, taz, Dec 20th.
Tanja Fielder, Auf dem Pappbett endet Sehnsucht, Morgenpost, Dec 16th.
Schwarzwaldklinik, Ticket, Dec 11th.

1998
Susanne Gaensheimer, In Search of Discussion Island – About the Book Big
Conference Centre, by Liam Gillick, Index, No. 22, February.
Karl Holmquist, Hospital, Flash Art March/April.
Jade Lindgaard, Le Plexiglas Philosophical, Le Monde/Les Inrockuptibles,
6–12 May.
David Musgrave, A to Z, Art Monthly, May.
Jorn Ebner, Dickes Make-up, dünnhäutige Kunst, Frankfurter Allgemeine Zeitung,
11th July.
Laura Moffatt, Liam Gillick, Art Monthly, July/Aug.
Inglenook, Village Voice, 21st July.
Ken Johnson, Inglenook, New York Times, 24th July.
Eric Troncy, Liam Gillick/Villa Arson, Les Inrockuptiples, Summer.
Christoph Blase, Liam Gillick, Blitz Review.
Paul Cassirer Kunstpreis, Berliner Morgenpost, September 30th.
Morning Edition, NPR, New York, October 3rd.
Kerstin Braun, Wie bildende Kunst Theater reflektiert, Neue Zeit, Oct 9.
Anders Eiebakke & Bjønnulv Evenrud, Liam Gillick, Natt & Dag, Dec/Jan.
Berit Slattum, Kommuniserende britisk samtidskunst, Klassekampen, Dec 9.

1999
Salon 3, Flash Art, Jan/Feb.
Heinz Schütz, Steirischer Herbst '98, Kunstforum, Jan/Feb, No. 143.
Holland Cotter, Changes Aside, New York Times, February 12.
Roberta Smith, Continued Investigation of the Relevance of Abstraction, New York
Times, Feb 12.
Catsou Roberts, Ouverture de Salon 3, Art Press, No. 243, Feb.
Sue Spaid, Conceptual Art as Neurobiological Praxis, Village Voice, April.
Andrea K. Scott, Conceptual Art as Neurobiological Praxis, Time Out, New York, April.
Andreas Denk, Nur Wasser Läßt sich Leichter Schneiden, Kunstforum, May/June.
Ronald Jones, A continuing investigation into the relevance of abstraction,
Frieze, Issue 47, Summer.
Brita Polzer, Kunst, Annabelle, June.
Radio DRS 2, Interview with Liam Gillick, June 29.
Claudia Kock Marti, Viereck und Kosmos, Die Südostschweiz/Glarner Nachrichten, July 2.
Edith Krebs, Er ist ein Jongleur, Zürich, Tages Anzeiger, July 3.
Liam Gillick, Neue Zürcher Zeitung, July 9.
Martin Engler, Verspätetes Millennium, Frankfurter Allgemeine Zeitung, July 21.
Daniel Kurjako, Szenarien zwischen Gestern und Morgen, August 5.
Eva Grundl, Erklärt Kunst die Welt, Südkurier, August 12.
Elisabeth Wetterwald, XN, Parachute, July/Aug/Sept. No. 95.
Süddeutsche Zeitung.
Asprey/Jacques Documentary, Channel 4.
Britische Kunst wie fürs Wohnzimmer, Focus, 25 Oct.
What is art today?, Beaux Arts Magazine, Dec.

2000
Jonathan Jones, Liam Gillick, The Guardian, January 12.

167

PUBLISHED TEXTS BY LIAM GILLICK

1988
ARCO/Interviews, article, New Art International, January.
Günther Förg, article, New art international, May.
A week of British Art, article, Art Monthly, July/August.
Grenville Davey/Gary Hume/Michael Landy, article, New Art International, October.

1989
Show & Tell, exhibition review, Art Monthly, February.
Caroline Russell, exhibition review, Art Monthly, May.
Gary Hume, exhibition review, New Art International, June.
At Face Value, exhibition review, Artscribe, Summer.
Bethan Huws, exhibition review, Art Monthly, October.
Richard Wentworth, article, New art international, October.
Robert Mangold/Bruce Nauman, exhibition review, Artscribe, November/December.
Michael Craig Martin, exhibition review, Art Monthly, December/January.

1990
Critical Dementia: The British Art Show, exhibition review, Art Monthly, March.
Ian Davenport, Article, Artscribe, March/April.
Page 2, editorial, Art Monthly, July/August.
Ghost, Gallery Guide, published by the Chisenhale Gallery.
Allan McCollum, exhibition review, Artscribe, Summer.
Paris – France, article, Art Monthly, September.
Les Ateliers du Paradise, exhibition review, Artscribe, September.
A new necessity/Edge '90, exhibition review, Artscribe, September/October.
Kay Rosen, exhibition review, Artscribe, October.
Seven Obsessions, exhibition review, Flash Art, November/December.
Conversation with Damien Hirst, article, Artscribe, November/December.
Vincent Shine, exhibition review, Art Monthly, December/January.

1991
Lucia Nogueira, exhibition review, Artscribe, March.
Lawrence Weiner, exhibition review, Art Monthly, March.
The Placebo Effect, article, Arts Magazine, May.
James Coleman, exhibition review, Artscribe, June.
Gambler, exhibition catalogue, published by Building One.
Conversation with Xavier Veilhan, catalogue for exhibition No Man's Time, CNAC, Nice.
Conversation with Eric Troncy, catalogue for exhibition No Man's Time, CNAC, Nice.
Akira: Nothing changes nothing stays the same, film review, Artscribe, Summer.
Langlands & Bell, exhibition review, Artscribe, Summer.
Simon Linke: A funny thing happened on the way to Artforum, article, Artscribe, Summer.
Pistoletto, exhibition review, Art Monthly, September.
Un centimetre egal un metre/Xavier Veilhan, catalogue essay, APAC, Nevers.
Red, yellow, blue, black, white and grey, book review of De Stijl, Art Monthly, December.

1992
Windfall, exhibition review, Artscribe, January.
Trading Images, exhibition catalogue, Exhibit A, Serpentine, February.
Reasons to like the work of Karen Kilimnik, article, Documents, March.
Ridiculous Jimmy Stewart films, interview, Documents, March.
Doubletake, exhibition review, Art Monthly, March.
The bible, the complete works of Shakespeare… article, Meta 2, April.
Bethan Huws/Making work and turning your back on it, article, Parkett, Summer.
Mike Kelley, exhibition review, Art Monthly, July/August.
Marylene Negro and the corruption of data, article, Blocnotes, August.
New York Story, article, Documents, October.
Listes et divers definis… article, Art & Culture, November.

1993
Laura Ruggeri, notes, Documents, February.
Ericson & Zeigler, exhibition catalogue, WSCAD, March.
Jeremy Deller, radio feature, Radio 5, March.
Barclays Young Artists Award, exhibition review, Art Monthly, March.
Psycho: Douglas Gordon, radio feature, Radio 5, May.
Curating for pleasure and profit, article, Art Monthly, June.
History, article, Documents, June.
Keith Moon was my father, Jeremy Deller, note, Documents, June.
Langlands & Bell, catalogue essay, Museet for Samtidskunst, Oslo.
Julian Opie, exhibition review, Art Monthly, December/January.

1994
Wall to Wall, exhibition catalogue, Southbank Centre, January.
Global Art, Ken Lum, article, Flash Art, January/February.
Barbara Kruger, book review, Art Monthly, February.
Paul Mittleman, note, Documents, February.
Grand Prix, exhibition catalogue, Air de Paris/Axel Huber, June.
Context Kunstlers, article, Art monthly, March.
Wall to Wall, Audio Arts Special Issue, Vol. 14 No. 2.
Liam Gets A Serial Killer Annoyed, project, Art & Text, September.
The Game Show Fights Back, television review, Blueprint, September.
Audio Arts, Discourse and… book, Academy Editions, September.
From Coatbridge to Piacenza, catalogue essay, CCA, September.
McNamara, project, Sunshine/Jahresring, September.
Erasmus is Late, catalogue essay, On-Line, October.
Wish You Were Here, exhibition review, Art Monthly, October.
Some Went Mad…, Neue Bildende Kunst, Berlin, October/November.
Lifestyles of the Rich and the Dead, exhibition review, Documents, Autumn.
McNamara, project, New Observations, November/December.
Archives & Atlases, essay, Meta 3, December.
Like Sure or Not, essay, Paletten, December.
McNamara, project, Nummer, Winter.

1995
Important Postmen, catalogue essay, Möbius Strip, January.
The Institute of Cultural Anxiety, exhibition review, Blueprint, February.
There is no zero, article, Blueprint, March.
Miss Me: Michael Joo, article, Art Monthly, April.
When Are You Leaving, article, Art & Design, Spring.
Project for Art & Text, Summer.
The Late Show, article, Art Monthly, September.
The Art of Context, article, Art Monthly, October.
Henry Bond & Liam Gillick, essay, Symposium on Photography XV, October.
Philippe Parreno, catalogue essay, Le Consortium, Dijon.
Forget about the ball and get on with the game, with Rirkrit Tiravanija, Parkett.
Guide yourself through the gallery, John Baldessari, Gallery Guide, Serpentine Gallery.
I will not make any more boring art, interview with John Baldessari, Art Monthly, October.
Best Dressed Chicken in Town, The Rock Video Gallery, Review, Blueprint, October.
Interview, Neue Bildende Kunst, November.
The Moderator Goes on Holiday Article Purple Prose, December.

1996
Felix Gonzalez-Torres, Obituary, Art Monthly, March.
Like turning a chair into a switch, interview with Angela Bulloch, Documents.
Fascinating: Dennis Hopper Provides Ace Colour, film review, Art Monthly, March.
Ill Tempo, article, Flash Art.
What the Butler Saw, book review, Tate Magazine.
The Why Scenario, lecture for Ratti Foundation.
Tripart, project, Paletten.
A Viable Place: Der Umbau Raum, article, Art & Design.
Cinema is the new Architecture: Elizabeth Wright, catalogue essay, Showroom Gallery.
L.Y.S.E.N.K.O. Carsten Höller, catalogue essay, Glück, Oktagon.
The Imperfect Crime Part One, Liam Gillick on becoming Giorgio Sadotti with notes by Giorgio Sadotti made while not being himself, article, Documents.
Future Intense, A story towards the work of Sarah Morris, interview, Documents.
From a symposium: March 25th 2000 flashing back to 1887, project, Transmission Gallery, Transmission Gallery.

1997
Leave Now, Before It's Too Late, Ross Sinclair's internationalism, catalogue essay, CCA, Glasgow.
Coming to terms with the terms, Echoes, book review, Art Monthly.
Were people this dumb before TV?, Liam Gillick interviewed by Eric Troncy, Documents.
Between the Park and the House is a Road, Andreas Schulze's hospitality, catalogue essay, Kunstverein Ludwigsburg.
Taking a bubble to the top of a mountain, Padraig Timoney, catalogue essay, Orchard Gallery, Derry.

1998
Prevision, catalogue essay, ARC, Musée d'Art Moderne de la Ville de Paris, Paris.
So there are at least two kinds of lobby, column, Art/Text, July.
A Meta-Dialogue via e-mail, catalogue essay, Goldsmiths College.
Lothar Hempel's Rigged Rooms, catalogue essay, Bureau Stedlijk, Amsterdam.
What kind of snow is that lamp made of? Richard Deacon taking illogical ideas to their logical conclusion, catalogue essay, Tate Gallery Liverpool.
Put Your Foot Down, Sylvie Fleury's passionate distance, catalogue essay, Le Consortium.
Circumstantial Evidence (Asleep in the dark, at night, with the lights off), article, Paradex, Pilot Issue.
Fifty Feet, Twenty Five Feet, Fifteen Feet, column, Art/Text, October.

1999
The Meeting of the 2nd of February, column, Art/Text, January.
Twenty-Five Years, The Rematerialisation of the Art World, Review of Lucy Lippard's Six Years, book review, Art Monthly, February.
Should the future help the past?, essay, Afterall, Pilot Issue.
La retour de la vache qui rit, "Les Ateliers du paradise", article, 1% Magazine.
Speculation and Planning, column, Art/Text, April.
Dreams, project, Venice Biennial, Hans Ulrich Obrist and Francesco Bonami, June.
Dinner at Franks', column, Art/Text, July.